The Art of
Japanese Ceramics

Volume 29
THE HEIBONSHA SURVEY OF JAPANESE ART

For a list of the entire series see end of book

The Art of Japanese Ceramics

by TSUGIO MIKAMI

translated by Ann Herring

New York · WEATHERHILL/HEIBONSHA · Tokyo

This book was originally published in Japanese by Heibon-
sha under the title *Toki* in the Nihon no Bijutsu series.

A full glossary-index covering the entire series will be pub-
lished when the series is complete.

First English Edition, 1972
Second Printing, 1973

Jointly published by John Weatherhill, Inc., 149 Madison Avenue, New York,
New York 10016, with editorial offices at 7-6-13 Roppongi, Minato-ku, Tokyo
106, and Heibonsha, Tokyo. Copyright © 1968, 1972, by Heibonsha; all rights
reserved. Printed in Japan.

LCC Card No. 77-162681 ISBN 0-8348-1000-X

Contents

1. Japan in World Ceramic Culture 9
 The Origins of Ceramics 9
 The Development of Japanese Ceramics 13

2. Ceramics in Japanese Life 38
 Characteristics of Japanese Ceramics 38
 The Spread and Development of Earthenware
 in Ancient Times 39
 Ceramics in Medieval Japan 40
 The Complexity of Early Modern Ceramics 57
 The Spread of Porcelains 62

3. The Nature of Japanese Ceramics 65
 The Development of Ceramic Culture in Japan 65
 The Diversity of Japanese Ceramics 67
 The Strength of the Popular Tradition 73

4. Low-fired Pottery of the Prehistoric Age 78
 Jomon Ware 78
 Yayoi Pottery 86

5. Early High-fired Ceramics 88
 Hajiki and *Sueki* 88
 Nara *Sansai* and Related Wares 108
 The Heian Period: *Sueki* and *Yama-jawan* 111

6. The Six Ancient Kilns 115
 The Appearance of Glazed Ceramics 115
 High-fired Stonewares 117

7. The Flowering of Ceramic Art 126
 Mino Ceramics 126
 Raku Ware 149
 Old Karatsu and Kyushu Wares 151
 Momoyama-Period Unglazed Stonewares 156

8. Porcelain and the Development of Decorated Wares 159
 Porcelains with Underglaze Painting 159
 Nabeshima Ware 162
 Kakiemon Ware 163
 Old Imari 167
 Kyo-yaki: Ninsei and Others 169
 Old Kutani 174

9. The Development of a Nationwide Ceramic Industry 179
 Ceramics in the Early and Middle Edo Period 179
 Regional Ceramics in the Late Edo Period 182

The Art of
Japanese Ceramics

Japan in World Ceramic Culture

THE ORIGINS OF CERAMICS The art of ceramics is the art of clay, and its creations are a tangible and intimate part of our lives. At the same time we can call ceramics the art of fire. It would be better, however, to say that it is the art of creating new entities from the mingling and blending of clay and fire.

Ever since paleolithic times or, for that matter, since the days of our earliest human ancestors, men have made and used tools to help in the struggle for survival. In earliest times they took stones and laboriously turned them into vitally needed implements. Eventually, however, as the period of migratory life drew to a close, more stable living patterns evolved, and at last man became free to try his hand at answering the challenge of clay. This came about as surpluses increased in primitive life, and it became necessary or desirable to store foodstuffs and other products. The discovery of clay, this new, marvelously malleable substance, soon aroused the creative impulses of our remote ancestors.

Men sought out clay and confronted it. Here, they felt, is a substance that will do as we tell it, if only we can learn what commands to use. The learning process had its difficulties, but by the beginning of the New Stone Age (c. 6000 B.C.) men were discovering ways to manufacture from clay the objects they desired.

Their earliest efforts seem to have produced building materials and storage containers. Such objects embodied the strong creative impulse of primitive people, as well as their instinct for self-preservation.

At first they used the sun's rays to bake their mud blocks and pottery, but in time they discovered the process of artificial firing, which brought about great improvements. Not only were fired vessels much improved in quality, but the unexpected possibilities of coloring also became known. This must have been a great innovation. Clay and fire were combined, and from them new forms were born. This was the beginning of ceramics.

Pottery manufacture was carried on in almost all primitive and prehistoric societies. Whether it first appeared in one area and gradually spread to tangent areas until it had reached its present far-flung state, or whether it was independently invented in many different places, we have no way of knowing. Even assuming the former supposition to be true, we cannot at present name either the place or the time of the great discovery.

At any rate, we are at least certain that pottery was being made by people living in the Near East, the cradle of Western civilization, as early as the fifth millennium B.C. In this area, particularly in Egypt and Mesopotamia, polychrome wares with red-and-black patterns painted on an attractive cream ground were produced along with plainer, unpatterned pottery. These ceramics are quite different from the early wares of Japan, where decoration was added to dull-gray surfaces by pressing

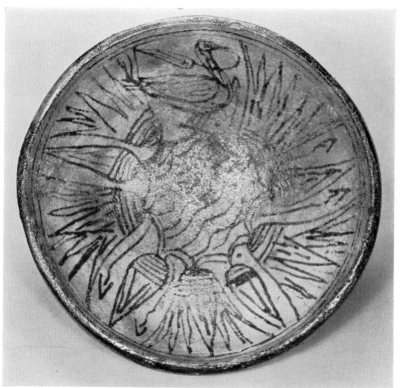

1. Bowl with design of lotus and waterfowl. Egypt. Fifteenth to fourteenth century B.C. Diameter, 16.4 cm. Excavated at Thebes.

or engraving or by the application of clay.

In this way, utensils were first made from the interaction of clay and fire. But several thousand years were needed to make the technical advances and improvements which were to produce high-fired ceramics of superior quality. High-fired ceramics are, of course, combinations of clay and fire, just as low-fired wares are. Still, there is a great difference in the end products.

The first high-fired ceramics worthy of the name appeared in Egypt about 3000 B.C. These Egyptian ceramics were somewhat different from modern high-fired wares. The body clay was made from silica that had been ground to a fine powder, and the shaped vessels were thickly covered with copper glazes in an alkaline-flux solution. In the popular sense, ceramics are glazed objects made of porcelain clays. Perhaps the raw materials used in these Egyptian wares place them in a different category,

but in the broader sense we may still accept them as ceramics.

These early ceramics are lovely, with their color as blue as the skies of Egypt. They may be the result of an effort to produce imitations of, or substitutes for, vessels that were actually made from rare blue stones, turquoise or lapis lazuli.

Once they succeeded in creating ceramic vessels of turquoise blue, the Near Eastern peoples set about embellishing them with painted designs. By the time of the New Kingdom in Egypt in the sixteenth century B.C., they had learned how to paint desired patterns in underglaze manganese pigments or purplish black. Their chosen patterns were mostly simple yet strong designs of swimming fish or lotuses and other plants. At any rate, this invention of painted ware is worthy of note, for it deepened people's attraction to ceramics. At the same time, Egyptian glazes developed greater variety in

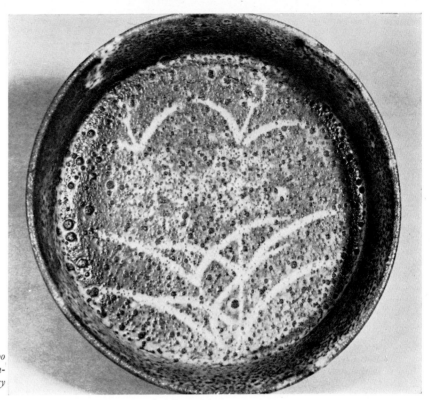

2. *Dish with design of bamboo grass. Shino. Late sixteenth century. Diameter, 16.8 cm. Suntory Art Gallery, Tokyo.*

color: red, yellow, purple, and purplish-black glazes all came into use, supplementing the original blue (Figs. 1, 3).

High-fired glazed wares were also made in Mesopotamia, where they usually took the form of tiles used for architectural ornament. Although their age is not quite so great, the tile murals depicting sacred animals that were made in Babylonia during the sixth and seventh centuries may be said to represent the finest ceramics of this area (Fig. 7). Near Eastern vessels decorated with colored alkaline-flux glazes continue to show improvement all through the pre-Christian era.

Near the end of the second century B.C., a new type of ceramic ware appeared in the eastern parts of the Mediterranean area under Roman rule. It was a ware essentially the same as those in use today, with a body of porcelaneous clay covered with colored glazes in a lead-flux compound. In this type

of ware, copper glazes produce vivid greens, while iron glazes yield warm browns. The finished utensils brim with color and brightness, and the people of the Roman Empire loved them (Fig. 5).

In the lands of the Near East, the alkaline-glaze wares traditional in Egypt and Mesopotamia went on being made and were joined later by the lead-glazed ceramics invented in eastern areas under the domination of Rome. Subsequent to the seventh and eighth centuries A.D., they underwent further development as the basis for Islamic wares.

But the next stage in ceramic progress—the development of porcelain as a result of advances in ceramic techniques—was not achieved by Islam or by any other area of the Western world. For porcelain, Europe and the Near East had to wait until the eighteenth century.

In East Asia, China is the focal point of early ceramic development. The first appearance of

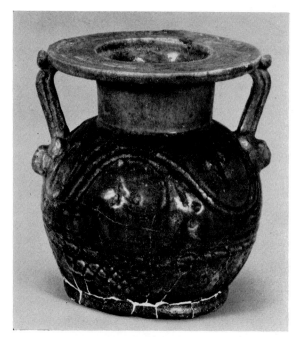

3. *Two-handled jug with relief pattern of grapevines. Egypt. Late Hellenistic period or early Roman Empire, first century* B.C. *or first century* A.D. *Height, 17.7 cm. Ohara Art Museum, Kurashiki, Okayama Prefecture.*

oxidizing-flame kilns. Because of this, the fired surfaces were a dark brown—that is, they were ash glazes. The vessels were fired at a heat of nearly 1200°C., which puts them in the high-fired stoneware class from the first. Upon this basis, Chinese ceramics developed, producing the excellent wares of the Warring States period (403–221 B.C.) and, in turn, of the Han dynasty (206 B.C.–A.D. 220).

From this time on, ceramic techniques continued to advance. Improvements in firing techniques and the mastery of the reducing kiln brought about the advent of celadon ware. This exquisite ware seems to have made its first appearance in the fourth century. Thanks to postwar advances in Chinese archaeology, new evidence for this was produced in 1953 in the form of a splendid Yueh-ware celadon incense burner (Fig. 10) found in a tomb of the powerful Chou clan, which flourished during the years 266–316. Around the first and second centuries of the Later Han, Roman techniques were introduced, resulting in the production of funerary stonewares in bronze and greens. These, however, seem not to have suited the tastes of contemporary China, for they soon died out.

After the beginning of the T'ang dynasty, in the seventh and eighth centuries, ceramic techniques grew more and more advanced. The Yueh celadons were much improved, and several new wares were developed in the celadon category: white-glaze wares, black-glaze wares, and glazed polychrome in three colors (Figs. 9, 40). At last, in the late T'ang and Five Dynasties periods of the ninth and tenth centuries, the long-awaited porcelains were produced, centering in the Ching-te-chen kilns of Kiangsi (Fig. 39). This porcelain was fired from kaolin clays and was far superior to ordinary ceramics both in hardness and in purity.

During the Sung dynasty (960–1280) Chinese porcelains improved rapidly. White-glaze wares, *ying-ch'ing* wares, celadons, and many other types of ceramics, stonewares, and porcelains were manufactured (Fig. 26).

With the Mongol invasions of China and the Near East in the thirteenth and fourteenth centuries, the decorative techniques of Islamic wares were introduced into China. These were refined

ceramics there was somewhat later than in Egypt or Mesopotamia, taking place in the Yin dynasty late in the second millennium B.C., during the formative period of Chinese civilization. In China's neolithic age, prior to the Yin dynasty, there had been great advances in the production of low-fired pottery. Lively polychrome wares appeared first followed by sophisticated black wares that were rich in variety. Because of this progress in pottery, true high-fired wares of high quality were produced soon after beginning of the Yin dynasty (Fig. 6).

There is a great difference between Chinese ceramic wares and those of Egypt or Mesopotamia. In the first place, the raw material is not the fused-silica mixtures of the West, but rather a fine porcelaneous clay of high fire resistance. The glazes are of iron in a soda flux, and the wares were baked in

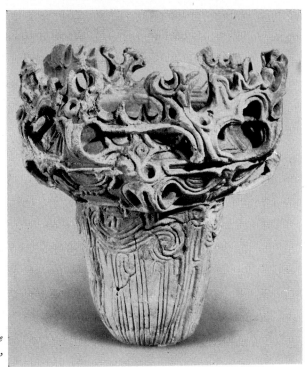

4. *Deep bowl with flame-shaped ornament Middle Jomon. Height, 36.2 cm. Excavated at Chojagahara, Niigata Prefecture. Itoigawa Board of Education.*

and used to create blue-and-white (Fig. 27), underglaze red, and the complicated gilt-overglaze enamels. In ceramics, China led the world in the fourteenth century.

Chinese ceramic styles and techniques were not limited to China alone. They were transmitted to nearby Korea, Japan, and Annam (now part of Vietnam), as well as to more distant Thailand. In each of these countries, both ceramics and porcelains were produced.

The techniques of the Yueh kilns had reached Korea, Japan's nearest neighbor, as early as the tenth century. From the eleventh through the thirteenth century the potters of Korea made magnificent celadon and inlaid celadon wares (Figs. 28, 29, 36). In the fourteenth and fifteenth centuries, during the late Koryo and early Yi dynasties, characteristic white-glaze wares led the ceramic field in Korea (Fig. 30).

THE DEVELOPMENT OF JAPANESE CERAMICS

The implements used by early peoples developed with the general growth of culture, and the raw materials for those implements show a continuous progression from stone through bronze to iron. Articles made of clay advanced through similar fixed stages in many cultures all over the world, evolving from low-fired earthenware to high-fired ceramics to porcelain. Whether in the proud and ancient civilizations of early Mesopotamia or in Japan, which made its entry into the civilized world as recently as the fourth or fifth century A.D., this pattern of ceramic development was universally the same.

It is presently thought that earthenware ceramics were first brought to a notable degree of development in the Near East around 8,000 years ago. Almost as soon as pottery making began, its techniques were used in the creation of beautiful poly-

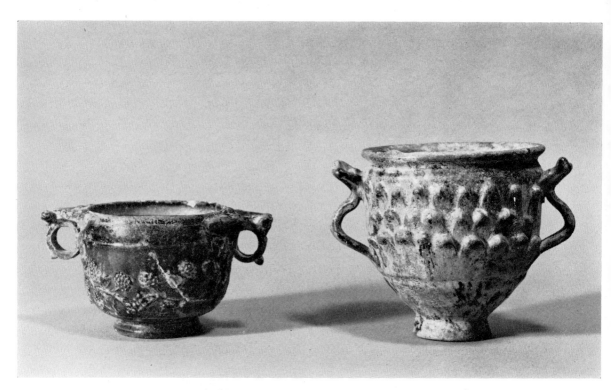

5. *Two-eared drinking cups with relief patterns. Roman Empire. Late first century* B.C. *to second century* A.D. *Heights: left, 7 cm.; right, 10.8 cm.*

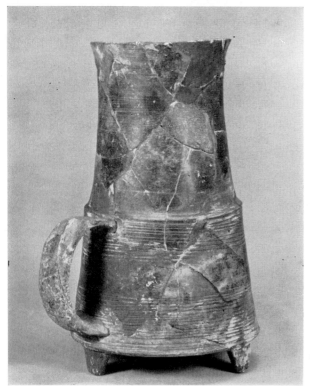

6. *Three-legged drinking vessel with handle. Black high-fired ware. China. Fifteenth to tenth century* B.C. *Height, 19.3 cm. Excavated at archaeological site on Liaotung Peninsula. Department of Humanities, Kyoto University.*

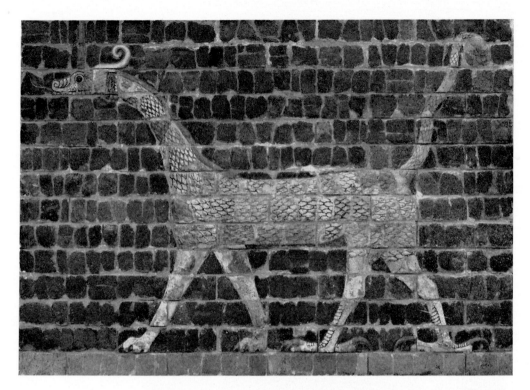

7. Colored tile mural depicting sacred mythical beast. Babylonia. Seventh to sixth century B.C. Length, 165 cm.; height, 115 cm.

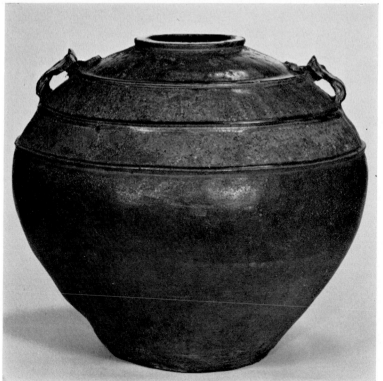

8. Eared pot with iron glaze. China. Second century A.D. Height, 34.2 cm. Idemitsu Art Gallery, Tokyo.

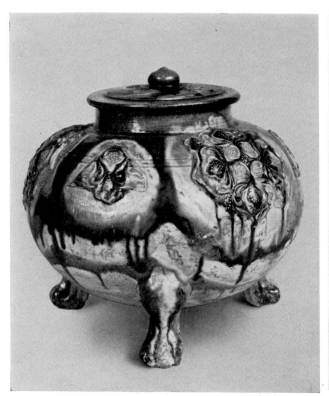

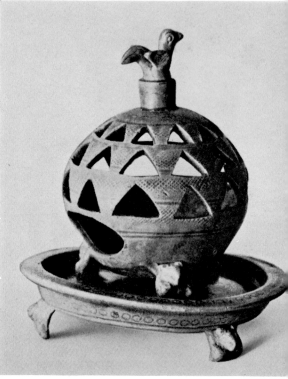

9. *Three-legged lidded jar with relief decoration. T'ang polychrome ware. China. Eighth to ninth century. Height, 20 cm. Tokyo National Museum.*

10. *Celadon incense burner with bird and animal ornaments. Yueh ware. China. Late third century. Height, 19 cm. Excavated from burial mound dated* A.D. *297, Kiangsu Province. Kiangsu Provincial Museum.*

chrome vessels decorated with painted surface designs. Soon after, the technique of painted ware spread through the entire Near East, and new wares with distinctly local flavors appeared in many regions.

Earthenware was also produced early in the Yellow River area of China, the fountainhead of East Asian culture. In China a number of wares were made during the New Stone Age: gray pottery with basket-weave patterns, polychrome ware, black earthenware, and other kinds. At present it appears that even the earliest of these wares dates back no further than 4000 B.C.

When we turn to the question of when pottery was first produced in Japan, we find that it is indeed a difficult one to answer. Up to the start of World War II, the stratigraphic researches of most scholars and the comparative study of pottery wares from the East Asian continent showed that the primitive ceramic vessels of the early Jomon period seemed to date from about 5000 B.C., at the earliest.

After the war, however, this date was moved much further back, and the early period was declared to date from around 8000 B.C. By the same token, the dawn of the age of ceramics was set back to about 10,000 B.C. These new dates are the results of calculation by the carbon-14 process discovered during the war, a method of dating that utilizes the

11. *Jug with multiple spouts. Sueki. Ninth century. Height, 21.8 cm. Excavated at Kurozasa kiln site number 36, Miyoshi,* ▷
Aichi Prefecture.

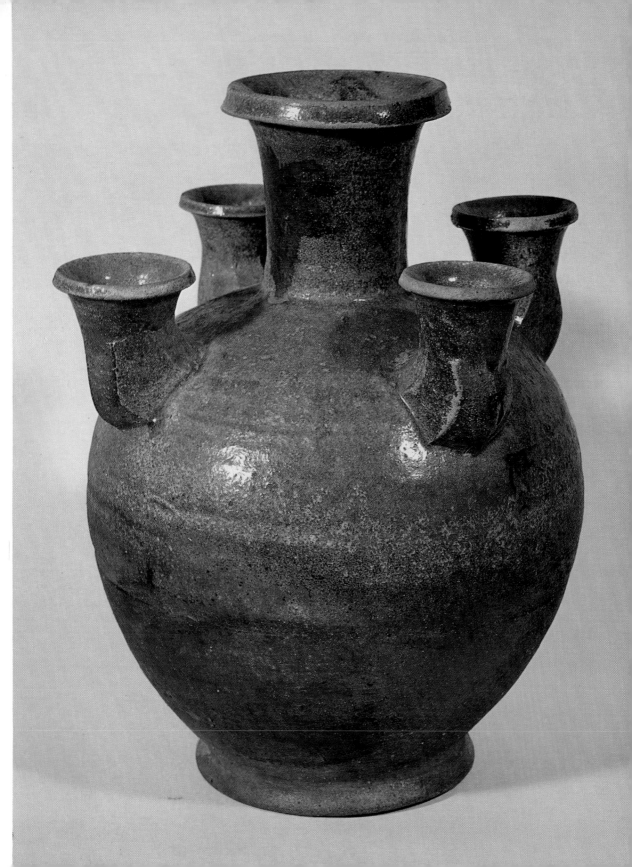

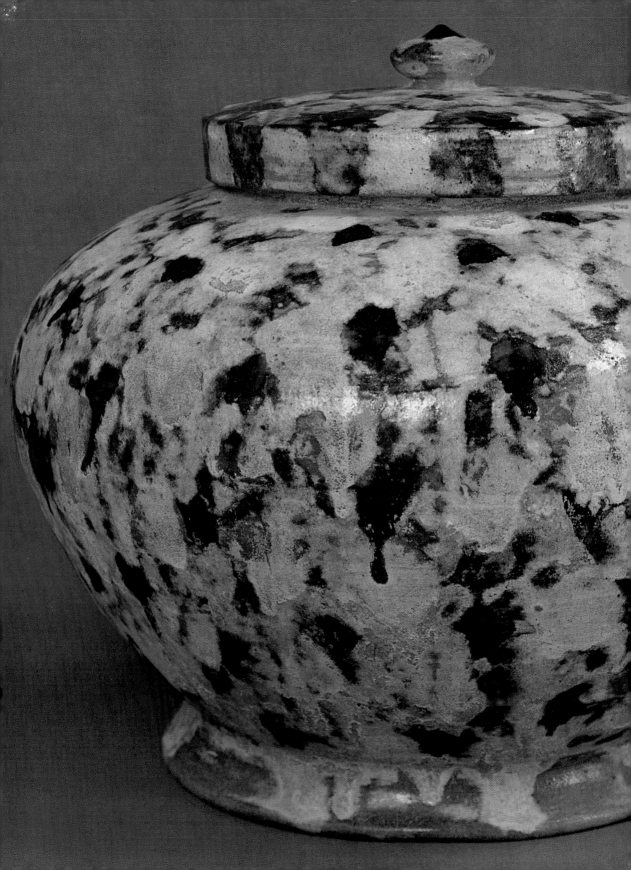

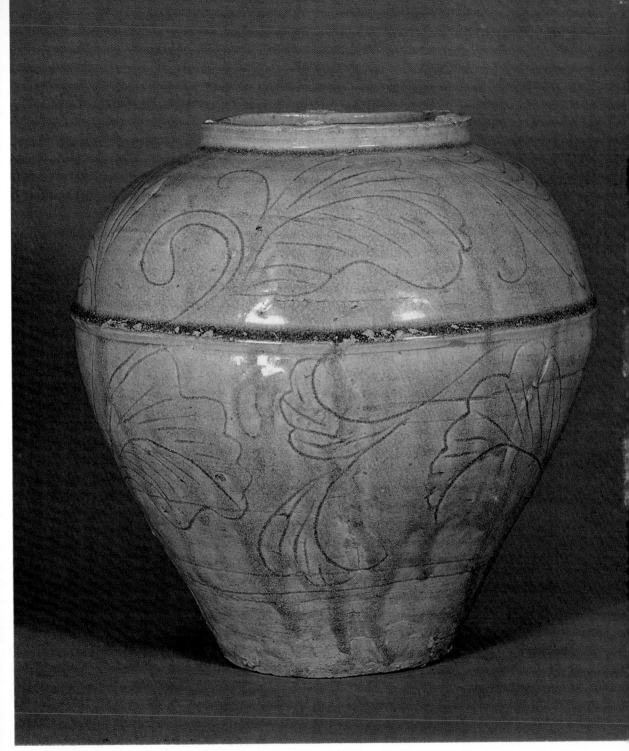

13. *Jar with peony design. Old Seto. Late thirteenth to early fourteenth century. Height, 27.7 cm. Excavated from memorial stupa dated 1306, Kakuon-ji, Kamakura, Kanagawa Prefecture.*

◁ 12. *Pot with lid. Nara sansai. Eighth century. Height, 22.8 cm. Excavated at Kitanaso cremation and burial site, Koyaguchi, Waka-yama Prefecture. Kyoto National Museum. (See also Figure 118.)*

14. Vat. Tokoname. Thirteenth century. Diameter, 56.8 cm.; height, 57.3 cm. Excavated at Itayama, Handa, Aichi Prefecture. Tokoname Ceramic Research Center, Tokoname, Aichi Prefecture.

15. Bowl with design of reeds and wild geese. Shino. Late sixteenth century. Length, 23.6 cm.; height, 5.4 cm. Umezawa Memorial Hall, Tokyo.

16. Three-eared jug. Bizen or Tamba. Dated 1460. Height, 45.5 cm. ▷

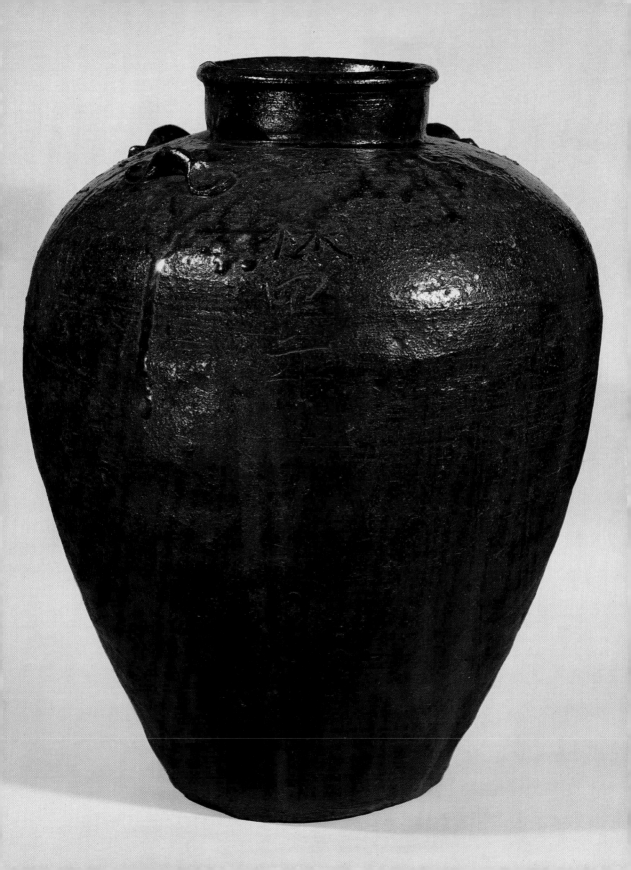

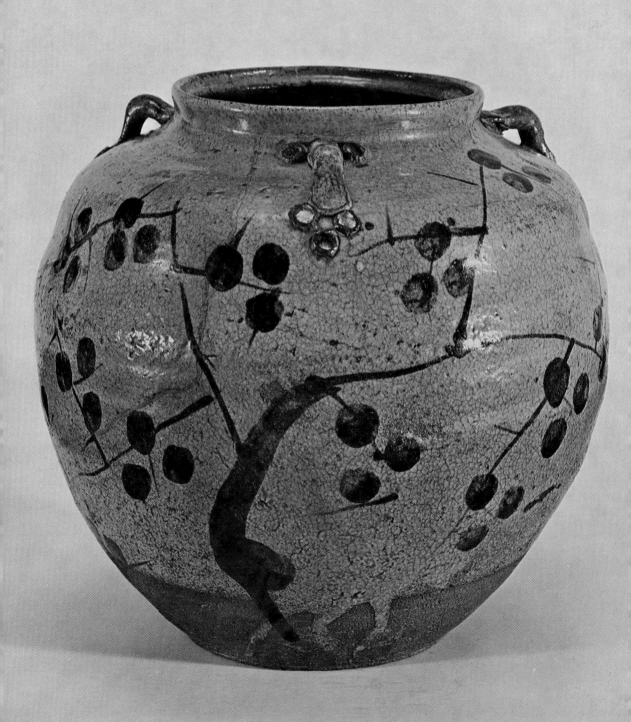

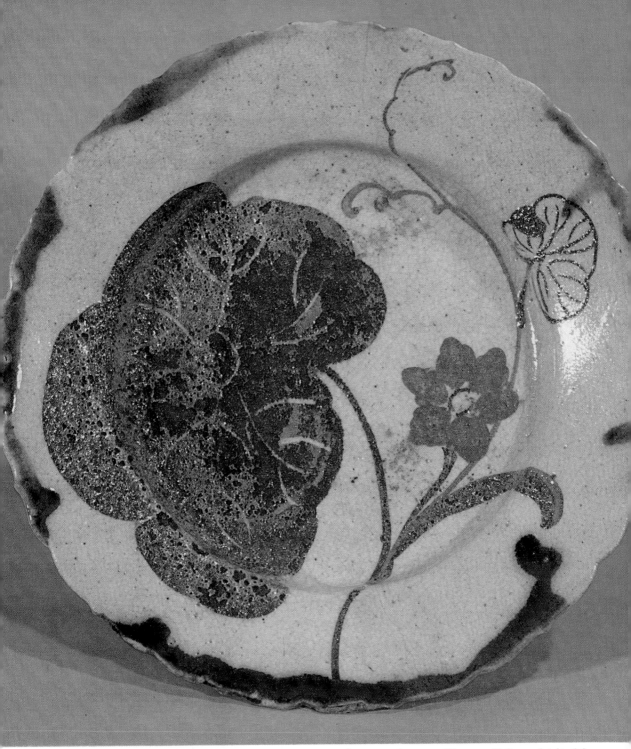

18. *Footed plate with design of vines. Oribe. Late sixteenth to early seventeenth century. Diameter, 20.9 cm.; height, 6.3 cm.*

◁ 17. *Four-eared jar with design of persimmon trees. Old Karatsu.*
Early seventeenth century. Height, 17 cm. Idemitsu Art Gallery, Tokyo.

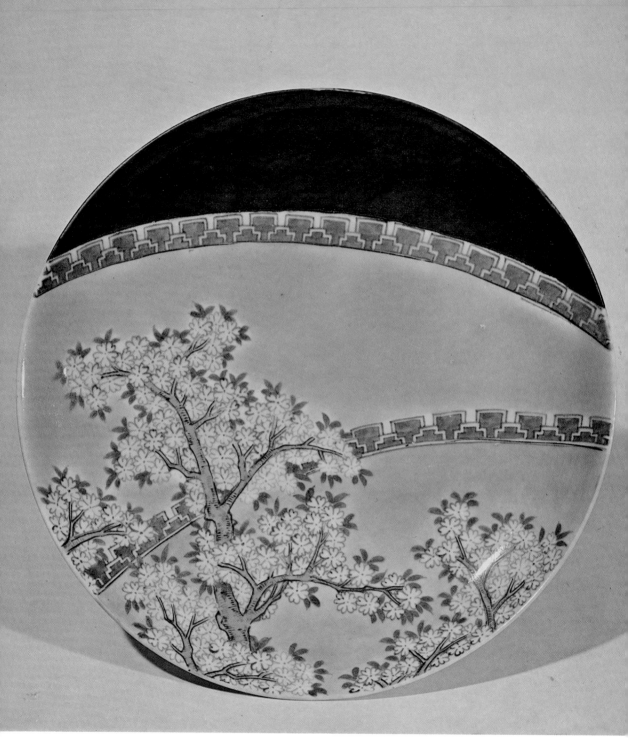

19. *Plate with design of cherry blossoms and curtains for a cherry-blossom picnic. Nabeshima. Second half of seventeenth century. Diameter, 19.8 cm.; height, 4.2 cm.*

20. *Jar with design of fish in net. Early Imari. First half of seventeenth century. Height, 13.2 cm.* ▷

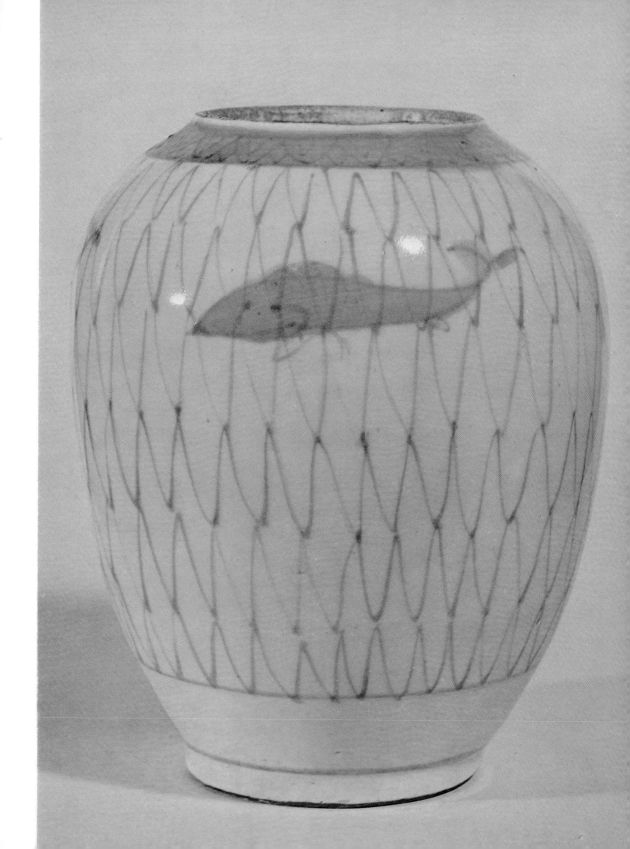

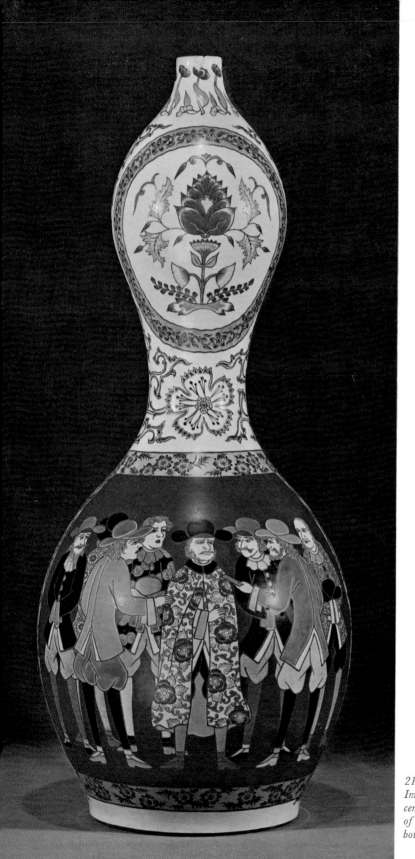

21. Sakè decanter picturing foreigners. Old Imari. Late seventeenth to early eighteenth century. Height, 56 cm. Cleveland Museum of Art. (See Figure 181 for reverse side and bottom.)

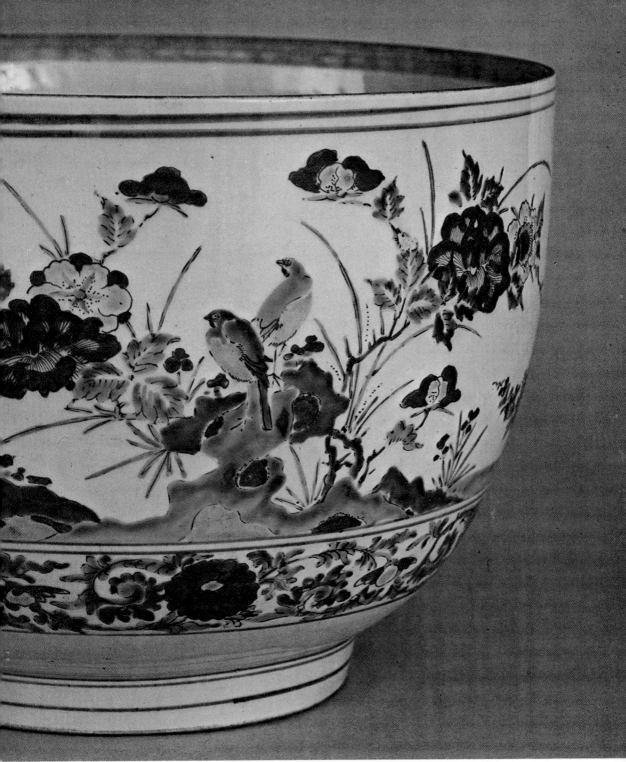

22. *Deep bowl with design of flowers and birds. Kakiemon. Second half of seventeenth century. Diameter, 30.6 cm.; height, 21.2 cm. Tokyo National Museum.*

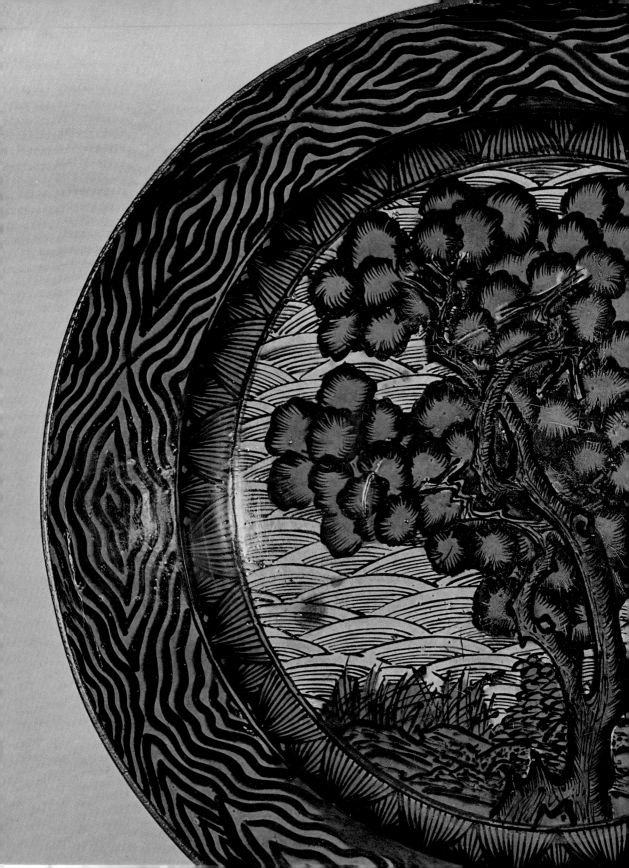

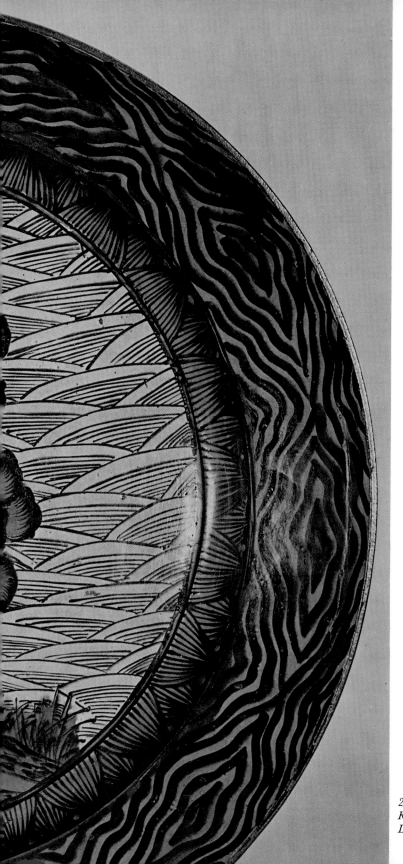

23. *Plate with pine-tree design. Old Kutani. Second half of seventeenth century. Diameter, 45 cm.*

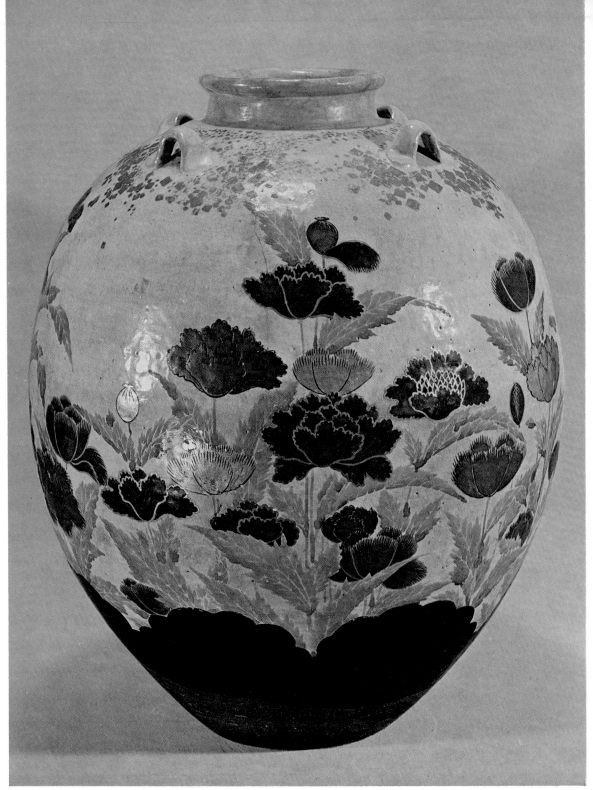

24. *Four-eared jar with design of poppies, by Nonomura Ninsei. Late seventeenth century. Height, 42.8 cm. Idemitsu Art Gallery, Tokyo.*

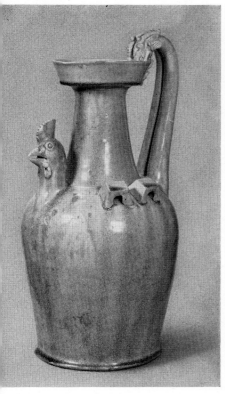

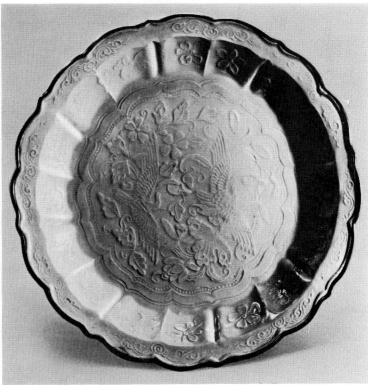

25. *Ewer with bird and dragon ornaments. Yueh ware. China. Sixth to seventh century. Height, 47 cm. Hakone Art Museum, Gora, Kanagawa Prefecture.*

26. *Plate with bird-and-flower design in relief. White porcelain: Ting ware. China. Eleventh to twelfth century. Diameter, 21.7 cm.*

radioactivity of carbon particles in organic matter. People in Japan were amazed to learn that their nation's art of pottery might well be the oldest in the world, and their surprise was, understandably, accompanied by touches of a rather childlike feeling of joyful pride in the discovery. Not long afterward, however, doubts began to arise—the date was simply too early, especially when compared with the known dates for pottery on the continent, which had been culturally more advanced than Japan, and calculations that produced a date of 12,000 B.C. or earlier came under suspicion. Satirical comments such as "In primitive times, sorcery was a science, but today science is a kind of sorcery" were once again being made about archaeologists.

Thus the suitability of the carbon-14 process for accurate use in Japan came under question, and much criticism was leveled at the results of the calculations. Today, just as before the war, most authorities claim that the origins of pottery in Japan date to some time around the fourth or fifth millennium B.C.

In any case, pottery first appeared in Japan at the opening of the Jomon period, which corresponds to the New Stone Age. Pottery objects of the Jomon type continued to be produced for several thousand years, but in the second or third century B.C. new firing techniques were introduced from the continent, and a new kind of ware began to be made. This pottery we call the Yayoi type.

DEVELOPMENT OF CERAMICS · *33*

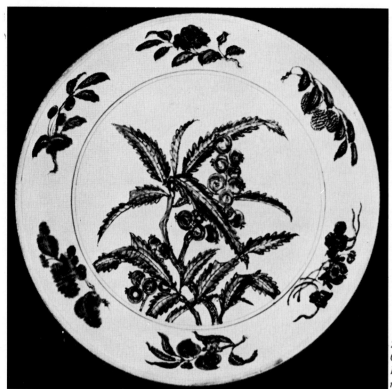

27. *Plate with painting of loquat boughs. Ching-te-chen blue-and-white ware. China. Fifteenth century. Diameter, 45.5 cm. Idemitsu Art Gallery, Tokyo.*

Since the firing methods of the Yayoi period (200 B.C.–A.D. 250) were more advanced, Yayoi vessels are found in richer variety than Jomon ware. Their coloring is brighter too, and the pottery itself is far sturdier. Nonetheless, in one important point there was no change: like Jomon ware, Yayoi pottery remained unglazed. From the fourth century on, when it becomes known as *hajiki*, rapid improvements were made in this style of pottery. It continued to be produced throughout the Tumulus (250–552), Nara (649–794), and Heian (794–1185) periods.

At the end of the fourth century or the beginning of the fifth, yet another superior ceramic technique was introduced into Japan from China by way of the Korean peninsula, and a new even more advanced ware began to be made. This was the pottery which we know as *sueki*.

Sueki is a dark-gray pottery with a hard, fine texture, fired at a high temperature of 1100–1200°C. The better examples give off a ringing, clear tone when tapped. As we shall see later on, the production of pottery much harder than any produced up to this time was due to improvements in kiln construction. In addition, the potter's wheel was employed at times for better control of shape. As a result, the form grew more streamlined, and the rate of production was speeded up.

Thus *sueki* became the dominant style, representative of the best in Japanese pottery. It was in continuous use from the Tumulus period through the Nara and the Heian periods. Still, in spite of the excellence of *sueki*, technically it is no more than another form of pottery—that is, it has not been deliberately glazed. In this respect *sueki* is unchanged from the Jomon and Yayoi wares that preceded it.

In the eighth century, during the Nara period, a

28. *Flower-shaped teacup and stand with rinceau design. Koryo celadon. Korea. Twelfth century. Diameters: cup, 7.9 cm.; stand, 15.9 cm.*

29. *Bowl with chrysanthemum design in underglaze inlay. Koryo celadon. Korea. Thirteenth century. Diameter, 19.7 cm.*

notable event took place. After the introduction into Japan of the three-colored ceramics of the T'ang dynasty, two somewhat similar wares began to be produced in Japan itself, especially in the area of the capital (Nara). One of these wares had a three-colored spot pattern done in lead glazes on a light ceramic body, while the other was characterized by just two colors—a green glaze splashed on a white ground. These were the first true ceramics produced in Japan.

As a matter of fact, light-bodied ceramics with three-colored glazes were also produced as regional wares in such places as the Korean kingdom of Silla and in Po-hai in Manchuria, inland from the Korean peninsula. From this we may assume that T'ang-style three-colored ware was popular among the aristocracy of northeast Asia during the eighth and ninth centuries.

In Japan, however, this popularity was short-lived. As soon as the Nara period was over (794), T'ang-style three-colored wares disappeared from the scene. Furthermore, distribution was extremely limited, extending only to the court, the major religious institutions, and the leaders of the aristocracy, so that it would be difficult to claim that this ware ever gained any really widespread currency.

The above-noted green-and-white ware continued to be made along with three-colored ware during Nara times and, in fact, endured somewhat longer, for it was still being made during the early years of the Heian period. But it, too, was used only within the limits of the upper classes and was very far from ever attaining general popularity.

In this way, green-glazed light-bodied ceramics sank into insignificance. Meanwhile, the people of the Heian period had discovered how to manufacture beautiful ash-glaze ceramic wares called

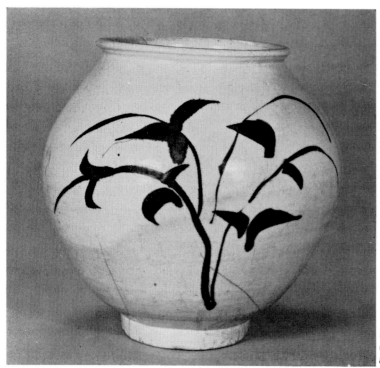

30. *Jar with underglaze design of wild orchids. White porcelain. Korea. Fifteenth to sixteenth century. Height, 22.9 cm.*

Heian *shiki*. Doubtless charmed by ceramics ornamented in greens and browns, they made efforts to re-create them, and it was probably these efforts that bore fruit.

Thus, in the Heian period, a new kind of *sueki* came into being: a ware with a light-green or light-brown glaze upon an ordinary *sueki* body. Even so, this was still nothing other than a specialized kind of ceramic ware, with a range of demand limited to a small segment of the aristocracy and clergy.

Although true ceramics in Japan developed as early as the Nara period, no new development was forthcoming, and the appearance of glazed ceramic ware really worthy of the name had to wait until the so-called Old Seto ware was created in the later Kamakura period, toward the close of the thirteenth century.

From that time on, glazed ceramics were pro-

duced in the area around Seto in the province of Owari (near modern Nagoya). By the late Muromachi period (1336–1568), ceramic crafts had spread to many kiln sites in the eastern part of Mino Province, where Shino ware was produced, followed shortly afterward by the production of Oribe ware. Before long, Kyoto, too, was witnessing the birth of a new ceramic type: Raku ware.

At the end of the sixteenth century, glazed ceramic wares appeared in Kyushu, the southernmost of Japan's four main islands. The Korean craftsmen who were brought to western Japan at the time of Toyotomi Hideyoshi's invasions of Korea (1592 and 1597) began to produce Korean-style glazed ceramics, closely adhering to the manner of their native land. Subsequent to this period, the production of glazed ceramics in Japan centered around three areas: Mino and Owari in the east, Kyoto in central Japan, and the island of Kyushu in the west.

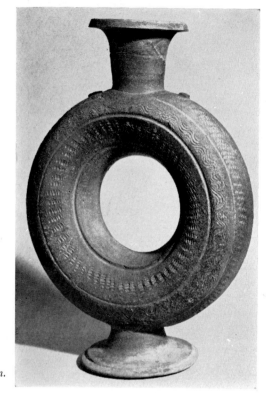

31. Ring-shaped jug. Sueki. *Sixth to seventh century. Height, 25.4 cm.*

Early in the seventeenth century, Japanese ceramics made yet another great advance. This was the beginning of porcelain production in Kyushu. The date was 1616, and the innovation is attributed to the group of potters under the direction of the master Ri Sampei, who had come to Japan from Korea.

Nonetheless, due in part to the monopoly policies enforced by the lords of the Nabeshima domain of Hizen Province, in which the porcelain-kiln township of Arita was situated, the art of porcelain firing did not spread into other areas until long afterward. It was not until the Kansei, Bunka, and Bunsei eras (1789–1830) in the later years of the Edo period that porcelain manufacture began to be carried on throughout Japan.

In conclusion, let us note that the techniques of overglaze enameling came into use from the middle of the seventeenth century. The history of overglaze painting in Japan is often said to have begun with the wares decorated by the master potter Kakiemon of Arita in Hizen Province. At about the same time, however, the great potter Nonomura Ninsei was making overglaze wares in Kyoto, while the production of the so-called Old Kutani ware dates from only slightly later.

CHAPTER TWO

—•—

Ceramics in Japanese Life

CHARACTERISTICS OF JAPANESE CERAMICS The period of earthenware production which prepared the way for the appearance of true ceramics was unusually lengthy in Japan. The first signs of ceramic art are found in the Nara period, but the development of genuine ceramic manufacture had to wait until the late Kamakura period, in the latter half of the thirteenth century. In this respect, Japan was of course far behind China and well behind the Korean peninsula too. True ceramics were already being produced there in the eleventh century. As for porcelains, these did not appear until the early Edo period, in the first part of the seventeenth century. In all cases, the techniques were learned either from the advanced culture of China or from the Korean peninsula, which had previously acquired this knowledge from China; in this way, new phases opened up, in pottery production first, and in porcelain later.

In China, pottery dates from at least the Yin dynasty, in the thirteenth century B.C., while true porcelains were produced from the late T'ang and the Five Dynasties periods in the ninth and tenth centuries A.D. In Korea, too, true pottery appears in the eleventh century and porcelain by the latter part of the fourteenth. In comparison with these, it must be admitted that the date of the first true ceramic production in Japan is quite late indeed.

Interestingly enough, however, the long delay in the transmission of techniques from more advanced areas was one of the reasons for the creation in Japan of highly individual ceramics filled with a strong and characteristic Japanese flavor. In this country, even at the times when new techniques were adopted from other countries, there already existed techniques and modes that had been able to reach a high degree of independent development over a long period of time. As a result, the newly imported crafts could hardly keep from being influenced by these native modes. The development in Japan of ceramics with an individual character is mainly due to this.

A good example of this tendency may be seen in the rise of Old Seto ware, which was first produced during the late Kamakura period (1185–1336). The origins of Old Seto are usually attributed to Kato Shirozaemon Kagemasa, who is said to have accompanied the famous Zen priest Dogen to South China, studied the art of ceramic manufacture, and later attempted to produce ceramics of his own in the Seto district after returning to Japan. Now, setting aside the question of whether or not it was indeed Kato Shirozaemon himself who learned and transmitted Chinese techniques, when we examine Old Seto ware, the shapes and colors are clearly seen to be modeled upon *temmoku* glazed wares or upon *ying-ch'ing* and celadon wares of the Southern Sung. But the results of this borrowing have produced ceramic objects entirely different in character and general feeling from the contemporary ceramics of South China (Figs. 42, 43). The

Japanese wares were fired in renovated *sueki* kilns of a type totally unrelated to the sophisticated Chinese kilns of the day, and the clays, too, differ. Considering these reasons, the existence of some divergences would seem to be only natural under the circumstances.

When one looks for comparison at the techniques and sensibilities of Korean potters of the Koryo period, who took Yueh celadons as their models and actually did succeed in producing wares (celadon and Koryo celadon) that were very close to the Chinese originals (Figs. 36, 39), one can readily realize just how great this divergence was. All such differences notwithstanding, once the manufacture of Old Seto had begun, the craftsmen went on developing their native-born wares in their own way without making any notable effort to bring their products more closely into line with the ceramics of China. This may be attributed to the nature of Japanese society and to the aesthetic sense peculiar to the people of Japan, as well as to the great distance and wide ocean that cut the two countries off from one another. The same reasons doubtless account for the greater air of individuality and the strong, freshly natural flavor that set Japanese wares apart when they are compared with ceramics from Annam, Thailand, and other areas which were, artistically and technically, under strong Chinese influence.

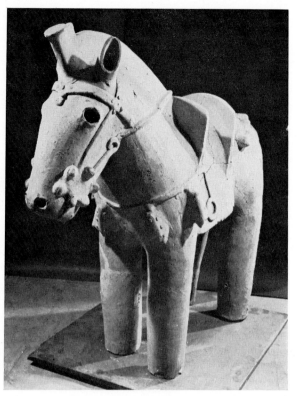

32. Haniwa *horse. Sixth century. Height, 85 cm. Excavated at Kumagaya, Saitama Prefecture. Tokyo National Museum.*

THE SPREAD AND DEVELOPMENT OF EARTHENWARE IN ANCIENT TIMES

The popularity of unglazed pottery in Japan remained in the ascendant for a remarkably long time. This accounts for the notable development of unglazed wares as well as for the high degree of variety and individuality in Japanese pottery. It is a well-known fact that the ancient Japanese Jomon-style pottery wares (Figs. 4, 35, 53–55) have a richness of variation in form unparalleled in any other culture on earth. Wares of the succeeding Yayoi style (Figs. 34, 56, 57) also show great variety in form and design. This variety stands out even more clearly when these Japanese wares of the early age of metal tools are compared with corresponding pottery from the Korean peninsula, where a greater uniformity was the rule.

In the case, however, of the *sueki* wares, which were produced from the Tumulus period through the Nara and Heian periods, the percentage of variation is smaller than might be expected from such a long span of manufacture (Figs. 31, 59, 60). This is probably due to the relatively narrow periphery of their use, which was limited to the court, the religious institutions, and the aristocracy, and principally to ceremonial functions at that.

When Japan was maturing into a unified state, the ruling classes promulgated a government based on a constitution, after the Chinese manner. They were united by a collective consciousness to which we may perhaps attribute the related qualities and general uniformity of *sueki* pottery.

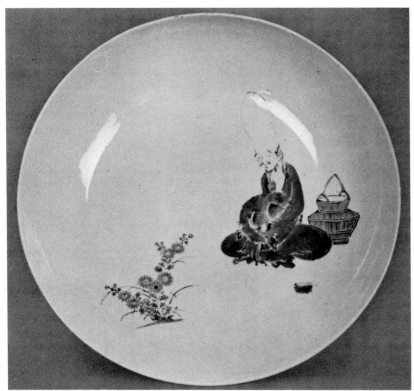

33. Plate picturing Jurojin, god of longevity. Kakiemon. Late seventeenth century. Diameter, 35 cm. Suntory Art Gallery, Tokyo.

34. Pot with incised geometric ▷ designs. Late Yayoi. Height, 36.3 cm. Excavated at Kugahara, Setagaya Ward, Tokyo.

35. Storage jar with curvilinear ▷ design. Middle Jomon. Height, 70 cm. Excavated at Okaya, Nagano Prefecture. Okaya Board of Education.

During the same era, however, a great volume of the everyday ware known as *hajiki* was also produced (Fig. 58). This red earthenware inherited and further developed the technological traditions of Yayoi ware. It differs from *sueki* not only technically but also in form and decoration. Thus, at one and the same time, two quite different types of pottery were being manufactured and used side by side. This noteworthy occurrence is the earliest example of the manifold nature of ceramic culture in Japan. In addition, the Heian period even saw the appearance of black earthenware and of white-bodied pottery vessels, so that the degree of complexity was further increased.

Thus it came about that the various types of ceramic wares, each firmly continuing the traditions of all earlier ages, began to be produced throughout most of Japan, and at length they won a firmly established place in the daily lives and affections of the Japanese people. They were transmitted unchanged into the world of medieval Japan—that is, from the Kamakura period on—at which point they entered another phase of singular development.

As we have noted, the earthenware of ancient times was in use over a very long period, eventually becoming an inseparable part of daily life, admired and loved. In addition, it continued to develop along highly individualistic lines. These were, and still are, important characteristics of Japanese ceramics, and in their turn they were able to exert a great influence in the ages to come.

CERAMICS IN MEDIEVAL JAPAN

While the origins of Japanese true ceramics (as distinct from earthenware) date from the Nara period, the wares themselves failed to show any noteworthy further

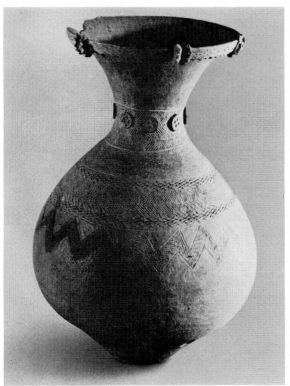

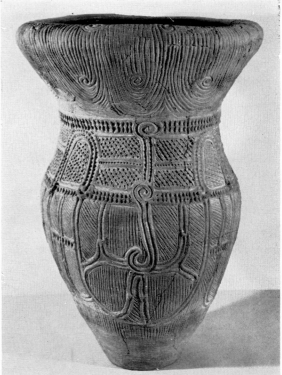

development during the several centuries of the following Heian period. It was only toward the end of the Kamakura period that deliberately glazed, high-fired ceramics were finally produced in Japan.

The birthplace of these first true ceramics in Japan was Seto in the old province of Owari (near present-day Nagoya). It is here that Old Seto yellow ware and Old Seto black ware—which we usually lump together under the name Old Seto—were manufactured (Figs. 49, 50). From the Kamakura period until well into the Muromachi period (1336–1568), however, this art of ceramic manufacture hardly showed any inclination to spread beyond Owari.

Even by the late Muromachi period it had reached no further than the neighboring province of Mino. As for other regions, they went on producing unglazed wares by means of the time-honored techniques of pottery production that had continued from the past.

When this state of affairs is compared with conditions in China, or on the Korean peninsula, Japan's closest neighbor, it seems very remarkable indeed. In Korea, too, unglazed pottery had been produced up until the earlier part of the Koryo period, in the tenth and eleventh centuries. But once the technique of celadon manufacture had been introduced, unglazed wares were swept away as the popularity of celadon burgeoned. In the subsequent Yi dynasty, beginning in the late fourteenth century, white and black porcelains are found, as well as glazed ceramics. After that, porcelains and glazed ceramics were produced at practically all of the kiln sites in Korea, and, apart from articles made for special purposes, unglazed ware disappeared from the scene altogether. With the exception of stonewares produced in a small area

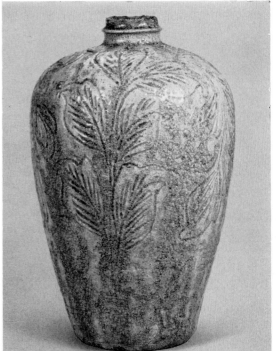

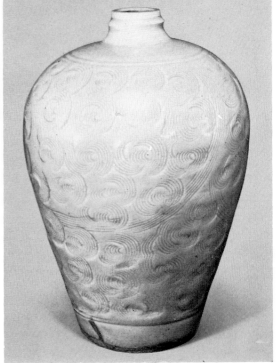

36 (above left). Jar with lotus pattern. Koryo celadon. Korea. Late twelfth to early thirteenth century. Height, 30.6 cm.

37 (below left). Bowl. Hajiki. Dated 763. Diameter, 19.3 cm. Excavated at site of former Heijo Imperial Palace, Nara. Nara Cultural Properties Research Institute.

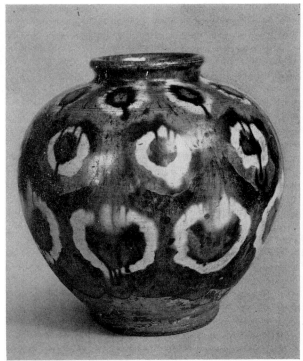

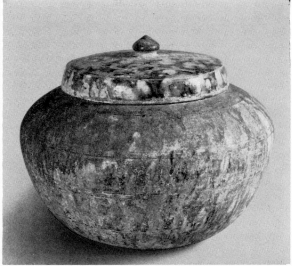

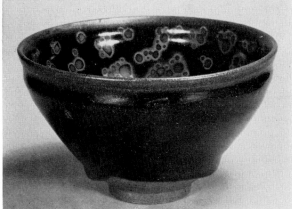

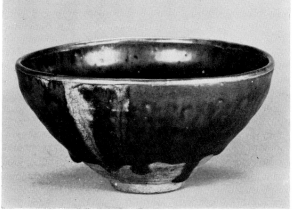

38 (opposite page, top right). Jar with leaf design. Old Seto. Late thirteenth century. Height, 25 cm.

39 (opposite page, bottom right). Jar with whirlpool pattern. Ching-te-chen ying-ch'ing ware. China. Twelfth to thirteenth century. Height, 25.6 cm. Said to have come from the site of Matsuyama Castle, Ehime Prefecture. Idemitsu Art Gallery, Tokyo.

40 (top left). Jar. T'ang polychrome. China. Eighth century. Height, 24.8 cm. Tokyo National Museum.

41 (top right). Jar with lid. Nara sansai. Eighth century. Height, 15.9 cm. Tokyo National Museum.

42 (right center). Temmoku tea bowl with iridescent glaze. Chien ware. China. Twelfth to thirteenth century. Diameter, 12.1 cm.; height, 6.6 cm. Seikado, Tokyo.

43 (bottom right). Temmoku tea bowl. Old Seto. Fourteenth century. Diameter, 12.8 cm.; height, 6.7 cm.

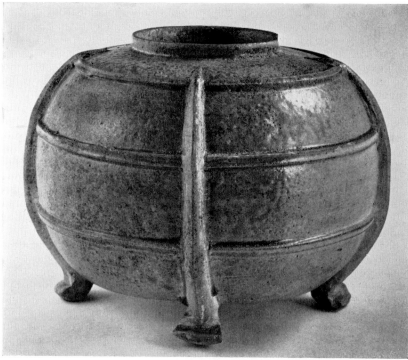

45 (opposite page, left). Jar with ▷
kesa-dasuki *pattern*. Sueki. *Late
twelfth to early thirteenth century.
Height, 27.5 cm. Excavated from
sutra mound of Ishiko-dera, Yu-
yama, Ehime Prefecture.*

46 (opposite page, right). Jar ▷
with waterfowl design. Sueki.
*Twelfth century. Height, 39.5 cm.
Matsunaga Memorial Hall, Oda-
wara, Kanagawa Prefecture.*

44. *Four-legged jar.* Sueki. *Ninth century. Height, 17.1 cm. Excavated at Mount Otowa,
near Kiyomizu-dera, Kyoto. Kiyomizu-dera.*

of the south, the case in China was just the same.

But the situation in Japan was different. As we have already seen, glazed ceramic ware was produced at Seto in Owari and in the Tokitsu area of Mino from the Muromachi period (which corresponds to the early Yi dynasty of Korea), but it was not to be found in other regions. The following explanation will help us to understand why glazed ceramics were not more widespread in Japan.

Through the Kamakura and Muromachi periods, the representative kiln sites of Japan were the so-called Six Ancient Kilns: Tokoname, Seto, Echizen, Shigaraki, Tamba, and Bizen. Among these, the kilns of the Chita peninsula, centering around Tokoname, operated on an amazingly large scale. Their products were supplied not only to the Chubu district (central Japan), Kinai district

(old name for the district around Kyoto), and Kanto district (area around present-day Tokyo)—all outlets that might be expected, both for geographical and economic reasons—but they were shipped even to the Tohoku district (northern Honshu) and the Chugoku district, in the west. In addition, products from Imbe and the other Bizen kilns were used widely throughout western Japan, while the Kinai district, which was the cultural and political center of the nation at the time, was the area of circulation for the wares of the Tamba kilns, among which Tachikui was foremost, and of Shigaraki, near the boundary of Omi and Iga provinces. The wares of Seto were also distributed to the Kanto and Kansai (Kyoto-Osaka) districts and elsewhere. But the range of demand for these wares was much more limited. For that reason, the

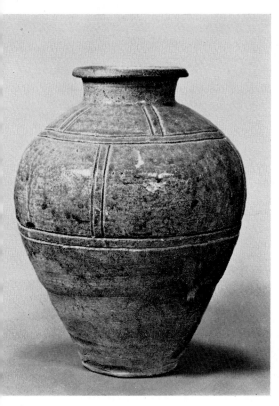

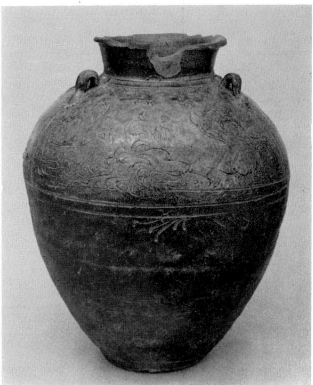

quantity produced was not great, and they do not seem ever to have come into general currency.

With the single exception of Seto, the products of all of these kilns were not glazed ceramics but unglazed wares—the high-fired stonewares, or so-called *yakishime*, which were a continuation of and an improvement upon the older traditions of pottery (Figs. 14, 16, 98, 99, 101). These high-fired stonewares (also known as *sekki* in Japanese) were extremely hard, resilient, and admirably adapted to practical use. Nonetheless, they were, strictly speaking, still not deliberately glazed ceramics. At times, they were ornamented on neck or body by lovely glazes of green or golden brown, but these were in reality natural phenomena, produced spontaneously within the heated kiln, and not glazes that had been intentionally applied to the vessels.

During this period, besides the Six Ancient Kilns there were other places—for example, the kilns making Kameyama ware in Hizen Province and the Shidoro kiln of Totomi—that also produced wares for daily use. Their products, too, were all high-fired stoneware.

Considering the facts in this light, we realize that in the Kamakura and Muromachi periods, in which ceramics appear at first glance to have blossomed suddenly with the advent of the glazed Old Seto ware, it was actually the unglazed wares continuing the traditions of pottery that still reigned supreme. When Japanese ceramics are considered against the background of world ceramics, this may be seen as one important characteristic trait.

Even after the beginning of the era of recent history, in the Momoyama period (1568–1603),

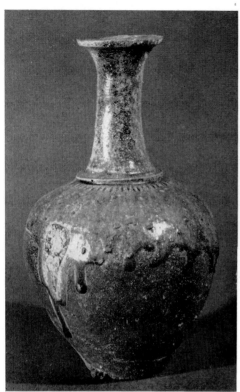

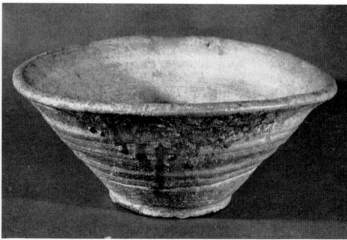

48. Bowl. Tokoname. Late twelfth to early thirteenth century. Diameter, 29.7 cm. Tokoname Ceramic Research Center, Tokoname, Aichi Prefecture.

49. Lion-dog. Old Seto. Late thirteenth century. Height, 18.3 cm. Excavated at Ichigami Shrine, Shiga Prefecture.

47. Long-necked jar. Tokoname. Twelfth century. Height, 27.9 cm. Tokoname Ceramic Research Center, Tokoname, Aichi Prefecture.

when many kilns for the production of glazed ceramics were opened in the Kyoto and Kyushu areas in addition to those at Owari and Mino, and the production of true porcelain began in the region around Hizen, unglazed pottery continued to hold its own to a degree that cannot be ignored. Witness to this is borne by the vast quantity of unglazed stoneware that went on being produced in Tokoname and Tamba, Bizen, Iga, and Shigaraki just as before, in answer to a general unceasing demand for tea implements and tea jars, seed jars, water jars, mortars, large spouted bowls, and the like. From this we may understand just how deeply these stonewares, or high-fired unglazed ceramics, had established roots in the tastes of the Japanese people.

From the fact that the people of medieval Japan seem to have found satisfaction and pleasure in unglazed ceramics, we can recognize certain interesting phenomena. The first of these is the extremely good quality of high-fired stonewares in Japan, while the second is the question of the unique Japanese taste.

The aspect of quality may be dealt with first. While it cannot be said that the clays used in producing medieval Japanese unglazed wares were everywhere of uniform good quality, the high temperatures and long firing period of the kiln techniques more than made up for this. It was thus possible to produce tough, strong wares that had an air of resiliency and answered well the needs of the users. In fact, from the standpoint of practical use, these unglazed wares may very likely have been superior to the glazed ceramics of the day.

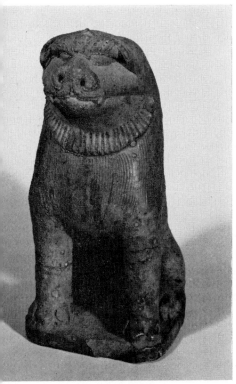

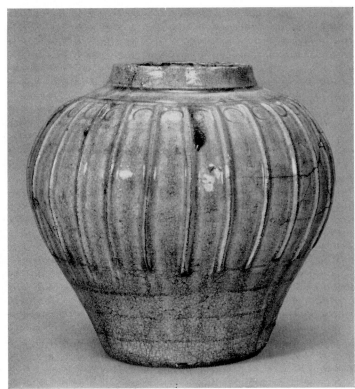

50. *Wide-mouthed jar with raised pattern. Old Seto. Late thirteenth century. Height, 19.6 cm.*

The second point, that of taste, may have some relationship to the strong affection for tradition held by the people of Japan's middle ages. It is possible, of course, to attribute the general lack of demand for glazed ceramics to the low living standards of the people at large, who were simply unable to purchase expensive ceramics. In fact, the glazed ceramics of the times are often Japanese-style copies of, or substitutes for, expensive Chinese imports—celadons from the Lung-ch'uan kilns, Ching-te-chen and *ying-ch'ing* wares, or Chi-chou-yao *tem-moku* wares—admired by contemporary aristocrats and prelates.

Nevertheless, when we look at the question in another light, we realize that, if glazed wares had come to be in great demand, this in turn would have caused a marked increase in production, and prices would have gone down to a level that even average farming people might have been able to afford. As for glazed ceramic wares themselves, items of the quality of Old Seto did not present any particular difficulties, technically speaking. All that was necessary was the application of a liquid glaze made of ground clay, wood ash, and iron oxide. By looking at the example of Korea, one may readily see that the popularization of glazed ceramics among ordinary citizens was by no means an impossibility. In a certain sense, true glazed ceramics are not so demanding technically as good unglazed stoneware, which, with its long, continuous firing period, requires a high level of skill in the potter. And even though there were no places where good clays were found in quantities to compare with those dug at Seto, high-fired vessels were produced

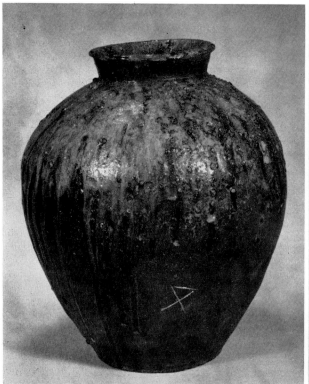 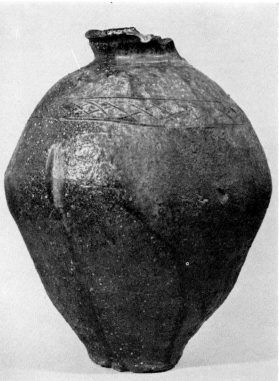

51. Jar. Echizen. Fifteenth to early sixteenth century. Height, *52. Jar with lattice-pattern band. Shigaraki. Thirteenth to*
37.5 cm. *fourteenth century. Height, 44.5 cm. (See also Figure 98.)*

in all areas in answer to the various demands of feudal society. Furthermore, progress in transportation and distribution increased. But in spite of all these favorable conditions, glazed wares still did not spread very far.

When the problem is approached in this way, one cannot but admit that the popularity of unglazed wares in Japan's middle ages was not due solely to their high quality. Another reason was the affection with which the people of the nation must have regarded these wares, for it was purely in answer to public demand that the manufacture of unglazed ceramics continued.

The main source of this demand was the agricultural population throughout the country. Also, since most of the potters themselves were rural people, their works were rich in practical qualities and filled with the elegance of simplicity, which may be said to have struck a powerfully sympathetic chord in the aesthetic sensibilities of the agricultural class. They had no use or desire for meaningless overdecoration.

The practical strength and purity, the rustic warmth and naturalness of medieval unglazed ceramics doubtless sprang from sources such as these.

53. Deep bowl with design of animal face. Middle Jomon. Height, 43.8 cm. Excavated at Okaya, Nagano Prefecture. Okaya ▷
Board of Education.

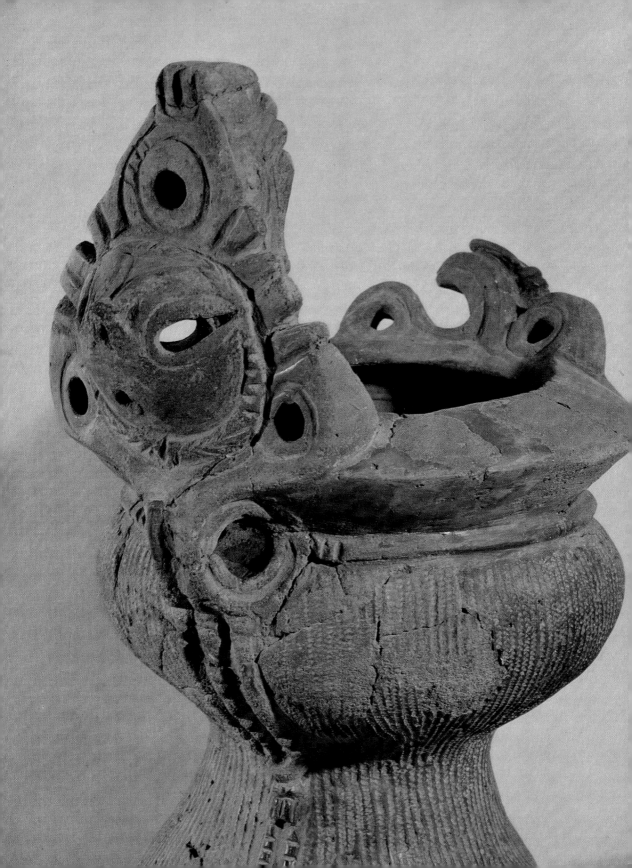

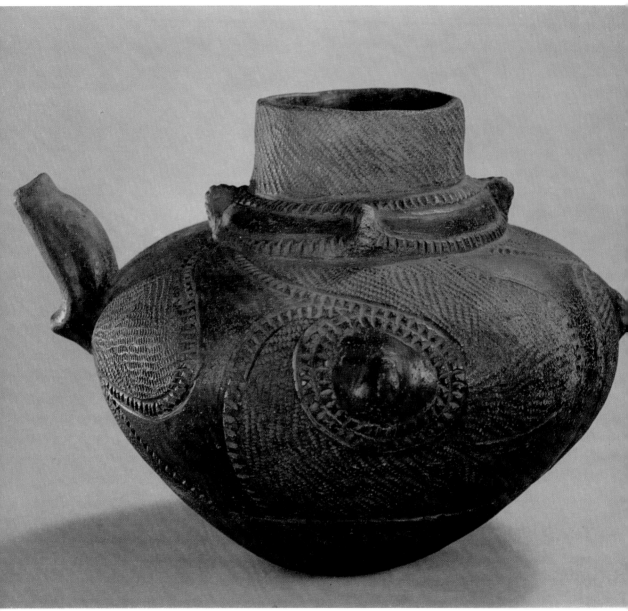

54. *Jar with curvilinear pattern. Terminal Jomon. Height, 21.5 cm. Excavated at Towada, Aomori Prefecture. Tokyo National Museum.*

55. *Deep pot with geometric pattern. Late Jomon. Height, 50.7 cm.* ▷ *Excavated at Horinouchi shell mound, Ichikawa, Chiba Prefecture. Tokyo National Museum.*

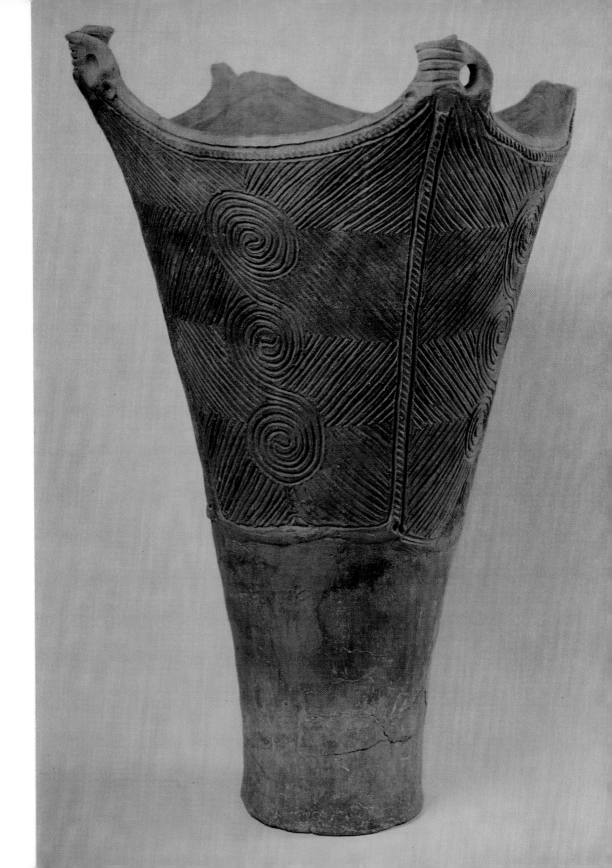

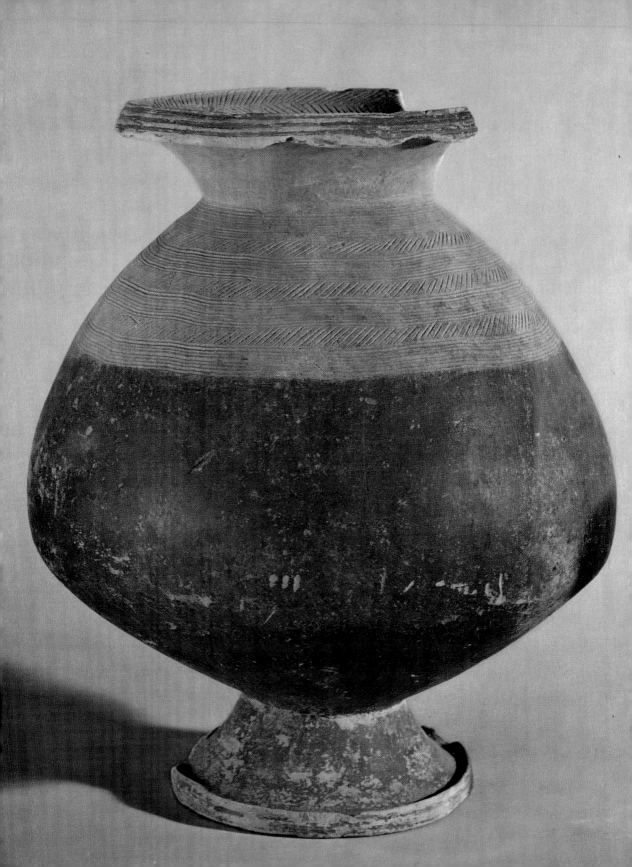

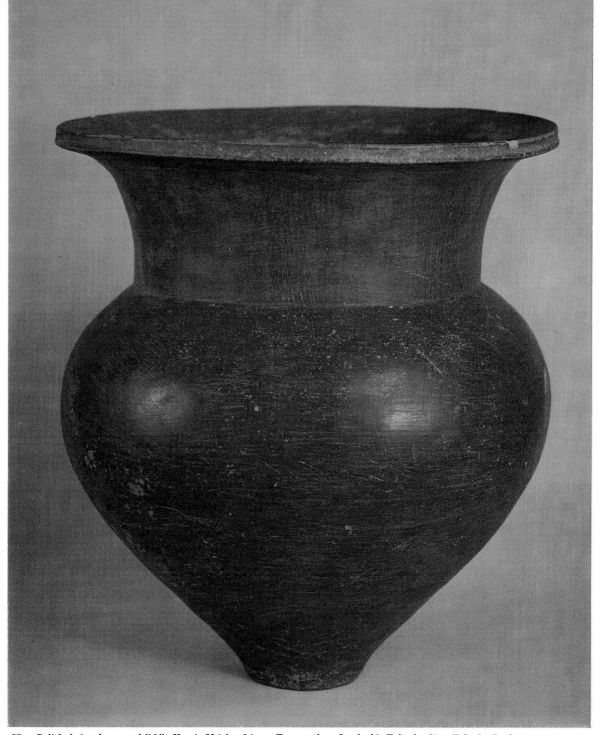

57. Polished cinnabar pot. Middle Yayoi. Height, 34 cm. Excavated at Jonokoshi, Fukuoka City, Fukuoka Prefecture.

◁ 56. Cinnabar pot with stand. Middle Yayoi. Height, 27.7 cm. Excavated from grounds of Owari Hospital, Ichinomiya, Aichi Prefecture. In custody of Ichinomiya City.

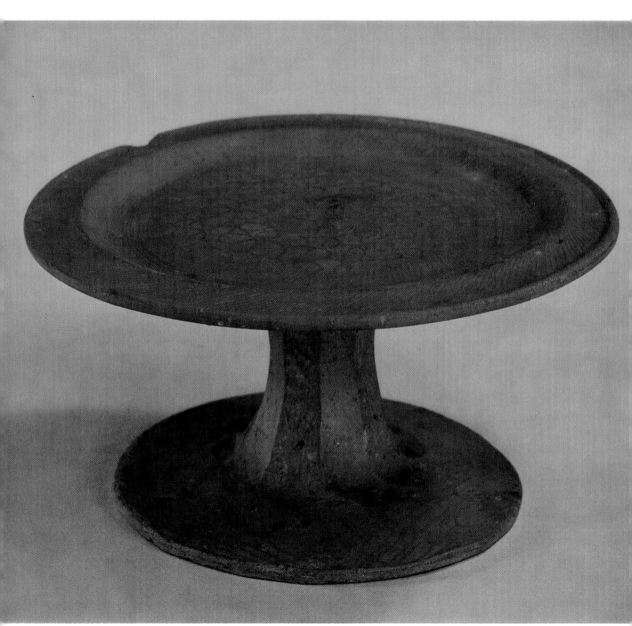

58. *Cinnabar dish with tall base.* Hajiki. *Eighth century. Height, 9.5 cm. Excavated at Shibuya, Yanagimoto, Tenri, Nara Prefecture.*
Tokyo National Museum.

59. *Pot with animal ornaments and stand.* Sueki. *Sixth century.* ▷
Height, 45.3 cm. Excavated at Iwahashi Senzuka tumulus site, Waka-
yama City, Wakayama Prefecture.

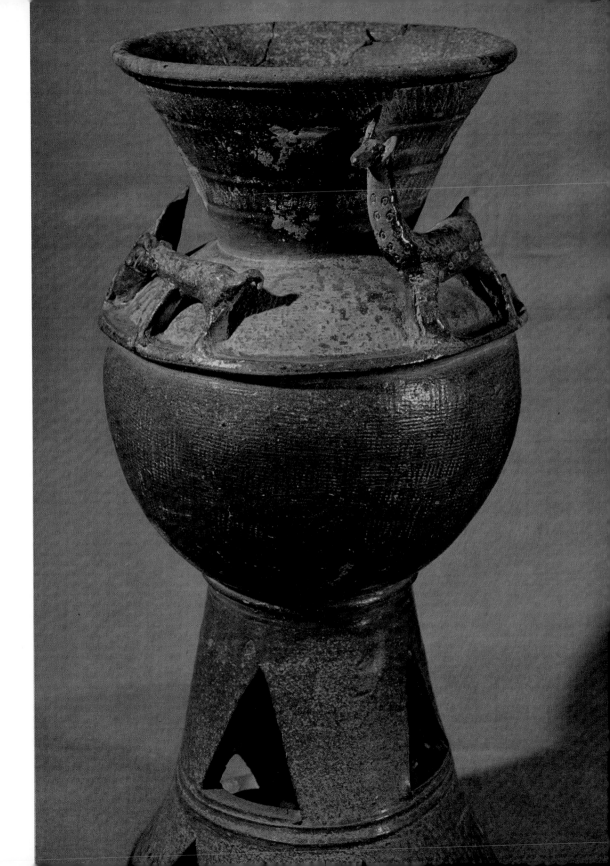

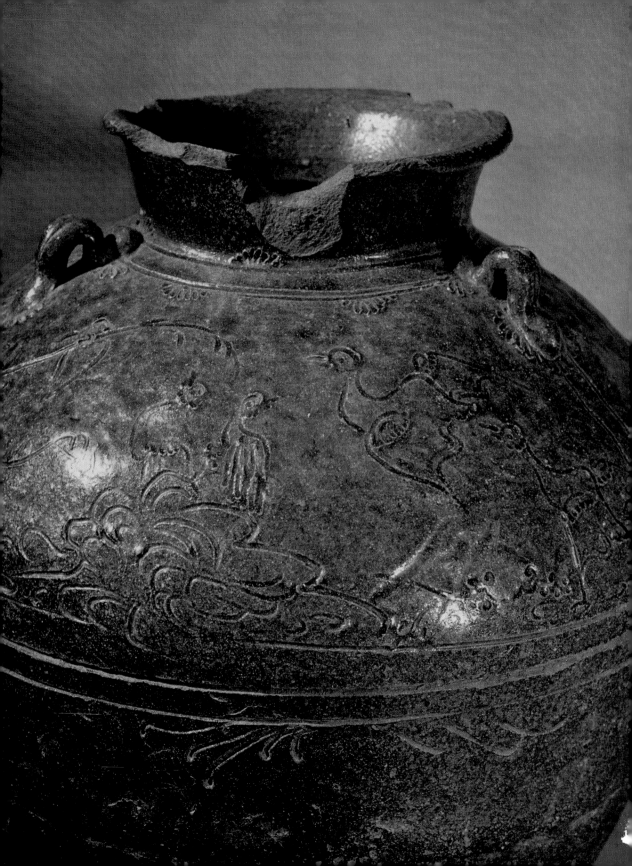

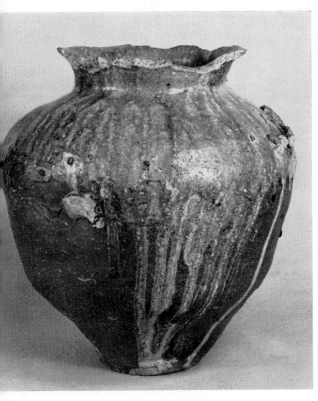

61. *Jar. Bizen. Twelfth century. Height, 33.5 cm. Excavated from sutra mound at site of former Daitei-ji, Okayama Prefecture.*

on the Japan Sea coast, and at Tokoname in the Tokai district facing the Pacific. From cities and country districts alike, demand for these wares continued, whether in the form of water-storage jars, bowls, mortars, or tea jars. During this period, form became more harmonious than in previous eras, but contours and outlines came to have an unexciting character that gave an impression of small-scale triviality. This may have arisen from the loss of resilience and the sapping of energy that gradually overtook farming areas under the rule of the Tokugawa shogunate.

The two new phenomena that arose at this time were the further evolution of nonporcelaneous wares and the beginning of true porcelain production. In the latter part of the sixteenth century, during the Momoyama period, the materialization of a new social structure gave impetus to the growth of ceramics. One of the immediate causes may be found in the burgeoning of cities, following the spread and increase of wealth. Another was the fashion of tea drinking and the tea ceremony.

The late Muromachi period, which immediately preceded the Momoyama period and the unification of Japan, was an era of political strife and confusion, and the need for structural changes in government and society was evident. The older sources of authority, limited in number, that had held restrictive, centralized power for so long, gradually broke down. Control passed into the hands of many strong provincial families, both great and small, typified by the warlike daimyo military leaders during the century or so of civil strife that ended in the late 1500's.

In addition, groups of newly risen merchants gathered in major cities and seaports all over the land, carrying on industry and trade and amassing capital. Since this brought a notable development to the provincial cities, the wealth of the country tended to spread, and the seaports and administra-

THE COMPLEXITY OF EARLY MODERN CERAMICS

In glazed and unglazed wares alike, medieval ceramics are relatively uncomplicated in character. By contrast, ceramics tended to become rather more complex during the sixteenth century. The reason for this increasing complexity is that the structure of Japanese society was undergoing rapid development, and tendencies toward greater differentiation in class and social status had appeared. In line with this trend, the qualities that people sought in ceramics tended to differ according to their relative positions in society.

In the modern era, too, the manufacture of unglazed wares has continued as before. This situation was identical in Tamba and in Bizen, in Echizen

◁ 60. *Pot with waterfowl pattern.* Sueki. *Twelfth century. Height, 39.5 cm. Matsunaga Memorial Hall, Odawara, Kanagawa Prefecture.*

tive centers of all areas saw the rise of a moneyed class. People raised their standard of living and their status in accordance with the wealth they possessed. In the field of ceramics, too, ornately decorated and richly colored glazed objects came to be used in place of the older unglazed wares. Witness to this is given by the quantities of imported Chinese ceramic objects unearthed side by side with the native unglazed Seto and Mino wares from the historical sites associated with notables of the Muromachi period. Needless to say, the ancient port cities of Hakata in Kyushu and Sakai (now part of Osaka) are included among these sites. Thus, the demands of this new ruling class for ceramic articles of ornament and use inevitably encouraged the expansion of the ceramic industry.

Originally, the drinking of tea—steeped tea and, especially, opaque whipped tea made from a mixture of hot water and finely powdered green tea leaves—was enjoyed by the court nobles and the clergy of the Kamakura period. In the Muromachi period, however, this habit gradually spread among influential people in the capital city of Kyoto and its environs, in time reaching even the local magnates and well-to-do families of the provinces. In the latter half of the fifteenth century, the principles of the tea cult (*cha-no-yu* or *sado* in Japanese) were first set down in accordance with the precepts of Murata Juko (1422–1502) and were further developed by Takeno Jo-o (1502–55) in the first half of the sixteenth century. By this time, the fashion of drinking tea had gained popularity among *nouveau riche* landholders and townsfolk, and during the period of struggle for the unification of Japan it extended even to the general farming population.

Tea bowls are a necessary adjunct to the enjoyment of tea. For use as tea utensils, good glazed ceramics are far superior to unglazed wares. With the popularization of tea drinking, the need arose for ceramic bowls and other paraphernalia for use with tea. At first this need was supplied by imported Chinese wares such as celadon porcelains and *temmoku*. As a supplement to these, however, replicas of Chinese *temmoku* bowls were produced at Seto (the so-called Seto *temmoku*) as early as the first half of the Muromachi period (Fig. 43).

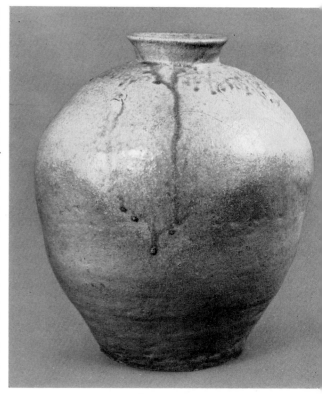

After that, the demand for tea utensils only increased. From the first half of the sixteenth century on, apart from the imported Chinese wares, some products of Bizen, Shigaraki, and other old established kiln sites began to be singled out as suitable vessels for tea and were put to use by the tea masters (Fig. 63). This tendency is noticeable in the era of Takeno Jo-o, but during the ascendancy of Sen no Rikyu (1521–91), the most famous tea master, it became even more marked. Rikyu himself had tea utensils made by special order at Seto, as well as at Shigaraki, Bizen, and other popular traditional kilns. These are known as *kuniyaki*, or "native wares," and they came to be highly valued by the general public.

This demand for domestic wares, which began in the early sixteenth century, had a close connection with improvements in kiln firing techniques that resulted in the creation of ceramic products su-

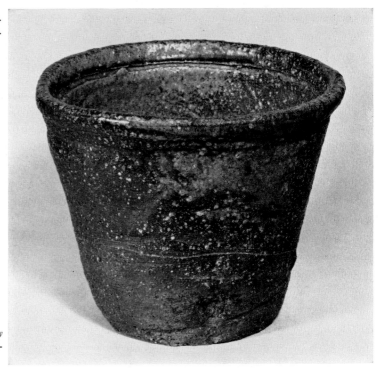

63. Onioke *water bowl for tea-ceremony*
use. Shigaraki. Late sixteenth to early seven-
teenth century. Height, 20 cm.

perior to any that had appeared in Japan before.

Apart from the production of *temmoku* wares at Seto in Owari subsequent to the early Muromachi period, late Muromachi saw the birth of Yellow Seto (Ki Seto) around Toki in Mino province, while somewhat later, in the middle of the sixteenth century, Shino tea ware (Figs. 64, 65) first appeared in the Mino area, followed shortly by other wares such as Oribe (Fig. 102). Their invention came about in answer to the needs of the times.

This course of events next led to the birth of ceramic production in Kyushu. It is thought that Kyushu ceramics were first made on the Matsuura Peninsula of Hizen Province by Korean potters who had come to Japan toward the end of the Muromachi period, but actual large-scale production began only after the arrival of Korean craftsmen captured during Toyotomi Hideyoshi's invasions of Korea. The Koreans built kilns through-

out the Kyushu area, including those in nearby Nagato Province at the western tip of Honshu, and manufactured not only bowls and other tea utensils but also a great volume of ceramic objects for everyday use (Figs. 17, 67, 69, 104, 106).

After the wares of Mino and Seto, which matured gradually out of a long tradition, and the Kyushu ceramics, which were products of advanced techniques newly imported into Japan, the next important genre to make its appearance, toward the end of the sixteenth century, was the ceramic art of Kyoto, which began with the Raku ware of the Momoyama period.

Raku is a kind of light-bodied ceramic ware invented expressly for the tea cult. In the technique of its production, as well as in its construction and coloration, it is quite distinct from the wares that preceded it in Japan. Raku represented a new set of values, and we may say that these were brought

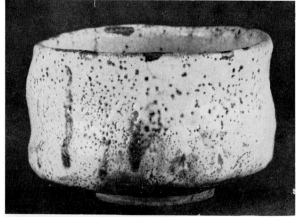

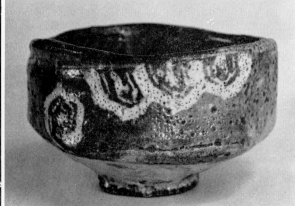

65. *Tea bowl known as Mine no Momiji (Autumn Foliage on the Mountain). Shino. Late sixteenth to early seventeenth century. Diameter, 14 cm.; height, 8.7 cm. Goto Art Museum, Tokyo.*

64. *Two views of tea bowl known as Hirosawa. Shino. Late sixteenth century. Diameter, 12.5 cm.; height, 8.4 cm.*

about by the quickening of a new age—the beginning of modern times. In the areas around Kyoto about this time, experiments were undertaken to give new form to high-fired unglazed ceramics. The appearance of pottery like Iga ware (Fig. 103), which attempts to arrive at a new kind of beauty by the deliberate repudiation of existing forms, was doubtless also a result of this emerging spirit and atmosphere.

In Kyoto and its environs, the center of Japanese artistic culture, new types of ceramics continued to appear in answer to the wishes of the newly risen officials and rich merchants. With the advance of culture into the early modern era, these ceramic types became established as a result of their great excellence in ornament, rich coloring, and elegant design. At the same time, the recognition granted to individual potters opened up a new phase in the history of modern ceramics, one worthy of particular attention.

Among the renowned potters of this period were men like the Raku artists Chojiro (Figs. 70, 164, 165) and Nonko (also called Donyu; Fig. 163); Hon'ami Koetsu (Figs. 107, 168), and the masters of decoration, Nonomura Ninsei (1598–1666; Figs. 24, 84, 85, 185) and Ogata Kenzan (1663–1743; Fig. 152).

Thus it came about that glazed ceramics were being manufactured in eastern Japan at Seto and Mino and in the west at many kiln sites in Kyushu, with the central Kyoto area in between. The products of these kilns included a variety of house-

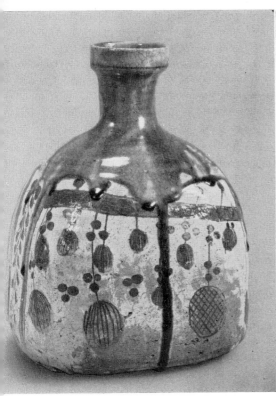 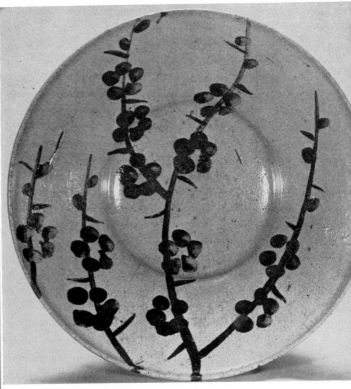

66. *Sakè decanter with bead-necklace pattern. Oribe. Late sixteenth to early seventeenth century. Height, 24.5 cm.*

67. *Plate with design of plum blossoms. Old Karatsu. Early seventeenth century. Diameter, 20.3 cm.*

hold articles in addition to the now indispensable tea utensils. When these became popular, glazed ceramics gradually tended to supplant unglazed high-fired wares as the mainstream of ceramics in Japan.

In spite of this tendency, however, unglazed wares continued to hold their own, being produced in quantity just as before at Bizen, Tamba, Shigaraki, Tokoname, and similar sites. This continuity shows how firmly unglazed ceramics were fixed in the lives and affections of Japan's farming population.

In the east, glazed Mino and Seto wares; in central Kyoto, Raku and decorated ware; in Kyushu to the west, Old Karatsu and other Korean-style ceramics—at the opening of the early

modern era, all of these wares were being produced at the same time, yet they were not interfering with one another in the least. There were, of course, mutual influences through the exchange of techniques and methods of kiln construction. (Also, there was an occasional borrowing of styles, producing wares with names like Karatsu-style Seto, but these are not of great moment.) Appearing with the glazed ceramics were the older high-fired unglazed wares, still being manufactured on a large scale at Tokoname in Owari Province, Tachikui in Tamba, Imbe in the Bizen district, and other ancient kiln sites. In early modern Japan, it came about that a great variety of different wares were turned out at the same time in districts throughout the country. This phenomenon is a

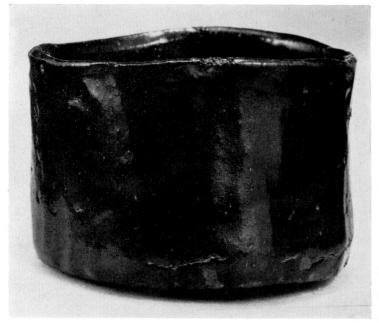

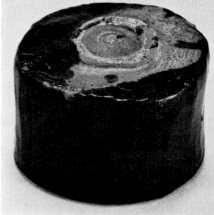

68. *Two views of tea bowl known as Oharame (Woman of Ohara). Black Seto.*
Late sixteenth to early seventeenth century. Diameter, 13.3 cm.; height, 8.7 cm.

major distinguishing characteristic of ceramic manufacture in Japan. Also, only a little later in the early modern period, the beginning of porcelain production added an element of even greater complexity to this already diverse picture.

THE SPREAD OF PORCELAINS

Following the late-sixteenth-century expansion of glazed-ceramics production, porcelaneous wares were introduced and manufactured. It is said that porcelain production in Japan dates from 1616, when porcelain clays in Arita, Hizen Province, were first found and used by a group of Korean craftsmen under the leadership of master potter Ri Sampei (Yi Sam-p'yong), who had come to Japan at the time of Hideyoshi's Korean invasion. Since a beautiful white-glaze porcelain was produced, it seems reasonable to assume that Ri

Sampei and his followers had a deep knowledge of the art of porcelain firing.

In a number of ways, porcelain has advantages over nonporcelaneous wares. It is extremely hard and durable, while its surface, as seen through the transparent vitreous glaze, appears white and pure. As a result, designs painted on the body have a serenely clear beauty. In porcelain manufacture, an advanced type of kiln is necessary: a continuous step-chamber kiln like the one shown in Figures 160, 166, and 174. With this kind of kiln, wastage is reduced, and it is possible to achieve efficient mass production. The large amount of Chinese blue-and-white ware imported from the fifteenth century on may be attributed not simply to a fashion for admiring foreign products but also to the superior practical qualities of these porcelaneous utensils.

Once porcelain firing had begun in the neighbor-

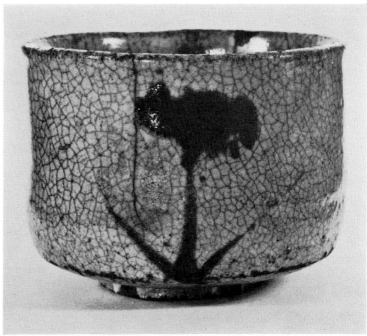

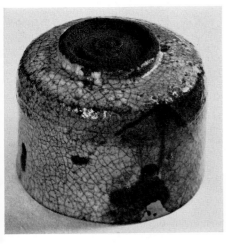

69. Two views of tea bowl known as Ayame (Iris). Old Karatsu. Late sixteenth to early seventeenth century. Diameter, 12.2 cm.; height, 9.3 cm.

hood of Arita, it soon became a major industry in the region, fostered by the protection and the monopoly policies of the Saga fief. The vast quantities produced were shipped at first to all ports throughout Kyushu and next throughout the entire country. They were also widely exported, by way of the Dutch East India Company, to other parts of the world. Since the ceramics of Arita were shipped from the nearby seaport of Imari, they became known under the name of Imari ware (Figs. 20, 144, 149, 150).

At some time in the middle of the seventeenth century, the efforts of Sakaida Kakiemon and his family achieved success in the form of porcelains with overglaze-enamel decorations (Figs. 22, 145, 146). These were developed throughout the Arita district. Following the appearance of such diverse styles as Old Imari and Nabeshima (Figs. 19, 147,

148) in addition to Kakiemon, porcelains won even greater esteem.

Nonetheless, during the early and middle part of the Edo period, porcelain manufacture was limited to Arita and its environs. With the exception of overglaze wares from one or two kilns, such as Kutani in Kaga (Fig. 153) and Himetani in Bingo (Fig. 77), porcelains were hardly ever produced in other regions. This failure to expand to other areas is usually attributed to the strict secrecy enforced by the Saga authorities, who were attempting to prevent the transmission of porcelain techniques to outsiders. There is no doubt that this is indeed one of the main reasons. Even so, the fact that porcelain manufacture did not spread to other districts cannot, in all likelihood, be explained away by Saga's restrictive policies alone. When we compare the cases of Himetani, where porcelains

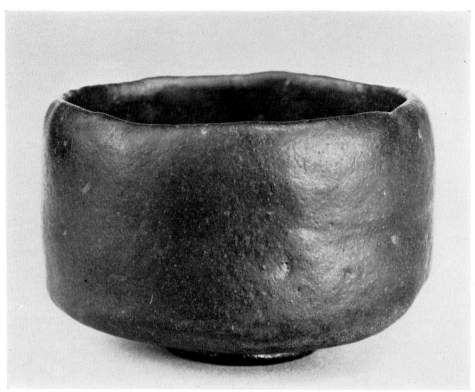

70. *Tea bowl known as Shunkan, by Chojiro. Late sixteenth century.*
Diameter, 10.8 cm.; height, 7.9 cm.

were actually made during the Kambun era (1661–73), and Kutani (Figs. 23, 151, 153), which began porcelain firing in 1655, it becomes obvious that there must be other reasons as well.

One of these is the abundance of porcelaneous clays around Arita. This means that production costs were low, which made it difficult for other areas to compete with Arita commercially. Another reason lies in the enduring popularity of the beloved traditional unglazed ceramics and the relatively inexpensive newer glazed wares, which were widely used throughout the nation.

From the middle of the seventeenth century, the porcelains produced at and around Arita in the Hizen area were shipped to all parts of the country. At first, they were admired by city dwellers, but later they found their way into rural areas. In this way they came to occupy a prominent place in Japan's ceramic manufacture, together with the older pottery and unglazed ceramics.

In the decades before and after 1800, porcelain manufacture ceased to be a monopoly of Arita and finally spread throughout the whole of Japan. During these years, it was carried on at sites that had already been producing the older ceramic wares, and at length it began to take precedence over them. Even so, the older products were still turned out in vast quantities, continuing to fulfill a great variety of purposes in town and country alike. This fact is most significant, for it helps us to understand much about the tastes and preferences in ceramic ware that characterize the Japanese.

CHAPTER THREE

The Nature of Japanese Ceramics

THE DEVELOPMENT OF CERAMIC CULTURE Japanese ceramics as a whole share certain distinguishing qualities. The first of these is the multifarious, cumulative nature of Japan's ceramic culture. The explanation of this phenomenon may be as follows. When we examine the general state of ceramic development within Japan, we note that, even when new eras began, accompanied by the development of new, advanced techniques that produced superior ceramic forms, the older types of ceramics made by established methods did not die out; rather, both new and old wares continued to be produced and used side by side. Toward the end of the fourth century, for example, the production of *sueki* wares began in the Kinai district, and eventually, with the passage of time, *sueki* manufacture spread throughout the country. Nonetheless, the *hajiki* wares, which were direct descendants of the old Yayoi pottery, still went on being produced all over Japan, just as before. Accordingly, throughout the Tumulus period, and even in the Nara and Heian periods, which followed it, both types of wares were made and used. Moreover, there was not even any social class distinction in their use. Within one and the same household, both *sueki* and *hajiki* wares were to be found. (They might, of course, have been used for different purposes, but this is only natural and does not alter the basic point.)

In the Nara period, even though polychrome glazed (Nara *sansai*) and monochrome-green glazed wares were produced for the use of the court, the clergy, and the aristocracy, these leaders of society still went on using *sueki* and *hajiki* just as they had done before. No matter how excellent the new wares were, they never reached a position where they could supplant the older products to become the sole representatives of the era.

This multifariousness continued much the same in the centuries following the mid-Kamakura period. Old Seto (Fig. 13), a glazed ware that was functionally superior to anything produced up to then, indeed made its appearance, but it was unable to replace the high-fired unglazed wares that had fallen heir to the *sueki* traditions. As a matter of fact, some scholars believe that Old Seto is merely a variant current of the mainstream of high-fired unglazed wares made by the Six Ancient Kilns (of which the Seto kiln is one).

In early modern times, the strong continuity of tradition and the cumulative nature of Japanese ceramics, in which new and old wares continued in use side by side, became even more apparent. Along with the opening of the new era, the use of glazed wares gradually spread, and they came to be produced on a large scale in many places: Yellow Seto, Black Seto, Shino, and Oribe at Mino and Seto in eastern Japan; wares such as Raku in centrally located Kyoto; and Agano, Old Karatsu, Old Satsuma, and similar glazed ceramics in Kyushu to the west. In spite of this, Tokoname in Owari, Tachikui in Tamba, Imbe in Bizen, and other old

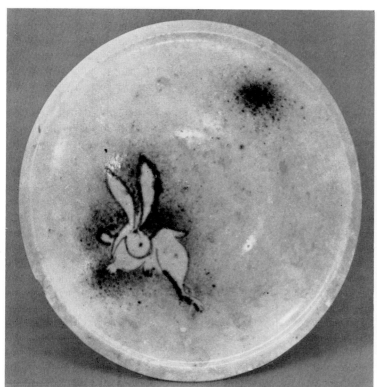

kilns continued to produce unglazed wares as energetically as ever. With this in mind, we can judge the strength of the tendencies noted above.

With the establishment of porcelain manufacture in the Arita district of Kyushu at the beginning of the seventeenth century, the condition of Japanese ceramics suddenly became all the more complex, as glazed wares, unglazed high-fired wares, and porcelains were all used at the same time.

The history of ceramics in other countries is entirely different. Whether in nearby Korea and China, in Annam and Thailand to the south, or in distant Europe and Persia, whenever a superior ceramic ware made by new techniques has been introduced, it has tended to supersede older wares and replace them to become the characteristic style of the times.

A good example is provided by the ceramics of Korea, which, just as those of Japan did, received Chinese influences in technique. When true ceramics were first produced, they usurped the leading position formerly held by pottery, being supplanted in turn when porcelain manufacture began. Even though ordinary ceramic production may have continued in areas that had no porcelaneous clays, in all other areas of Korea porcelains reigned supreme.

In China, the unglazed high-fired wares beloved in Japan were indeed made at kilns in one part of the south, but these were objects made for a special use, and they were certainly not important enough to compare with glazed wares in the general situation of Chinese ceramics of the time.

The case of the Near East is much the same. With the exception of pottery water-storage jars and flasks, all wares were uniformly glazed, hard-fired,

71 (opposite page, left). Plate with design of rabbit. Early Imari. First half of seventeenth century. Diameter, 15.1 cm.

72 (opposite page, right). Faceted sakè decanter with chrysanthemum design. Early Imari. First half of seventeenth century. Height, 23.5 cm.

73. Jar with overglaze design of flowers and birds. Kakiemon. Second half of seventeenth century. Height, 27.9 cm.

true ceramics. In Europe, the situation was hardly different.

This phenomenon arose, in most cases, as new, technically superior products overtook those made by the old methods of the past, and it may be cited as an important characteristic of ceramic-industry development throughout these areas.

In Japan, whatever the era, it almost never happens that cultural innovations advance by means of superseding, completely erasing, and triumphing over those of an earlier day. This Japanese peculiarity is such that, when new cultural developments occur, or when differing cultural forms are introduced from other nations, they coexist with the older, traditional forms without seeming unnatural in the least. In thought, in literature, and in art, this same characteristic persists. Not surprisingly, this remarkable relationship of Japanese

civilization to new cultural influences is mirrored in the history of ceramic culture as well.

THE DIVERSITY OF JAPANESE CERAMICS During the course of the development of Japanese ceramics, it was no doubt the attitudes of the people themselves that fostered this cumulative characteristic. There was also the important factor of great diversity, the two qualities combining to add a further degree of brilliance and complexity to Japan's ceramic culture. By diversity, or multiplicity, we mean that in the same era, and within the single genre of ceramics, many varieties came into being, all of which amicably continued to exist together, with little or no mutual interference. The ceramics of the early modern period provide a case in point.

Among the porcelains of Arita, we find white-

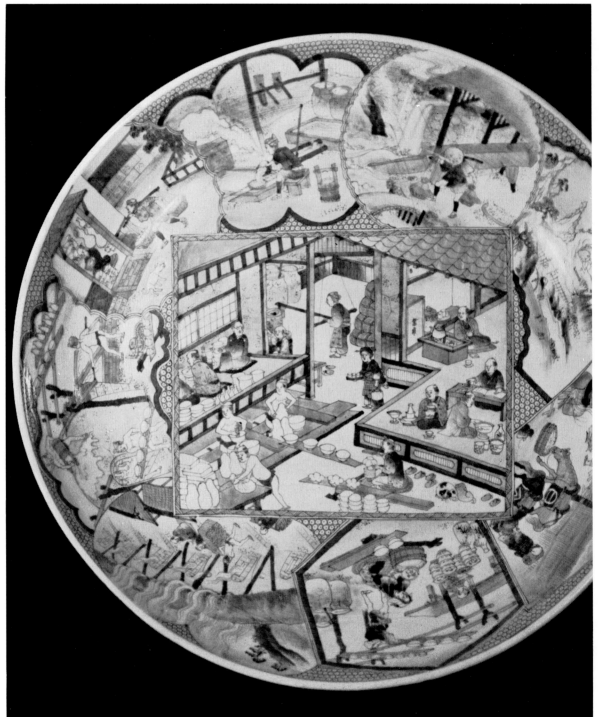

74. *Large plate picturing activities at Arita ceramics factory. Arita. Late seventeenth to early eighteenth century. Diameter, 59.5 cm.*

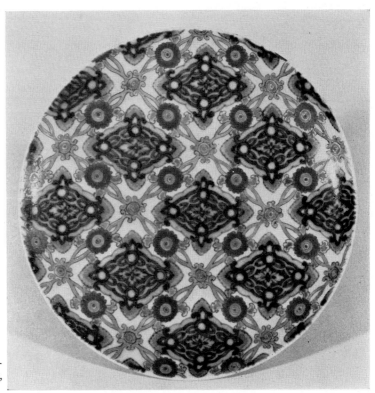

75. Plate with chintz-print pattern. Nabe-shima. Mid-seventeenth century. Diameter, 15.5 cm.

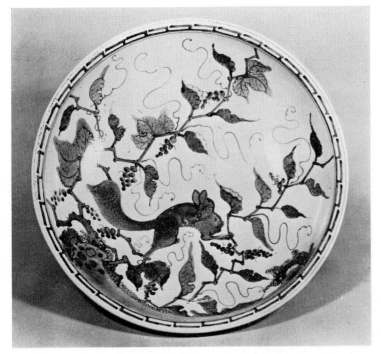

76. Plate with design of squirrel and grapevines. Old Imari. Second half of seventeenth century. Diameter, 46.7 cm.

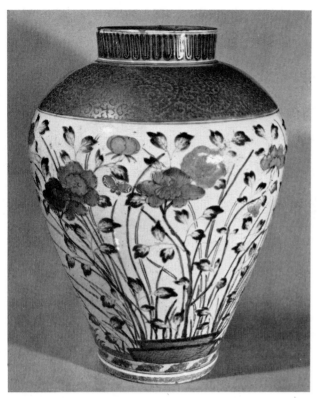

77. *Vase with design of peonies in gilt overglaze enamel. Old Imari. Second half of seventeenth century. Height, 46 cm.*

78 *(opposite page, left). Figurine of* ▷ *woman. Old Imari. Late seventeenth century. Height, 35.8 cm.*

79 *(opposite page, right). Figurine of* ▷ *woman. Kakiemon. Late seventeenth century. Height, 41.7 cm. Tokyo National Museum.*

glazed wares, celadons, black wares, and blue-and-white with underglaze painting, as well as over-glaze-enamel porcelains. Even in wares with under-glaze painting alone, there are Korean-style de-signs in the Chinese manner and others of a purely Japanese nature. With such a wealth of ornamental styles, there are, of course, a myriad of entirely different ceramics.

Kakiemon, Old Imari, and Nabeshima wares are vastly different in nature, yet all were separately produced within the narrow confines of the Arita district in Kyushu. There may have been internal or external qualifying conditions that contributed to this development, but, putting aside a handful of exceptions, such as the Ching-te-chen kiln of China, there are few examples elsewhere of so many different wares, each set off by individual char-acteristics and flavors, independently produced

within the boundaries of one area. This, no doubt, is due to the ready receptivity with which the Japa-nese of the age welcomed a variety of different utensil forms and types at the same time without being troubled by the slightest feeling of dishar-mony. This quality may even be said to spring from the social and psychological habit of combining unrelated objects or ideas in order to create a new and meaningful harmonious unity. In Japan this deliberate attitude of multiplicity in ceramics is in contrast with the tendency to uniformity so often found in other nations.

We have here dealt with the question of multi-plicity by examining Arita wares, attempting to find in this multifarious nature a distinguishing characteristic of Japanese ceramics as a whole. Similar judgments can be made by comparing the unglazed wares of the era.

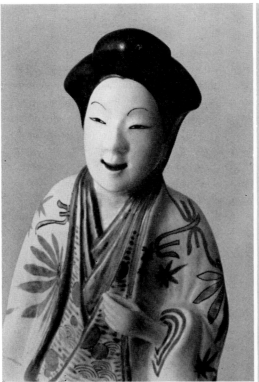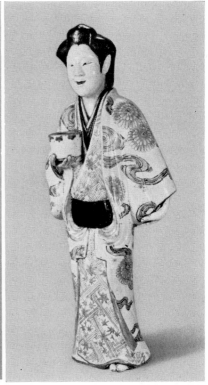

In the same mid-seventeenth-century period when porcelain production was flourishing at Arita in Hizen and in the same general area of northern Kyushu and the western tip of Honshu, numerous unglazed wares of distinctly individual natures were still being made at a number of different kilns: Hagi, Susa Karatsu, Agano, Takatori, Karatsu, Yatsushiro, and others within Old Karatsu itself. There were many distinct subdivisions in production, each with its own individual characteristics—the Karatsu wares of Kishidake, Matsuura, Saga, Taku, Takeo, and Hirado, for example. The same was true of the Satsuma wares of southern Kyushu. While these are all kilns of a common Korean origin, they nonetheless produced different ceramics, varying according to location, as at Naeshirogawa, Tateno, or Ryumonji.

A similar situation prevailed, of course, in the Home Provinces (the Kinai region), centering around Kyoto, as well as in the eastern districts of Owari and Mino. In the Home Provinces alone, there were such wares as Awataguchi, Kiyomizu, Otowa, Mizoro, and Oshikoji, all prior to the appearance of Nonomura Ninsei. After his time came the Kenzan-style and Asahiyama wares, which were greatly under his influence. These conditions spread throughout the Kinai district and beyond, with the development of Akahada ware in Nara, Akashi ware in Settsu, the Bizen Shizutani ware, Takamatsu ware at Sanuki in Shikoku, and the Odo ware of Tosa; each of these retained its own regional color and flavor.

As offshoots of the eastern wares of Mino and Owari, we find the Etchu Seto wares in Etchu Province, Takayama ware in the mountain province of Hida, Obayashi ware in Shinano, and the

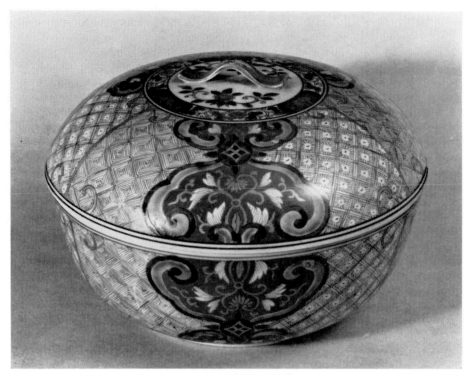

80. *Covered bowl with gilt overglaze enamel. Old Imari. Late seventeenth to early eighteenth century. Diameter, 22.7 cm.*

Shidoro kilns of Totomi. Again, the immensely wide range of variation found among the overglaze enamels made in Kaga Province under the name of Kutani provides another good illustration of this multiplicity.

As we look at the names of these kilns and investigate the differences among the various wares, we can understand just how kaleidoscopic was the variety of the ceramics of the early Edo period. Most of these were made in response to local needs, but many were also sold on a commercial basis through wide areas of the country.

The construction of many kilns throughout Japan is related to the establishment of the Tokugawa political system and to the growth of a regional economy. In some cases, kilns came under aristocratic patronage, producing private tea wares (*oniwa-yaki*) for leading daimyo; in others, they became fully developed regional ceramic centers that made brilliant contributions to the nation's ceramic art. Whatever the circumstances, we cannot ignore the fact that the economic and cultural requisites for this multiplicity sprang from the people of Japan themselves.

During the years from the late eighteenth to the early nineteenth century, when porcelain manufacture was spreading throughout the country, the manifold nature of Japan's ceramics became still more pronounced. Especially in the districts to the west of Mino and Owari, kiln sites increased in number, and types of wares became even more diverse, in porcelains, glazed wares, and unglazed high-fired wares alike. The scene came to be so varied and complex that it is difficult to single out any one category as the mainstream of Japanese ceramics. One is even tempted to wonder whether any

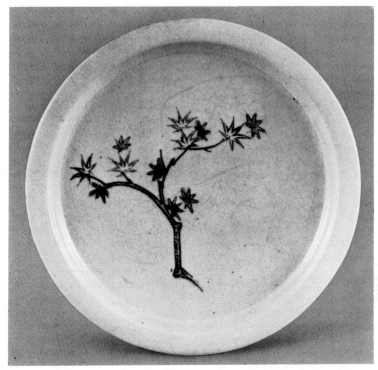

81. Plate with maple design. Himetani. Second half of seventeenth century. Diameter, 14.8 cm.

other ceramic-producing nation has ever created such a profusion of wares as nineteenth-century Japan. We cannot, of course, go into detailed comparisons here, but it is doubtful whether China herself could boast of so great a ceramic variety.

In examining the evidence, we find that the multiplicity of Japanese ceramics is indeed significant, not only as a trait of ceramic culture but perhaps also as a guide to one general aspect of Japanese culture itself in the broadest sense.

THE STRENGTH OF THE POPULAR TRADITION

The third characteristic of Japanese ceramics that we shall deal with here is their strongly plebeian and rural nature. Expressing this idea in different terms, we might say that the role played in ceramic development by aristocratic and official circles was relatively unimportant. By way of exploring this in depth, we may find it helpful to reconsider the situations in China and Korea.

The pre-eminent beauty and the technical superiority of Chinese ceramics are common knowledge. The porcelains of the Sung, T'ang, and subsequent dynasties are particularly well known. In these, however, and hence in the world of ceramics at large, the leading role is played by official wares, products of factories under court or government control and protection. The elegance and refinement typified by Northern Sung official wares and Southern Sung court celadons are common to all products of the official kilns. Particularly revered as the epitome of Chinese ceramic taste are the blue-and-white wares and the underglaze-red wares produced at the official Ching-te-chen kiln during the Ming dynasty, along with the splendid *famille*

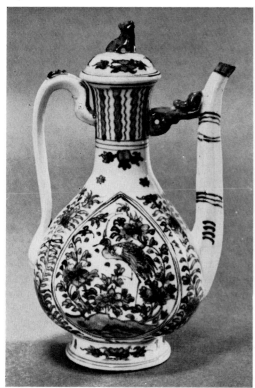

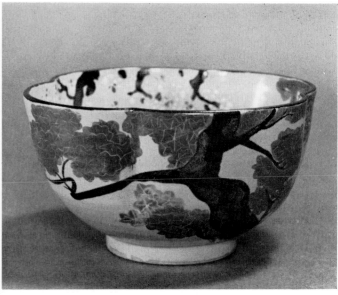

83. Bowl with design of cherry and maple trees, by Ninnami Dohachi. First half of nineteenth century. Diameter, 17.8 cm.

82. Ewer with bird-and-flower design, by Ninnami Dohachi. First half of nineteenth century. Height, 21.2 cm.

rose porcelains of the Ch'ing dynasty. These official, or *kuan*, wares of Ming and Ch'ing held the definitive position in Chinese ceramics and were representative of the highest ceramic standards of China.

In Korea the situation was much the same. Korean production of glazed low-fired ceramics began with the three-colored polychrome wares of Silla and other areas during the Three Kingdoms period (57 B.C. to A.D. 68), but the earliest manufacture of true ceramics is marked by the Koryo-period (918–1392) celadons. These exquisite porcelains are symbols of their age, but they, like their Chinese counterparts, were wares with a strongly official flavor. The handsome white-glaze and blue-and-white porcelains typical of the subsequent Yi dynasty are also products of government kilns in the Cholla Namdo area. In fact, it is next to im-

possible to discuss Chinese and Korean ceramics without some mention of official factories and court wares. The situation in Japan, however, is somewhat different.

Prior to the modern age, it is possible to regard early *sueki* and Nara polychrome wares (the so-called Nara *sansai*) as products of official kilns. Although the three-colored Nara wares were quite handsome, they did not have a wide currency, and they disappeared from the scene as soon as the Nara period was over. From that time on, throughout the classical and medieval periods, there was nothing that could be clearly categorized as a national official kiln. There were, it is true, the green-glazed wares of the Heian period and the so-called Heian *shiki* vessels produced at Sanage in Owari, some of which were essentially court wares, but they are hardly universal enough to merit mention.

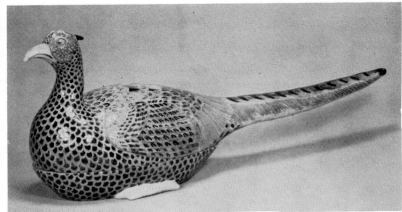

84. *Incense burner in form of cock pheasant, by Nonomura Ninsei. Late seventeenth century. Length, 47.6 cm. Ishikawa Prefectural Art Museum.*

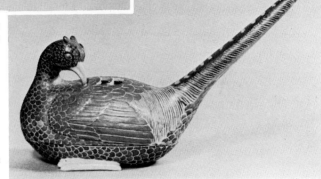

85. *Incense burner in form of hen pheasant, by Nonomura Ninsei. Late seventeenth century. Length, 37.5 cm.*

This characteristic continued until recent times. After the opening of the Edo period, domanial and private kilns were set up under the patronage of provincial daimyo. Among these, the Nabeshima kiln of the Saga fief in Hizen Province (modern Saga Prefecture) was especially notable. This, however, was no more than one small current within the mainstream of Japanese ceramic production, and it cannot be singled out as representative of Edo-period Japanese ceramics in general. There were, indeed, many wares which were the equal of those of Nabeshima.

In contemporary Kyoto, it was just the same with the overglaze enameled wares of Nonomura Ninsei (Fig. 24). Ninsei did benefit from the patronage of the Ninna-ji temple, with its prince-abbot, and in this sense he did have certain official sanction. As a matter of fact, however, his works were not generally used by the clergy; rather, many were made in reponse to the demands of well-to-do townsmen of Kyoto and Osaka, and in this respect they may actually be associated with the newly risen urban middle class.

In contrast with the lack of official kilns and court wares is the strong production of wares for bourgeois and peasant use. This is made clear by the deeply plebeian character found in the Kakiemon and Old Imari wares of Arita in Hizen, the Kutani enamels of Kaga, and other representative overglaze wares, as well as by the enormous power of endurance of the strongly rural unglazed stonewares, which continued the traditions of the middle ages into the modern period.

Unglazed high-fired wares were produced in quantity at the Ogama kiln in Bizen, in Tamba, and at the Teppo kiln of Tokoname. They included pots

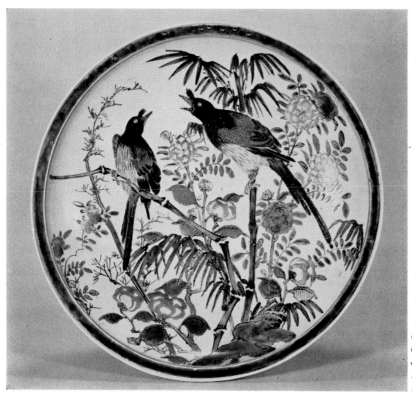

and huge storage jars, open pitchers, bowls, and plates for household use. The fact that these stonewares, which inherited the traditions of Kamakura and Muromachi times, were still being turned out en masse tells us how great were the popular demands for, and affection toward, such wares. The high position accorded to them is a phenomenon seen rarely, if ever, in the ceramic culture of other countries. It may be safely termed a special characteristic of Japanese ceramics.

These wares fulfilled their practical functions admirably. In addition, they suited the tastes of townsman and farmer alike and were deeply rooted in the society of the times. The strong, uncluttered beauty and the warm sense of community solidarity to be found in the wares of Bizen and Tamba (Figs. 100, 101) are surely the very spirit of rural society, springing from within the earth itself. When we

recall that most of these wares were produced by potters who were countrymen themselves, half farmers and half craftsmen, these qualities become even easier to understand.

After the middle of the Edo period, however, a growing weakness in ceramic form, coloration, and tactile sense may be observed. This is perhaps a reflection of the conditions in a rural society that was gradually losing its old vitality.

In contrast, and by way of compensation, came the growing popularity and increasing production of overglaze enamels and porcelains such as Old Imari, Kakiemon, and Old Kutani. The increasingly wide market area and the birth of originality in design (apart from technical dexterity) are indications of the energy of the burgeoning urban society.

I have here singled out three qualities as typical

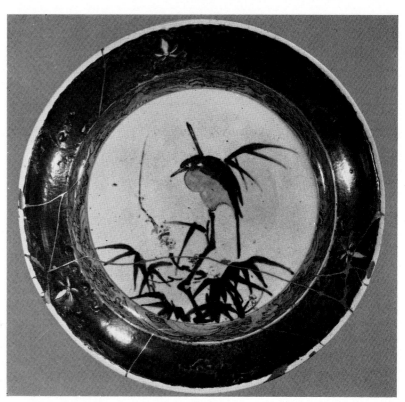

87. Plate with design of kingfisher. Old Kutani. Second half of seventeenth century. Diameter, 35 cm.

characteristics of Japanese ceramics. In summary, they are as follows: first, the cumulative nature of ceramic culture, in which high-fired unglazed pottery (stoneware), glazed wares, and porcelains all coexist; second, the tendency toward multiplicity, which develops manifold variety even within the three broad categories of earthenware, glazed wares, and porcelains; and, third, the strongly popular character, which stands out when all of these numerous varieties are reclassified along general socioeconomic lines, and the courtly, official side of Japanese ceramics is seen to be less important than the bourgeois and rustic aspects—the anti-official side, one might say.

Still, one should not forget that these are all very general qualities, based on an overall view. When the facts are considered in minute detail, other distinguishing features will appear.

CHAPTER FOUR

—◆•◆—

Low-fired Pottery
of the Prehistoric Age

JOMON WARE "Jomon period" is the alternate name for the neolithic age in Japan. During this period, the most important implements and tools were objects made of stone. Even so, when hearing the word "Jomon," the first thing the Japanese think of is not stone tools at all, but rather the Jomon-style pottery that was produced throughout the period. This early pottery takes its name from the rope patterns (*jomon*) with which it is decorated (Figs. 35, 53–55). It is familiar and important to the Japanese at large and to all who are interested in Japan's history and culture as well, and it is the oldest type of pottery to have been bequeathed by the ancient inhabitants of the Japanese archipelago.

To give a brief definition, Jomon ware is a primitive type of pottery made by hand from good pottery clays found near Stone Age settlements. In the earlier stages of its production, most of the objects made were storage jars and deep containers (Figs. 88, 89), but later these were supplemented by pots and bowls bearing fantastic handles (Figs. 53, 90), and, in time, teapotlike vessels appeared (Fig. 54). In addition to these utensils and containers, the richly appealing, original clay figures known today as *dogu* (Fig. 92) were made. Since the potter's wheel was as yet unknown, of course, all these objects were made by such manual methods as coiling,

stacking, or simple kneading and shaping. At the start, kilns especially for firing pottery did not exist, so objects were simply heaped up and baked within open fires.

Although the methods of manufacture were very primitive, the forms themselves were strong, free, and imaginative, with ample power to move us today. This pure, naked beauty, which strikes our hearts intuitively and directly, requires no intermediary of custom or knowledge, for it is an expression of essential humanity itself.

As the name *jomon,* or "rope pattern," indicates, there are often designs and patterns decorating the surfaces of the vessels. In application these patterns are quite complex. Some vessels have only surface patterns, while others have further ornamentation in addition to these.

Varieties of surface design include stamping, twist patterns, impressions, incising, and rope patterns. The additional kinds of ornamentation also include a number of complicated designs added by relief construction in clay coil, by erasure, or by engraving and the use of red pigments. Occasionally stylized designs based on anthropoid faces and animal figures occur, but these are not, strictly speaking, pictorial elements.

There seems little doubt that the ground patterns originally resulted from pounding and other proc-

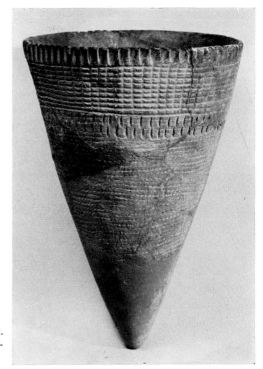

88. *Deep pot with pointed bottom. Archaic Jomon. Height, 22.8 cm. Excavated at Jaodo, Sumida, Iwate Prefecture. Department of Humanities, Tohoku University, Sendai.*

esses used on the walls of vessels to seal joints and improve forms. Still, from the fact that this ground ornament is found only on outer surfaces, and from the care given to its arrangement and design, it is obvious that the aesthetic selectivity of the Jomon people was already at work. The sense of beauty in ground patterns also began here, while ornamental devices over and above the ground pattern were likewise present from the first. These are all mute monuments to the strong accord with nature and art felt by the Jomon people, to their prayers, to the longings and aspirations which sprang from the depths of their hearts in that distant age.

The epoch of Jomon-ware production was exceedingly long. Since it extended for several thousand years, there were many changes in both form and decoration in accordance with the social changes and development of the times.

At present, the Jomon period is divided into either five or six eras. The five-era classification includes only Archaic, Early, Middle, Late, and Terminal Jomon, but postwar developments in archaeology have made it necessary to add yet another era prior to these—Primeval Jomon.

These eras are differentiated to mark the changes in culture and character that accompanied the progressive development of the Jomon period. Accordingly, in the field of pottery as well, different characteristics are noticeable, permitting us to clearly distinguish the various eras. By examining all of these in turn, we can trace the development among the early dwellers in Japan of sensitivity to the beauty born from fire and clay.

The era of Primeval Jomon marks the origin of pottery production in Japan. The pottery vessels of this era consist mostly of small, primitive, gray-black bowls molded by hand. Their shallow, rounded bottoms indicate that they may have been

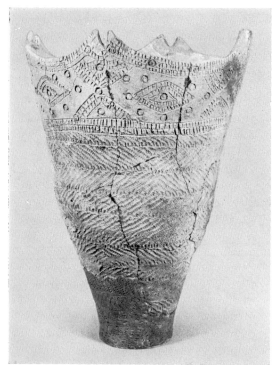 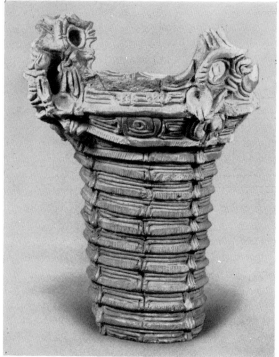

shaped on the flat of the maker's hand. Even on these extremely primitive vessels of a hunting and gathering society, there was already ornament made by the surface application of narrow clay-coil strips. At first, this ornament seems faltering and clumsy, but, like the drawings of children, it contains an ingenuous purity.

Pottery of this type has been found in Aichi Prefecture on the central Pacific coast of Honshu and in Nagasaki Prefecture in Kyushu, as well as in Niigata Prefecture, facing the northern Japan Sea, but all these places seem to have produced wares more or less of the same type. This is noteworthy, for it shows that the inhabitants of the entire Japanese archipelago were making similar pottery, even at such an early date.

As to the question of just when Jomon wares of the Primeval era were first produced, two quite different theories are current among scholars, and

it is not yet clear which is more likely to be true to fact. One is the theory of Professors Sosuke Sugihara and Chosuke Serizawa, who accept the results of carbon-14 tests in setting the date at sometime around 10,000 B.C. The other theory, supported by Messrs. Sugao Yamanouchi and Tatsuo Sato, is based on corroborative evidence from the Asian continent and from stratum levels; it opts for a starting point of about 3500 B.C. For the time being, at least until fresh evidence is forthcoming, it seems that reaching a final conclusion may be difficult indeed, but since this problem has considerable bearing on the dating of the following eras, the controversy is here mentioned in passing.

Primeval Jomon sites have, as yet, been discovered in only a few places in Japan. By contrast, sites representative of the Archaic era have been unearthed all over the country, which tells us that

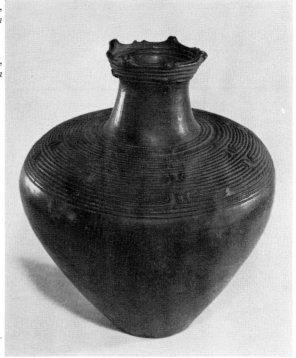

89 (opposite page, left). Deep pot. Early Jomon. Height, 35 cm. Excavated at Futatsugi shell mound, Kashiwa, Chiba Prefecture. Nanzan University, Nagoya.

90 (opposite page, right). Deep pot. Middle Jomon. Height, 37.5 cm. Excavated at Asahi shell mound, Himi, Toyama Prefecture. Department of Anthropology, Tokyo University.

91. Small-mouthed jar. Terminal Jomon. Height, 35 cm. Excavated at Umenai, Sannohe, Aomori Prefecture.

pottery manufacture of this kind was carried on throughout Japan.

Ceramic vessels of the Archaic Jomon era (Fig. 88) generally share common characteristics. Deep bowls or tubs made by the coil method have bottoms curved so sharply that they almost appear to be pointed. Outlines from the wide-open mouth to the bottom may be either concave or slightly convex, but these curves are always clear and direct, adding a beauty of sharp tension to the overall shape of the object.

Surfaces are covered with simple uniform patterns of the same type: straight parallel lines drawn with clam shells, and impressed designs, oblong, triangular, or fingernail shaped. The general impression is clean, strong, and resilient; it is almost surprising to find these qualities at such an early date.

During this era, the bow and arrow were in common use, and in all aspects, great advances occurred in the development of a hunting culture. The spirit of the primitive yet energetic society may have been uncomplicated, but it was overflowing with keen vitality, which doubtless played its part in the production of the ebullient, clean-lined pottery. At the same time, the apparent simplicity of living and the uniformity of ceramic technique resulted in the production of vessels of more or less the same type throughout the nation. In the lives of these primitive Jomon people, who boiled their game in pottery vessels with pointed bottoms sunk into the ground at hearthside, there was a strength and vigor appropriate to their level of cultural development.

As the Archaic Jomon era came to an end and the Early Jomon began, a great change occurred in the decoration and form of pottery vessels all over the nation. By comparison with the preceding eras,

92. Statuette of a goddess. Late Jomon. Height, 12 cm. Excavated at Ebaradai, Sakura, Chiba Prefecture. Department of Archaeological Research, Meiji University, Tokyo.

93. Jar with design of human face. Middle Yayoi. Height; 69.5 cm. Excavated at Ozakata, Shimodate, Ibaraki Prefecture. Tokyo National Museum.

the climate appears to have been growing gradually milder, so that the forests and surrounding seas teemed more richly with fish and game and other foodstuffs, conditions of living improved, and constant nomadism was no longer necessary. As the time spent by groups of people in one place lengthened, implements with distinctly individual characteristics began to appear in the various regions. The same tendency may, of course, be seen in pottery development.

Early Jomon pottery is characterized by the deep, flat-bottomed kettle or pot for boiling (Fig. 89). While this remains the basic form throughout, some of the vessels flare out in increasing ratio to their height, while others are widest at midsection. There are many variations; some vessels are even decorated with several peaked scallop patterns on the top rim.

Ornamentation became quite complex during this era. Patterns were made by winding a cord around the body of a vessel or by stamping marks with shells. With these as a ground, some areas might be enclosed by straight or curved outlines or further embellished by pierced relief designs. Decoration gradually began to move out of the flat stage into the three-dimensional.

Pottery of this era was less sharp and vibrant than that of preceding times, and the feeling of coarse, brute strength increased, but variations in ornamentation and vessel shape also showed a marked increase.

Pottery that at last combined both strength and sophistication arrived during the Middle Jomon era (Figs. 4, 35, 53, 90). During this era, the circumstances of the Jomon-style hunting and fishing economy improved considerably, and a greater element of stability affected the lives of people in all regions. Under these conditions, Jomon pottery

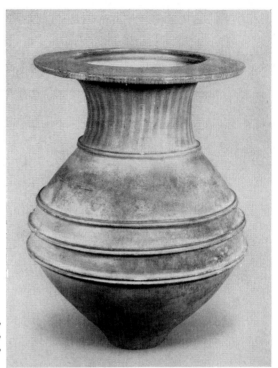

94. *Pot with design in cinnabar red. Middle Yayoi. Height, 40.7 cm. Excavated at Karakami shell mound, Kazamoto, Nagasaki Prefecture. Matsunaga Memorial Hall, Odawara, Kanagawa Prefecture.*

blossomed forth into full maturity. The grandeur and growing variety in form and rich multiplicity of ornament are not only superior to those of any other Jomon era but also can take pride of place even in a world-wide comparison. Regional differences increase. In vessel types, the tubs, pots, and jars of earlier periods are joined by shallow bowls, bowls with pouring lips, and even by spouted utensils; vessel sides and bottoms are solid and thick.

The typical form for vats and deep pots of this era is a sort of caliper shape, with the flat-bottomed tubular body suddenly flaring out at mid-point and narrowing again as it reaches the top.

On the surface, a rope pattern was applied as a ground ornament. Further decoration was added by a number of different methods: by incising, raised or lowered relief, and the application of rolls or pledgets of clay. In this deliberate ornamentation, contrasts in depth and relief are quite pro-

nounced, and in effect they may even be regarded as sculptured. Regional styles and variations are many and marked.

Figure 53 shows one work that typifies the height of Middle Jomon art—a deep bowl with an ornament in the form of an animal face. This vessel, with its weird face and snakelike decoration, has risen above the level of a mere cooking pot. It may be regarded as a memorial to the maker's world view and aesthetic awareness, expressed with the aid of fire and clay. In construction and design, it greatly exceeds even the conceptions of present-day abstract artists, and it has a highly individual excellence.

In the Middle Jomon era, the hunting economy of the earlier epochs was brought to maturity, while the members of a tribal society gained the ability to express clearly and with great beauty, by means of plastic form, the supernatural longings

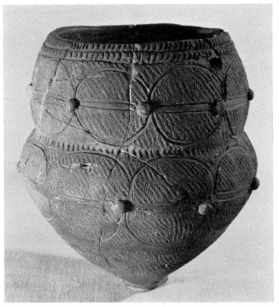

95. *Deep pot. Late Jomon. Height, 17 cm. Excavated at Hirohata shell mound, Sakuragawa, Ibaraki Prefecture.*

hidden in the hearts of the various groups. These people, so to speak, raised their voices in a song of pride which echoes even to this day.

When the Middle Jomon era was drawing to a close, mannerism began to set in. Strength of form and aesthetic tension were gradually lost, and in their place appeared the finished and even polished techniques characteristic of Late Jomon (Figs. 55, 95).

During this age, society made even further advances, and pottery objects were created to serve any number of different purposes. Small drinking bowls, trays with raised edges, plates, and vessels in a shape which is the forerunner of later vases and jars, all made their first appearance at this time, as did deliberate differences in quality relating to the intended uses of particular vessel types.

Methods of construction were much the same as in the Middle Jomon era. Since, however, more emphasis was laid on specific function, the technique of construction by stacking clay rings was streamlined, and forms became smoother and more finished. Some vessels even possess an air of considerable refinement.

In decoration, parts of the rope-pattern ground were rubbed out and marked off by ring bands of geometric patterns in straight and curved lines. The fluid design thus created has great rhythm. In contrast to the externalism of Middle Jomon, the aesthetic expression now changed to internalism. The sensibilities embodied within these vessels could only have been expressed by craftsmen who found all the values of life within the traditions of their community. It seems that society too was gradually changing from a structure based on small units that fostered individuality to large-scale anti-individualistic groups.

The tendencies of Late Jomon became the determining factors in the closing phase, or Terminal Jomon era, of the Jomon period, which perhaps was also the era that saw the first attempts at crop cultivation in Japan. The life of the people grew more firmly fixed in their various regional settlements, while the control exercised by the group over its

96. *Detail of Late Yayoi jar with design of men in boat. Height of figure at left, 6 cm. Excavated at Karako, Tawaramoto, Nara Prefecture. Department of Humanities, Kyoto University.*

individual members increased, indicating that whenever a kinship with the land itself is born, in any way whatsoever, modes of living and the world of the spirit invariably grow more complex.

In ceramics of the Terminal Jomon era, a clear and immediate distinction exists between finished and rough utensils—that is, between "plain" and "fancy" types. The storage jars and deep pots found in overwhelmingly great numbers are rough, unfinished vessels for everyday use. In contrast to these are the exquisitely fashioned jugs, bowls, cups, plates, spouted vessels, and burners obviously intended for special use. Especially in these latter, the old rope pattern is thrust aside for C-shaped, S-shaped, and X-shaped patterns or cloud and spiral motifs applied by engraving or erasure techniques. This curvilinear pattern upon a warm background design exhibits the beauty of pure abstraction.

Terminal Jomon pottery reached its highest development in the northerly Kanto and Tohoku districts. These northern wares are probably the most exquisite products of the entire Jomon period (Figs. 54, 91).

We have here allotted what may seem an inordinate amount of space to considering the pottery of the Jomon period. This was to allow for the realization that the earliest inhabitants of the Japanese archipelago invested more than usual fervor in their work with fire and clay during this long epoch. The splendid products of this fervor are unequaled by any other pottery of the prehistoric world.

These flowers of the highly individualistic Jomon people are unique in both form and fragrance. They reveal an amazing variety. It is interesting that the many different forms should have made their appearance solely in accordance with the progress of society during the various eras in this period when contact with outside regions was at a minimum. As we have noted earlier, this multiplicity is a harbinger of a major characteristic found in the later ceramics of Japan.

The primitive inhabitants of Japan thus invested

a great deal of emotional capital in utensils born from fire and clay; this intensity of feeling generated the energy for the creation of superb wares of immense variety. We may say that this energy remained strong and constant during subsequent eras, becoming the inspiration for pottery and, eventually, porcelain production. It also became the primary factor in the progress made in ceramics that people created out of a close awareness of their own needs, in answer to the demands of the times. It has a direct kinship with Japanese ceramics of later ages.

YAYOI POTTERY Around the third century B.C., the Jomon period came to an end, bringing the striking change in the nature of pottery that we have previously noted. When we look at Yayoi pottery with eyes already accustomed to Jomon, the first things we notice are the bright, cheerful color tones of warm russet, the rich, smooth curves in which the vessels are shaped, and the absence, or scarcity, of surface ornament (Figs. 56, 57). Further, there are more vessel types, including high-footed vessels and tall stands in addition to large and small jars, bowls, and spouted vessels. Functional beauty, lively colors with immediate appeal, and the brio of freely flowing curves almost in the modern spirit—all these qualities in Yayoi wares readily elicit the admiration of the viewer.

In all these characteristics, this ware stands in complete contrast to Jomon, with its dull-gray coloring, absence of linear fluidity, and heavy, at times even oppressive, ornamentation. Why there should be such an enormous difference between these two pottery styles is, indeed, a fascinating and puzzling problem.

When we inquire just why the entire country should have been overwhelmed by pottery that contrasted radically with that of earlier epochs, we find that there are sound social reasons for the change. We have given independent status as a historical time division to the Yayoi period because it marks the beginning of a new age in Japan, socially and economically. The old hunting, fishing, and gathering economy of the Jomon period was superseded by the beginning of life patterns based on rice culture, and these brought tremendous changes in the structure of society.

Although it is not known whether the continental techniques of rice cultivation entered Japan by way of the Korean peninsula or by way of the Ryukyu Islands, it is at least certain that they were introduced from outside and were first practiced somewhere on the southern island of Kyushu. As soon as these advanced agricultural methods were accepted in Japan, they quickly spread, and within one or two centuries they had become known throughout almost all the country. When rice culture assumed the central place in the economy, social conditions were altered, and the uniform group structure became stronger than ever.

As living groups solidified into a society based on the production of rice, this social ethic also influenced the manufacture of utensils and other artifacts, including, of course, pottery. In contrast with the Jomon world, in which makers produced works in their own individual styles, reflecting the working of their own egos, a single collective standard was demanded, and along with this came a search for a new collective emotional basis in tune with the new standards.

At the same time that this conformist demand arose, the techniques of manufacturing a new high-quality patternless ware—warm rose red in color—were introduced from the outside. The Yayoi people of northern Kyushu adopted these techniques and used them to make appropriate utensils for their new society. This, no doubt, accounts for the birth of the pottery that we know today as Yayoi.

When these northern Kyushu people accepted the new style, they abandoned the old Jomon forms and used the new techniques to make high-quality ware in reddish tones. The surfaces were smoothed with a paddle or edging tool, were decorated in red as often as not, and were polished to a high finish. Generally, the vessel midsections were full and bulging, narrowing as they approached the bottom, a form particularly appropriate for storage jars. This harmony of curved lines (Figs. 57, 94) created a new plastic aesthetic that was not to be found

during the Jomon period. With the potter's wheel as yet unknown, the production of such full flowing curves solely by the process of building up clay coils must have required considerable effort and skill. Even so, it was just such an emotional expression that the people of the Yayoi period must have sought. At this time, however, as far as we know, there were as yet no special kilns for firing pottery.

As the Yayoi style spread to the north and east, its techniques blended with the lingering artistic consciousness of Jomon, and some vessels were given such surface ornamention as chatter marks and engraving (Figs. 34, 56). This combination of Yayoi pottery style with Jomon decorative influences, which sometimes extended even to form, is found throughout the country, with the single exception of the Kyushu area, but it is especially noteworthy in the Kanto area. In this rather backward area, the old individualistic, magical approach to pottery continued to flourish alongside the new functionalism. Alternatively, these two styles combined to form a new composite style, while at times they simply continued in a state of coexistence. This tells us that already, in this early period, one of the distinguishing features of later Japanese ceramics had already made its appearance, as old and new styles continued to flourish amicably side by side.

Yayoi pottery went on being produced for the next five or six centuries, up to around A.D. 300. The different levels of development are generally broken down into five subdivisions. In their Kanto-district forms, these are known as the Suwada, Miyanodai, Kugahara, Yayoi-cho, and Maeno-cho eras. Shape, ornament, and categories of vessel types change according to the era, but the differences are not so great as in the case of the Jomon eras.

The finest qualities of Yayoi vessels are found in their warm, rosy-brown hues, plausible linear forms, and flowing surface curves combined with a plainness of ornament. In all aspects, plastic and decorative, the ethos of Yayoi is diametrically opposed to that of Jomon. Nevertheless, we find that even as the new styles were being adopted and were gaining general currency, the old Jomon essences remained as firmly rooted as ever.

CHAPTER FIVE

Early High-fired Ceramics

HAJIKI AND SUEKI During the fourth century, the Yayoi period ended and the Tumulus period (so named because of the grave mounds dating from it) began. Once again, important new developments took place in the ceramic culture of Japan. The first of these was the manufacture and spread of *hajiki,* and the next was the appearance of *sueki,* a high-grade stoneware made according to advanced techniques introduced from the continent.

There are many ultimate causes for these developments. At the time, political strength was building up throughout the country, centering about powerful regional clans, while in the Kinai district the influence of the imperial house was gradually spreading. More frequent and positive contact was made with China and the kingdoms of Korea, from which craftsmen with knowledge of superior potting techniques must have come, introducing their skills into areas of Japan that were under the sway of these centralized sources of power.

The early Tumulus period saw vigorous production of *hajiki,* a rust-red pottery baked in oxidizing fires. This began in the provinces of Yamato and Kochi in the early fourth century and spread throughout western Japan, eventually to reach the eastern provinces (Figs. 37, 58, 108).

Hajiki wares may be safely termed the successors to, or the continuation of, Yayoi wares, which they greatly resemble in color, shape, and characteristic lack of decoration. In the case of some vessels found in the Kanto and other districts, it is sometimes difficult to make a clear-cut distinction between the two wares, to say which is *hajiki* and which is Yayoi.

In *hajiki*-style pottery, however, certain new vessel shapes unknown in Yayoi times make their appearance: small globular jugs (Fig. 108) and wide-rimmed pots. Surfaces are finely finished, but both form and firing are lacking in the refinement that distinguished Yayoi ware, so that many of the vessels appear clumsy or heavy. Still, shaping techniques showed more practice, from which we may deduce that the rate of production had been speeded up considerably.

The actual making of *hajiki* was uncomplicated. Pots and jars were built up by winding clay coils on a base set on a bed of leaves that took the place of a potter's wheel. Alternatively, small pots were simply built up from the palm of the maker's hand. These methods account for the impressions of leaves and fingerprints found on the round bottoms of so many vessels. Next, the vessels were beaten with notched sticks, smoothed with paddles or scrapers, and polished to finish the walls. Occasionally, articles were decorated with patterns painted with cinnabar or other red pigments, but such pieces were probably intended for special uses.

97. *Sakè decanter with pattern of fish and chrysanthemums. Old Seto. Late thirteenth to early fourteenth century. Height, 37.5 cm.* ▷

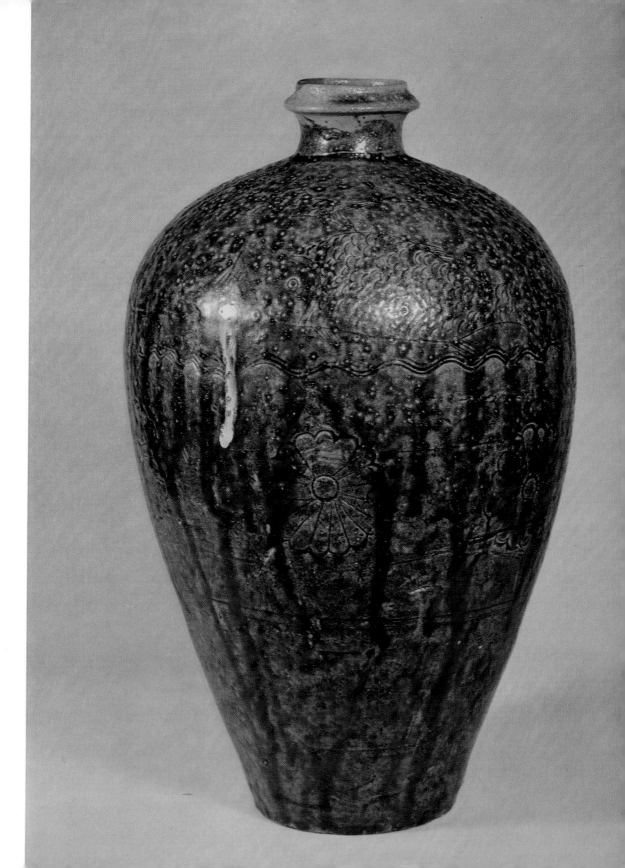

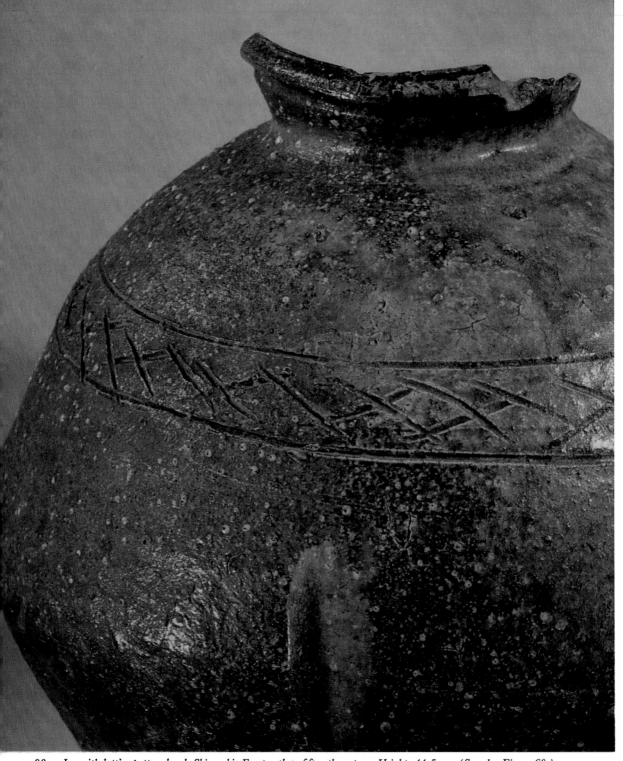

98. *Jar with lattice-pattern band. Shigaraki. Fourteenth to fifteenth century. Height, 44.5 cm. (See also Figure 60.)*

99. *Jar of abacus-bead shape. Echizen. Fourteenth to fifteenth century. Height, 62.2 cm.* ▷

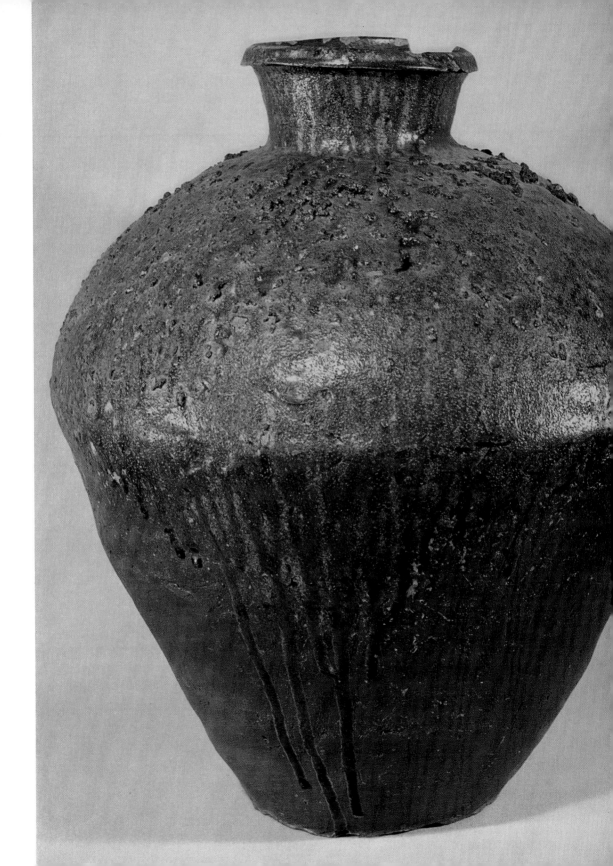

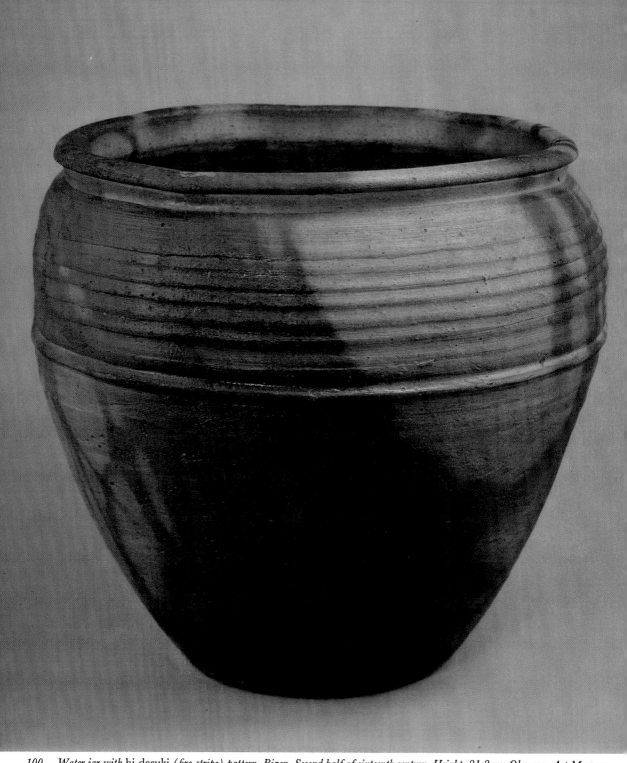

100. Water jar with hi-dasuki *(fire-stripe) pattern. Bizen. Second half of sixteenth century. Height, 31.3 cm. Okayama Art Museum, Okayama City, Okayama Prefecture.*

101. Jar. Tamba. Dated 1344. Height, 41 cm. Japan Handicraft Museum, Osaka. ▷

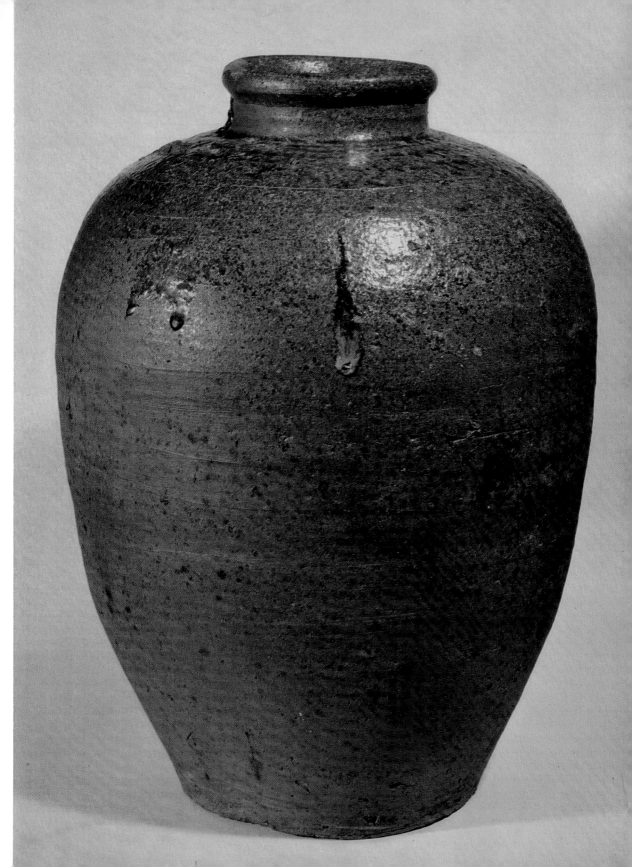

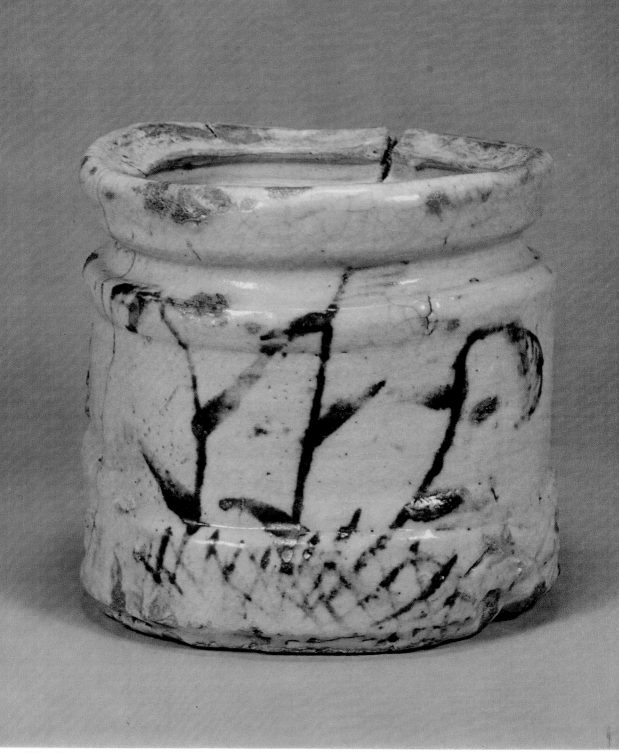

102. *Tea-ceremony water jar with design of grasses, known as Kogan. Shino. Late sixteenth century. Height, 17.6 cm. Hatakeyama Museum, Tokyo.*

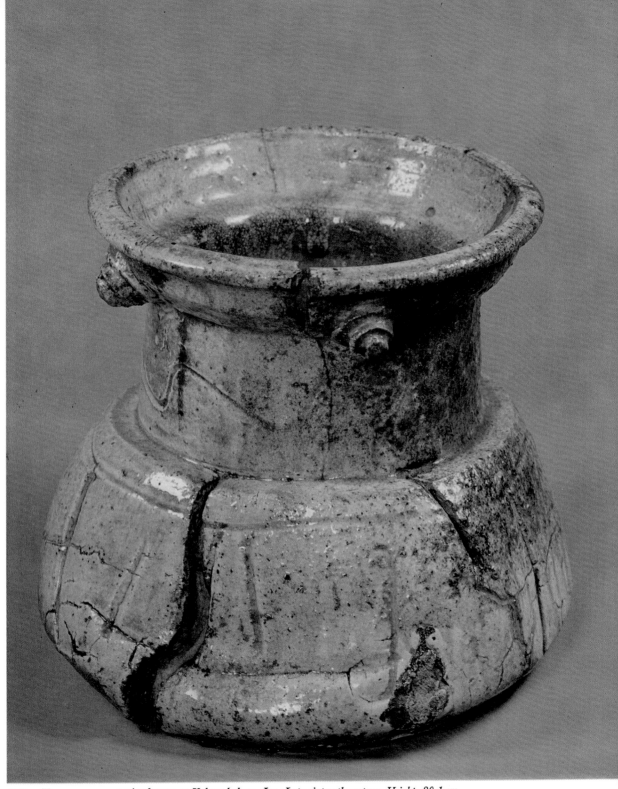

103. *Tea-ceremony water jar known as Yabure-bukuro. Iga. Late sixteenth century. Height, 20.1 cm.*

104. Jar. Old Karatsu. Late sixteenth to early seventeenth century. Height, 17.9 cm.

105. Dish with design of boats. Oribe. Late sixteenth to early seven- ▷
teenth century. Length, 18.6 cm.; width, 17 cm.; height, 7.2 cm.

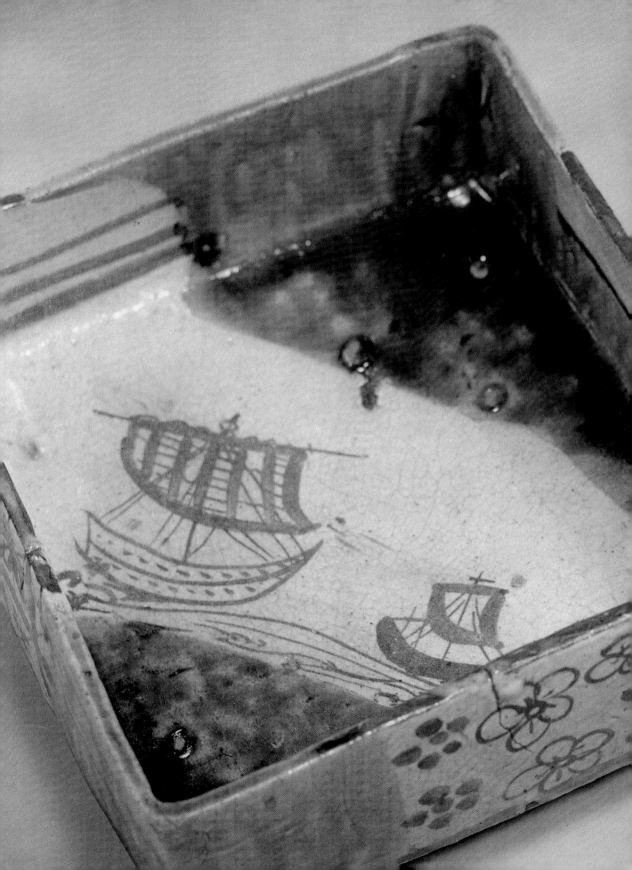

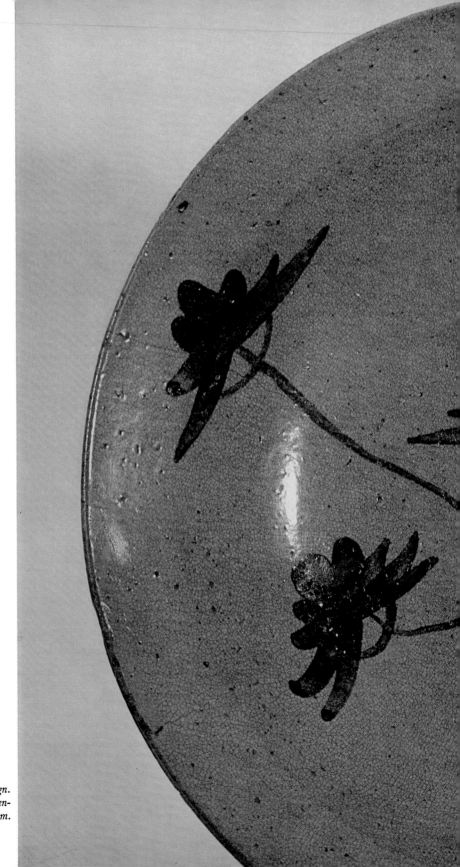

106. *Plate with pine-tree design. Old Karatsu. First half of seventeenth century. Diameter, 36.3 cm. Idemitsu Art Gallery, Tokyo.*

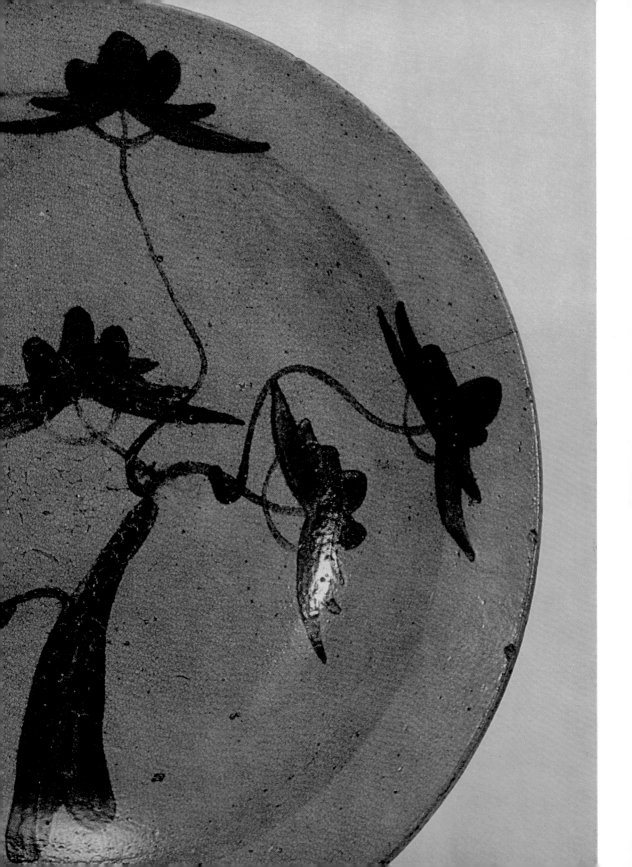

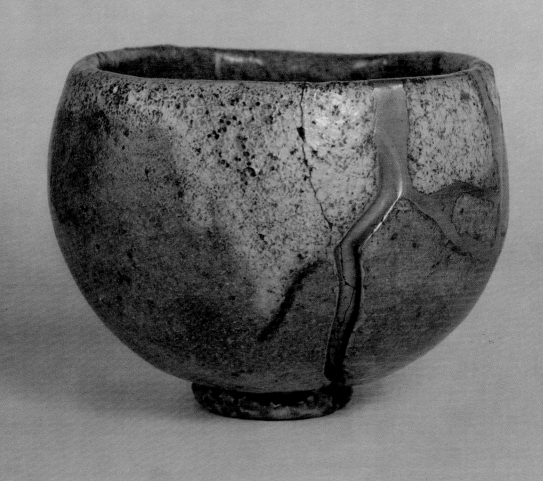

107. *Tea bowl known as Seppo, by Hon'ami Koetsu. First half of seventeenth century. Diameter, 11.6 cm.; height, 9.5 cm. Hatake-*
yama Museum, Tokyo.

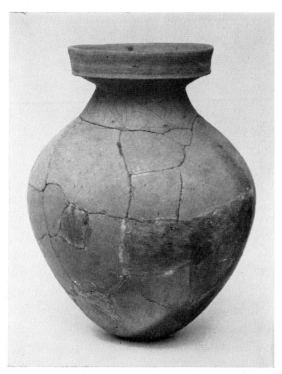

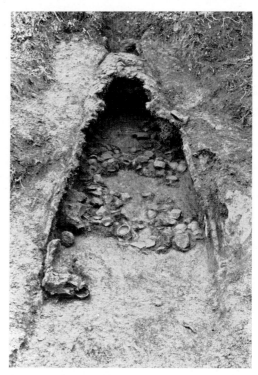

108. *Jar*. Hajiki. *Fourth century. Height, 39 cm. Excavated at Sakazu, Okayama Prefecture. Kurashiki Archaeological Museum, Kurashiki, Okayama Prefecture.*

109. Sueki *kiln site. Seventh century. Yashiro, Hyogo Prefecture.*

Hajiki techniques are simpler than those of the earlier, more complex Yayoi—the result, perhaps, of increases in demand for pottery during the Tumulus period that necessitated mass production. (This phenomenon of simplification accompanying mass production is seen again in the *yamajawan*, or "rough bowls"—also known as *gyoki* ware—in the latter part of the Heian period.)

Along with the increase in the production rate, actual production was no longer carried out by ordinary community members but by specialist craftsmen instead. Among the groups of potters, some of those in the Kinai area were known as *haji-be*, or potters' guilds, as shown in an entry in the *Nihon Shoki* (Chronicles of Japan), the oldest historical work in Japan, compiled in the eighth century. These craftsmen made the *haniwa* figures

(Fig. 32): hollow clay human and animal forms, naive and abstract in appearance, with cylindrical bodies and eyes cut into the clay. A great variety of these have been found.

At first, *hajiki* wares followed Yayoi forms, but by the end of the fifth century they were imitations of the *sueki* forms, as we shall shortly see. These conditions prevailed from the Tumulus period into the Nara and Heian periods. Over the centuries, however, forms changed, utensil types increased, and local variants appeared in all regions. Within each district, many different varieties of *hajiki* wares may be distinguished, and we should take some note of these. In the southern Kanto plain, there are four main subdivisions: the Izumi era (from the early fourth century to the beginning of the fifth, or the period of transition from Yayoi to *hajiki*), the

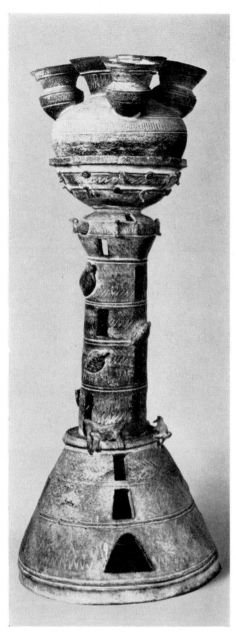

110. *Multiple-mouthed vessel with animal ornaments and stand. Sueki. Mid-fifth century. Total height, 70 cm. Excavated at Hanedo, Kanetake, Fukuoka Prefecture. Ise Shrine, Mie Prefecture.*

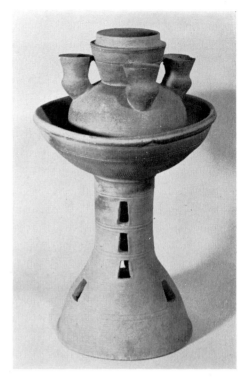

111. *Multiple-mouthed pot with stand.* Sueki. *Fifth to sixth century. Total height, 52 cm. Kashiwara Yamato Historical Museum, Nara Prefecture.*

Onidaka era (from the early fifth century, when *sueki* ware first appeared in the Kinai area, to the opening of the Asuka period), the Mama era (Asuka and early Nara), and the Kokubu era (Nara through early Heian). Recent opinion seems to favor the addition of a fifth era known as Goryo, prior to the Izumi era.

Since *hajiki* pottery was in everyday use by people of all social classes throughout the country, it has a comfortable air, born from warm sentiment. It is not pretentious in the least, and none of the wares, from tiny round pots to great wine vats, seem to be holding themselves at a distance (Figs. 58, 108). Rather, they appear so familiar and friendly as to seek out human company of their own accord.

This quality probably came from the conditions of their manufacture, simple and easygoing enough to be carried on by ordinary potters even without

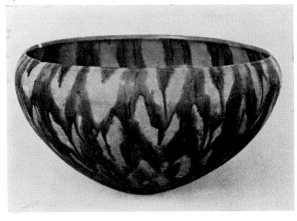

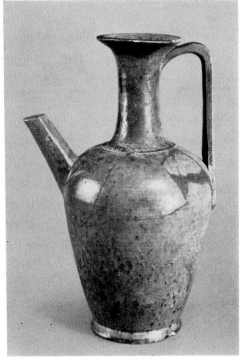

112. *Bowl. Nara* sansai. *Eighth century. Height, 15.8 cm. Shoso-in, Nara.*

113. *Ewer. Green-glazed ware. Tenth century. Height, 24.6 cm. Excavated at site of former Sanno-ji temple, Maebashi, Gumma Prefecture. Gumma Prefectural Museum.*

a special type of kiln. These wares possess yet another quality, however: a reflection of the stern, strict emotions of the people who made and used them. These emotions are here laid bare to our gaze, and whenever we come into contact with them, we too sense their inherent tension.

The solid, plebeian strength found in *hajiki* wares is another trait that may be seen in all the ceramics of Japan. After the Heian period, this characteristic is continued in the high-fired stonewares of the Kamakura period.

Sueki was a ware of an entirely new type, unlike any ceramics that had appeared previously in Japan. *Sueki* utensils are a calm mole-gray color (Figs. 59, 60). They were fired at such high temperatures that some objects even given off a clear, ringing sound when tapped. Low- and high-footed eating bowls, cups, jars, spouted wine pitchers,

brewing vats—all are more regular in shape, and for this reason they seem harder or perhaps more formal than Yayoi wares. They have about them a certain air of exoticism and superiority.

This new and different pottery was first made in Japan in the years around A.D. 400, following advanced techniques introduced by craftsmen from the Korean kingdoms of Silla and Paekche. The techniques ultimately stem from superior Chinese methods for making unglazed stonewares.

First and most important of these methods was the construction of kilns. These kilns were built either by digging a tunnel about ten meters (thirty-three feet) long into a hillside, parallel to the slope, or else by roofing over a ditch about one and a half meters (five feet) wide, similarly leading up a slope. In either case, the result was a semisubterranean kiln (Fig. 109). These sloping kilns could produce a

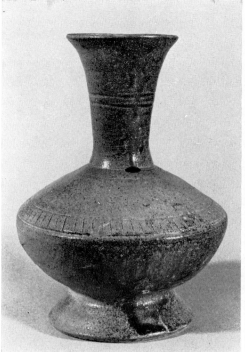

114. *Long-necked vessel with stand. Sueki. Eighth century. Height, 22.2 cm.*

115. Sueki *kiln site. Tenth to twelfth century. Kosobara Myojingadani kiln site number 1, Miyazaki, Fukui Prefecture.*

heat of over 1000°C., and it was possible to use them for the reduction process necessary to turn out dark-colored wares. *Sueki* is far harder than *hajiki*, and both its hardness and its extreme durability are the result of firing at high temperatures, sometimes in excess of 1200°C. The introduction of this process marked the beginning of an entirely new era.

The next major technical advance was the introduction of the potter's wheel. Both Yayoi wares and *hajiki* wares were shaped in round, flowing curves, but they were produced entirely by manual coil construction and not by the wheel. For this reason, the use of the wheel was a revolutionary innovation, permitting much more rapid production and incomparably better control over form, which resulted in the regular, precise outlines of *sueki* vessels. In the earlier period of *sueki* production it

seems that vessels were first built up by the old coiling methods and then were retouched or corrected on the wheel. Also, at times, these adjustments in shape were made not on the wheel but by pounding.

To this list of technical advances of the time, we should add the ability to select and use superior firing clays which would stand up under the high-firing process.

Kilns of the early *sueki* period are actually preserved at Otori in what was at that time the old province of Izumi (present-day Osaka Prefecture). As the site of the ruins of an entire potting complex, this area is quite well known. The tubs, jars, cups, bowls, cooking pots, lidded jars, and platters are all of new, unusual shapes (Figs. 11, 110), and they must have been a re-creation in Japanese terms of the contemporary pottery styles of Silla and Paekche.

116–17. Shards of sueki *with designs of wild boar pursuing man (116) and of flowering plants (117). Tenth century. Excavated in the Sanage area, Aichi Prefecture.*

In other words *sueki* had the appeal of the alien or the exotic, and it was probably a contemporary attempt at copying expensive imported foreign wares. It was doubtless valued for its novelty and its association with more advanced cultures, and it suited the tastes of the upper class, which sought just such qualities.

Another aspect of the *sueki* aesthetic was born inside the kiln itself, without any deliberate efforts on the part of the potter. When particles of fuel ash landed on the clay wares and fused under the high temperatures, colors would be added naturally to the surface of the vessel: lovely greens in the case of deoxidizing reduction or ambers and browns resulting from oxidation. These spontaneously produced glazes are truly a gift of nature, which added a further degree of beauty to *sueki* pottery. The necks and sides of some objects were decorated with geometric designs and chatter marks; these also add character to the vessels.

Since *sueki* was superbly functional and adapted well to quantity production, it came to be manufactured on a large scale in the Kinai district as the court of Yamato gradually extended its sphere of influence. By the end of the fifth century, small quantities were even being made in areas outside the Kinai district, and during the last half of the sixth century *sueki* was being produced at many sites in Kyushu, while its eastward expansion extended to a line drawn between modern Shizuoka and Ishikawa prefectures.

Despite the increased production of *sueki* pottery, the older, popularly used *hajiki* wares were still being turned out in all parts of the country. Even well into the Tumulus period, *sueki* was seldom if ever seen in some areas—for example, the Kanto

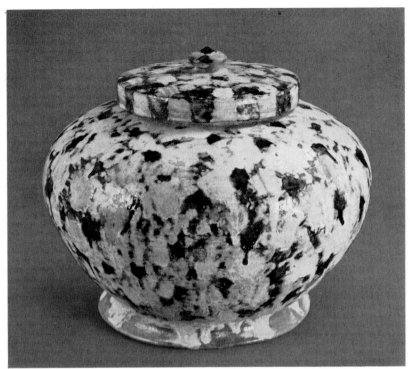

118. *Lidded jar. Nara sansai. Eighth century. Height, 22.8 cm. Excavated at Kitanaso, Koyaguchi, Wakayama Prefecture. Kyoto National Museum. (See also Figure 12.)*

district. In these regions, the popularity of *hajiki* continued unchanged. Even so, *sueki* exerted much influence on the world of *hajiki*. From the latter half of the fifth century—the Onidaka era of the Kanto district—*hajiki*-style copies of *sueki* forms assume a major degree of importance. We might say that in a certain sense such *hajiki* wares played the part of provincial substitutes for *sueki*.

With the passing of the Tumulus period and the advent of the Nara and Heian periods, *sueki* manufacture was carried on almost everywhere in Japan, apart from Aomori and Kagoshima, in the extreme north and extreme south, respectively. At present, several thousand *sueki* kiln sites are known to exist throughout the nation.

Sueki wares of the Tumulus period have been uncovered at contemporary dwelling sites, kiln sites, and from the tumuli themselves. There are many vessel types including vats, jars, low drinking bowls, footed drinking bowls, and dish stands.

All these objects have perfect bilateral symmetry and strict precision in addition to a grand monumentality. Such characteristics are an expression of an aesthetic sense born from within the new social structure of the times. The fact that this sense is given such open expression is mainly due to a mechanical cause—the potter's wheel. Besides this, however, much weight must be given to the desires of the new governing classes, who sought just such an authoritative aesthetic: an aesthetic of symmetry, logic, and a systematic spirit.

When we compare these qualities with the collective, or even subjective, warmth and softness still being preserved in *hajiki,* we are well able to understand the nature of *sueki*. Perhaps the task of softening the stern nature of *sueki* was left to the natural amber and green glazes which covered part of the surfaces, like the enveloping moss which softens the rugged outlines of a cliff.

As we have said elsewhere, the Tumulus period,

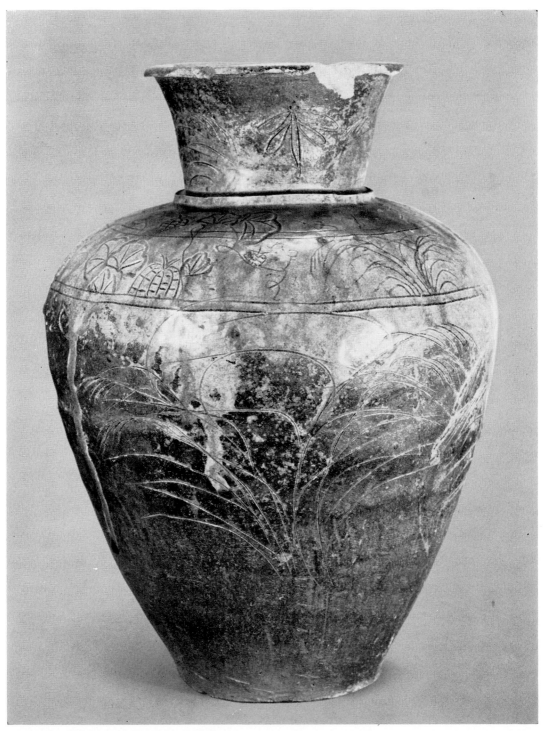

119.　*Jar with design of autumn plants.* **Sueki.** *Eleventh to twelfth century. Height, 40 cm. Department of Archaeological Research, Keio University, Tokyo.*

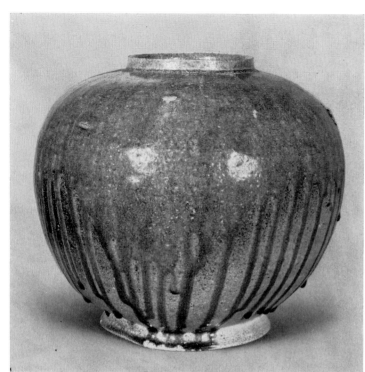

120. *Jar. Sueki. Ninth century. Height, 26 cm. Matsunaga Memorial Hall, Odawara, Kanagawa Prefecture.*

121 (opposite page, left). *Jar. Sueki. Eighth to ninth century. Height, 19.2 cm. Excavated at site of former Shimotsuke Kokubun-ji temple, Tochigi Prefecture.* ▷

122 (opposite page, right). *Jar with lotus-petal design. Atsumi kiln. Late twelfth to early thirteenth century. Height, 29 cm. Excavated from sutra mound at Gongenyama, Shingu. Wakayama Prefecture.* ▷

beginning in the fourth century, was ushered in, ceramically speaking, by the production of *hajiki* wares, which took over the position of Yayoi. They are earthenwares for a new age. By the time these in their turn had settled down to become a part of tradition and of the Japanese scene, the new, exotic, plastic sense of *sueki* ware was introduced. Even the makers of *hajiki* themselves drew inspiration from this fresh source.

Nevertheless, the currents of *hajiki* and *sueki* did not mingle into one stream. The former continued on its own solidly plebeian way, maintaining the traditional approach of the past. The latter took root among the governing classes and intellectuals as a representative of advanced, imported culture.

NARA SANSAI AND RELATED WARES The two currents, plebeian and aristocratic, running through Japanese culture made their first appearance during the

Tumulus period. By the arrival of the Nara period, they had merged into a dual mainstream, flowing forcefully along. One was the traditionalism of the existing native culture, while the other was based on new imports from outside. The first of these spread over the entire country to become the foundation for the common, basic national culture. The other was the intrinsically foreign impetus for the brilliant society of Nara, the capital, and its surrounding area. At Nara, as well as at the provincial centers of culture, these two currents blended quickly, adding new depths to Japanese culture. This tendency may be seen in the world of Japanese ceramics as well.

The main currents of ceramic culture in Japan during the Nara period were made up of the *sueki* and *hajiki* styles of the past. In addition to these, however, we find an entirely new, different kind of pottery, the beautiful three-colored, two-colored, and green-glazed wares known today as Nara

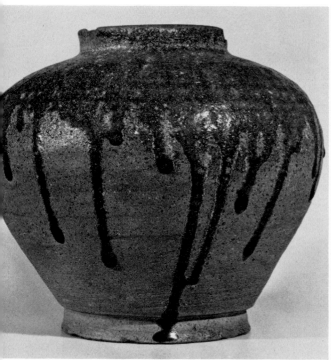
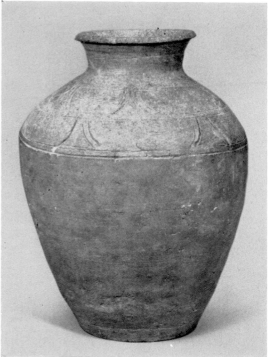

sansai (Nara three-color, or Nara polychrome).

Nara *sansai* (Figs. 13, 41, 112, 118) is a most appealing ware, made from high-grade, iron-free potting clays that were thoroughly refined and kneaded before being shaped on the potter's wheel into jars, bowls, and dishes. They are distinguished by soft, restrained curves.

The vessels were daubed with iron and copper glazes in a lead slip, covered with a transparent glaze, and kiln-fired at temperatures of around 800 or 900°C. (As yet, no Nara *sansai* kiln has been unearthed.) The result was a striking, exotic-looking ware with greens and golden browns dappling a white ground, well suited to the strong colors—reds, blues, yellows, greens—ornamenting the temples and palaces of the times. Nara *sansai* represented the rebirth of an aesthetic sense that came from distant shores. Still, it was not simply a copy of T'ang polychromes but a bright and graceful restatement of the Chinese color sense in purely Japanese terms. The craftsmen themselves were probably native to Japan.

The green-glazed wares, with their vivid pattern of green spots, are even more pleasant visually. In finishing these green wares, the potters seem to have made use of wax stencils in order to achieve better decorative effects (for example, the Shoso-in polychromes). They are the products of an entirely new aesthetic approach toward ceramics.

Nara *sansai* and green wares are the first deliberately glazed ceramics ever produced in Japan. Utensils included jars, bowls, drinking cups, and dishes. There are large vases with smaller ones attached to them, as well as covered medicine jars that, with their knob-handled lids, are among the richest and most graceful examples of this ware (Figs. 12, 41). In addition to these we find vases, tureens, incense burners, and even hourglass-shaped bodies for the hand drums used in Japanese court music.

These forms were all radically different from those current in other wares. Rather, they are similar to the characteristic ceramic forms in T'ang China, which boasted one of the most highly developed of civilizations. As a matter of fact, both the form and the chromatics of the Nara wares are based in great measure upon T'ang ceramic styles (compare Figs. 40 and 41).

In the spring of 1967, a wonderful discovery was made. The site of the ancient Daian-ji temple on the outskirts of Nara yielded thirty ceramic head-rests of T'ang polychrome ware, all damaged but all of beautiful workmanship. This tells us that the craftsmen of Nara Japan were indeed able to study actual examples of T'ang ceramics. Since, however, polychromes and green-glaze wares were being contemporaneously manufactured in the Manchurian kingdom of Po-hai and the Korean kingdoms of Koguryo, Paekche, and Silla, it may be that the actual techniques were introduced into Japan by craftsmen from one of these neighboring regions.

Some of the finest examples of Nara *sansai* and green glazes are preserved in the imperial Shoso-in repository at Nara. There are in all fifty-seven items, which can be divided as follows: five green-amber-white three-color polychromes; thirty-five green-and-white polychromes; thirteen green-glaze and three amber-glaze utensils; and one of a pure white glaze.

Many more such vessels are being found in the course of excavations at the old Heijo Palace, site of the ancient court of Nara. Most of these seem to have seen practical use; there are polychrome tureens and rice pots with bottoms scorched black by cooking fires. This is one point in which the Nara wares differ from their purely ornamental Chinese counterparts.

Three-color polychromes have been unearthed at many sites from the Kinai district through the western Chubu district, including temples (for example, the Kofuku-ji and the Ichijo-in of Nara), seats of local government (for example, Ohishima in Okayama), or burial mounds (for example, the funerary urns of Koyaguchi in Wakayama Prefecture and the tomb of Oharuda no Yasumaro in Nara Prefecture).

The presence of fragments in the tomb of the courtier Owarida no Yasumaro, who died in 729, tells us that these wares were certainly being made in the early eighth century. They were apparently the products of official kilns, and they provide us with one of the few examples of such government-sponsored factories to be found in the entire ceramic history of Japan.

Green-glaze ware was produced for a much longer time than three-color polychrome ware was, for it was still being made in the Heian period. Use of this ware extended throughout the country, and relics have been found over an area ranging from Akita (the Hottanosaku fort site in Semboku County) and Iwate (the Akikozawa site at Futago-machi, Kitagami) prefectures in the north to Kagoshima Prefecture in the south (the Kofuku site). Even in these provincial areas, the utensils used were often of superior quality, as may be seen from such examples as the group of ewers (Fig. 113), bowls and dishes excavated from one temple ruin at Maebashi in Gumma Prefecture.

Considering that these and other excavations are all sites of ancient temples or provincial administrative centers, we may deduce that the Heian green-glaze wares were products of kilns with some official connection, just as the polychromes of the Nara period had been. As far as we know, kiln sites seem to be limited to Nara, Osaka, Kyoto, Shiga, Gifu, and Aichi prefectures. According to the researches of Professor Shoichi Narazaki as recorded in his *Saiyu Toki Shutsudochi Meihyo* (A Catalogue of Polychrome Ware Sites), seventeen kiln sites had been discovered by 1966. Some of the green-glaze wares manufactured at these sites were shipped to temples, while others were supplied to the court and the aristocracy.

During the Heian period, in addition to the quality white-bodied wares that had been current in the Kinai district ever since Nara times, there appeared vessels of a dark-gray *sueki*-style ground. This may be due perhaps to the influence of *sueki* upon wares produced by official kilns during the Heian period and to the restoration of *sueki* to official status. At this point, let us return to a consideration of Heian *sueki* wares.

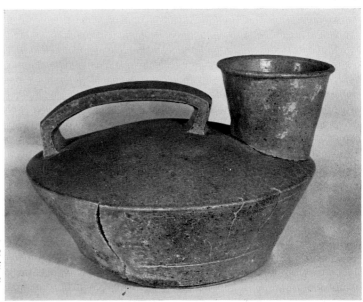

123. *Pitcher.* Sueki *(Heian* shiki*). Mid-tenth century. Height, 13.9 cm. Excavated at Kurozasa kiln site number 14, Morowa, Aichi Prefecture. Department of Humanities, Nagoya University.*

THE HEIAN PERIOD: SUEKI AND YAMA-JAWAN

In the Tumulus period, *sueki* ware had been made to satisfy the desires of the ruling class in the central area for the exotic and the unusual and as a response to their search for beauty. Afterward it became popular among the clergy and the aristocracy of the provinces, and the area of its manufacture gradually spread. By Nara times *sueki* was being produced almost everywhere. And at the end of the Nara period, the potter's wheel came into common use, greatly increasing the rate of production.

This was the state of things as the Heian period opened. By the latter half of the ninth century, however, there was a great change in the pattern of production. In the Kinai district, which formerly led the industry, *sueki* production came to an end, and the center of manufacture shifted to eastern Owari and western Mikawa provinces in the Chubu district to the northeast. From the mid-Heian period on, the principal kiln sites were near the Sanage mountain area east of modern Nagoya.

As the late Nara period (end of the eighth cen-

tury) verged on the Heian period, the number of *sueki* kilns in the Sanage area increased by leaps and bounds, and the smoke billowing from them became an index to their new prosperity and large-scale production. The products of these kilns included jars, tubs, water droppers, bowls, and the like (Figs. 120, 121). Flat-bottomed vessels are the most common, being best suited for general everyday use. Since the potter's wheel was now commonly used, the undersurfaces often show the neat marks left by the cord that was used to cut the finished vessels from the wheel. Some of the vessels are decorated with graceful designs of wildflowers and autumn grasses in deep line engraving (Figs. 45, 60, 116, 117, 119). They recall to us the visual poetry and elegance of the Yamato-e painting style (the native Japanese style as contrasted with styles borrowed from China). In form, there is a strong degree of standardization, possibly due to the atmosphere of official kilns during the so-called period of the *ritsuryo*, when the government was still feeling the influence of borrowed Chinese legal codes. This period also saw the first appearance of bowls and vases with high stands, which were

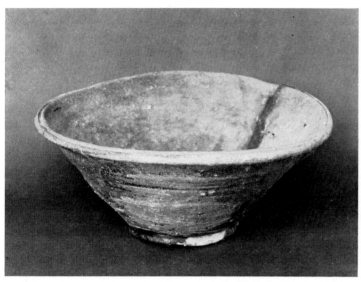

124. Bowl. Late twelfth to early thirteenth century. Diameter, 30.5 cm. Excavated at Nagane kiln site, Seto City, along with yama-jawan.

copies of bronze articles and meant for use in Buddhist temples (Fig. 114).

We can observe, during this age, the way in which *sueki* wares entered the daily lives of the aristocracy, not as ceremonial vessels but as objects for everyday use. At the same time, a new technique appeared: the art of applied ash glazing, which ornamented the vessels with ambers and greens. Figures 120 and 121 show examples of such artificially glazed *sueki* objects. With their bright-green drip-glaze decorations, they are quite handsome.

At some time in the middle of the tenth century, a new technique was added to the process of firing *sueki* ware. Firing could now be carried on with oxidizing flames, so that potters no longer had to rely exclusively on the old reduction process. The age of iron-gray pottery ended and bright, off-white wares of fine texture were produced.

These utensils were often glazed in lovely transparent pale greens, while the soft and flowing vessel forms have an air of great elegance. At last, *sueki* had abandoned its exoticism, becoming thoroughly naturalized in Japan. This new ware is known as Heian *shiki,* and it typifies the refined aesthetic tastes of the aristocracy at the height of the Heian period.

After Heian *shiki* ware was invented, it was put to a variety of uses. All sorts of everyday containers were made, and the scope of products ranged from inkstones to miniature stupas. There were also some handsome low pouring vessels of solid, even form with handles attached (Fig. 123).

Articles produced at the Sanage kilns were shipped not only to the main consumer centers in Kyoto and the Kinai district but also to areas as remote as the Kanto district and the western end of Honshu. Evidence for this far-flung distribution is provided by the *shiki* articles of Owari origin that were unearthed at Fukuyama in Hiroshima Prefecture.

In the twelfth century, toward the close of the Heian period, manufacture of these officially sanctioned Heian *shiki* wares at last showed signs of waning. This may have been a sign of the flagging strength of the Kyoto aristocracy, who had prized the elegant refinement of these wares and fostered their production.

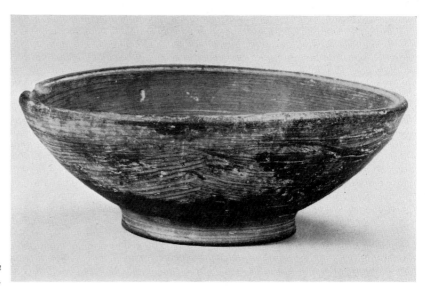

125. *Bowl. Black* hajiki. *Ninth
to tenth century. Diameter, 15.6 cm.*

The next noteworthy social change to occur throughout Japan was the rise of powerful provincial landholders, especially of the military class. This newly risen element of society favored pottery wares derived from the techniques of *sueki* but serving a more practical purpose: a tendency that well suited the abilities of potters who had been thrown upon their own devices and thus forced to struggle for an independent living after the weakening of court patronage. Now they were able to turn to the manufacture of pottery for the people at large.

The main genre they created was the so-called *yama-jawan* (rough tea bowl). This is a rough sort of *sueki* which sometimes goes by the name of *gyoki* ware. It was designed for large-scale mass production, using heavy, pebbly potting clays. The wheel was turned at great speed, in order to save the time and trouble required in turning a proper foot. Feet were often attached to bowls by hand after they were removed from the wheel. At first glance, these rough wares seem crude and unfinished. Nonetheless, they are an expression of popular sentiments, and there is something in their bold,

untrammeled form that has ample power to command admiration (Fig. 124).

Long before, at the dawn of its existence, *sueki* had been made in answer to the demand of the central ruling class for beautiful wares of the type created in advanced foreign countries. Now, eight centuries later, *sueki* at last found its way into the culture of the common people. In the following Kamakura period it was to form a strong foundation for the superb high-fired stonewares that characterize that age.

During the Nara and Heian periods, the flamboyant polychromes and *shiki* wares held the spotlight, but there was yet another ware upon the stage, hidden in their shadows. This was the old familiar *hajiki*, which, with its roots sent deep among the people at large, still was the strongest, most pervasive, and most vital element in the ceramic culture of Japan.

Ordinary folk depended almost entirely upon *hajiki* for bowls, dishes, cups, goblets, and other tablewares, as well as for storage vessels and cooking pots such as jars, vats, and bowls. Nor did they forget to add beauty to these utensils through orna-

ment. For this, they employed brush-stroke patterns and scraping.

In the ninth century the increasing demand for *hajiki* was accompanied by a tendency toward simplification and uniformity. At the same time, the Kinai district saw the appearance of black *hajiki* (Fig. 125) and the unglazed earthenware called *gaki* (also known as *kawarake,* or "tile ware"). The interior surfaces of black *hajiki* were smoked to a glossy black to cut down on absorbency and were then polished with a spatula. This technique introduced a new color sense into these wares, which had hitherto been of uniform russet hues.

Gaki attained perfection around the close of the tenth century. *Gaki* articles include footed bowls, plates, tubs, and the like, which were smoke-blackened inside and out before receiving a high polish. These utensils seem to have been mass-produced in kilns, for they show a certain standardization in form. At the end of the Heian period they exhibit the same tendencies toward popularization that distinguished the *yama-jawan.* Together with *sueki* and *hajiki* they show how extensively and rapidly the products of the steadily developing ceramic industry were infiltrating the everyday life of the country.

CHAPTER SIX

The Six Ancient Kilns

THE APPEARANCE OF GLAZED CERAMICS IN JAPAN The Kamakura period, which began in the late twelfth century, brought about great modifications in the political and social structure of Japan. The ancient political structure, centering around the court aristocracy, was broken up during the thirteenth century. A different social and political order came into existence, based upon the newly risen military class. This in turn brought about the growth of a new culture. While this new culture was firmly based on the heritage of the past, it nonetheless rose beyond the formalism of the previous age, seeking to produce works of strength and vitality. These are without doubt its outstanding characteristics.

The vigorous energy of society at large was reflected in the world of ceramics, and this art developed rapidly indeed during the period. The appearance of genuine glazed ceramics, which occurred in the vicinity of Owari, is one of the outstanding aspects of this development. The other was the production of high-fired stonewares.

Certain types of ceramic objects have been invariably unearthed in the course of archaeological investigations of sites related to the Kamakura period (1185–1336), particularly at tombs and kiln sites. These include wide-mouthed jugs with round, swelling bodies and broad-shouldered jars shaped like modern-day sakè decanters, with tiny pouring mouths and round, bulbous bodies

from which rise long necks flaring at the top.

These utensils are generally covered with a thick glaze of bright yellowish green, golden brown, or blackish brown that settled heavily and unevenly down the sides of the vessels, creating a variety of shadings, thicknesses, and patterns. The glazes are warm and almost fleshlike in texture. There are also patterns beneath the glazes: vigorous, freely flowing plant and arabesque motifs that have been sharply and incisively drawn with a graver, small designs applied with simple stamping devices, and even some ornaments in clay appliqué (Figs. 13, 38, 127, 129).

When we examine such works, we can imagine the unpretentious individuality of the actual potters who gave to them the qualities of warmth, grace, and harmony that still strike a responsive chord in our hearts today. These glazed ceramics, with their air of human intimacy and strength, are known as Old Seto ware. They are true ceramics, made in the area around Seto in Owari Province from the late Kamakura period (late thirteenth century) on.

Old Seto ware was made from the fine-quality clay of high fire resistance and great plasticity that was found in quantity in the neighborhood of Seto. Construction techniques included both the potter's wheel and the coil method. Large vats and containers were built up from coils, while smaller objects were usually thrown upon the wheel. The glazes were made principally from wood ash. Since

the iron content was high, firing in a reduction kiln produced glazes of an amber or brown color, while oxidizing flames produced green glazes. The kilns, following the older traditions, were basically semisubterranean *sueki* kilns that had been modernized, but there were separation pillars set up between the combustion chamber and the kiln chamber proper, with arrangements to allow the best possible use of the areas around the fire.

Among vessel types, four-eared jugs (Fig. 128), wide-mouthed jars (Figs. 13, 50, 129), wine jars (Figs. 38, 127), spouted pouring vessels, grating bowls, and plain tea bowls were quite common, while flower vases for use on Buddhist altars (Fig. 126) and deep platters were also found. Most of these were of shapes radically different from those characteristic of Heian-period *sueki* utensils, and this bears witness to the new nature of Old Seto. In form, some Old Seto vessels, such as the eared jars and wine vessels, bear a close resemblance to ceramics of Southern Sung. Thus we may assume that there is indeed a close connection between the two.

According to Professor Mikiya Akatsuka, in his book *Ko Seto* (Old Seto), this type of Old Seto first appeared at kilns in what is today the central part of Seto (the Upper Tonogawa and Kitabora kilns), with manufacture gradually spreading over a wider area. Large-scale factories such as the Tsubaki kiln date from the end of the Kamakura period.

Old Seto marks the appearance of an entirely new ceramic type, one hitherto unrepresented in Japanese ceramics. One attempt at explaining the origins of this new ware has taken shape in the so-called Toshiro theory.

The Zen master Dogen (1200–1253) went to China in search of further religious teaching in 1223. On this trip, Dogen is said to have been accompanied by a follower named Kato Shirozaemon Kagemasa (also known as Toshiro), who studied ceramic techniques during his six-year stay in China. After returning to Japan, he built kilns in several places, but in 1242 he settled in Ubaga-futokoro near Seto, opened the Seto kiln, and succeeded in producing glazed ceramics. He has been

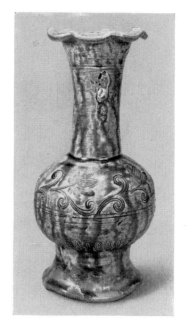

126. *Rinceau-pattern flower vase for use on Buddhist altar. Old Seto. Late thirteenth century. Height, 26 cm.*

revered as the founder of the ceramic industry at Seto ever since.

Considerable doubt exists as to whether or not this tradition has any historical basis. Nonetheless, it is clear that old Seto is a product of the introduction of continental styles and techniques. For proof, one need look no further than the obvious technical resemblance between Old Seto on the one hand and wares of the Southern Sung and Koryo-dynasty Korea on the other.

At the time, private Japanese trade with Sung China and Koryo Korea was flourishing. There was a considerable amount of coming and going between Japan and the continent, and vast quantities of white porcelain, celadon, and *ying-ch'ing* ware were imported, to become the prized possessions of aristocrats and religious institutions. For this reason, the idea that individual craftsmen might have gone to China for study at the behest of some Zen temple or other religious institution is not really so unreasonable as it might seem, nor unnatural in the least. In Korea, for that matter,

there were concentrations of Koryo celadon kilns in Cholla Namdo Province, just across the Tsushima Strait and practically within sight of Japanese territory.

I myself feel certain that the legend of Kato Shirozaemon contains a certain measure of truth insofar as it reflects the transmission of continental techniques into the Seto area from abroad (compare Fig. 38 with Figs. 36 and 39). In any case, the leading Seto potters, with hopes of making a new type of pottery, had set their sights on producing glazed wares similar to the celadons that had already swept all before them in Sung China. Unfortunately, the kiln construction of contemporary Japan was not sufficiently advanced to allow realization of their goals. With nothing better than refurbished *sueki* kilns, it was impossible to achieve complete reduction or really high-temperature combustion, and they were unable to advance beyond the amber or green glazes found in Old Seto.

While the introduction of foreign glazing techniques did help to bring about the production of this new and revolutionary ceramic ware in the relatively remote Seto area, there were, of course, other reasons for it as well. Seto was, and is, blessed with an unusual supply of superior clays. It had a long tradition of pottery manufacture extending back through Heian and Nara times. Further, from the late Heian period on, it had been recognized as the leading ceramic area of Japan. On top of all this, we cannot ignore the fact that from that time until the early Kamakura period Seto potters had already been aware of certain primitive ash-glazing methods. For all these reasons, the new art was first able to flower in Seto, and only in Seto.

The newly risen military class and the clergy set up such a great demand for Old Seto that manufacture soon spread to the eastern part of nearby Mino. The products were shipped far afield, to the Kanto district and to the western end of Honshu, as ceramics excavated from widely separated archaeological sites at Kamakura in the eastern Kanto district and at Fukuyama, Hiroshima Prefecture, tell us. From the early Muromachi period (late fourteenth century), oil-spot *temmoku* glazes in black and amber appeared in Seto *temmoku* (Fig. 43). This ware copied the imported Chinese *temmoku* wares (Fig. 42) that were popular with the upper classes and the powerful Zen prelates of the day.

In the Muromachi period, kiln construction improved, as shown by surviving examples such as the Konagaso kiln (Fig. 133), and it became possible to produce blue-green glazes. But the accompanying attempts at increasing production proved unfortunate, for the dynamism of the original Old Seto gradually slackened.

Old Seto and Seto *temmoku*—in the making of these the potters of late Kamakura Japan again borrowed the superior ceramic techniques of more advanced nations and used them to create new masterpieces. They became a kind of substitute for the Chinese ceramics sought by the ruling classes of the times, who yearned toward the advanced culture of the continent.

Nevertheless, the creative spirit of these craftsmen was in essence different from that of the florid culture so much favored by the upper classes. Rather, it was a rural spirit, representing a return to nature, that combined with the difference in kiln construction to infuse the uncomplicated Seto wares with linear vitality and warmth of color. This strong imprint of a feeling for nature gave to these wares a distinctly Japanese charm, quite alien to the original Chinese oil-spot glazes and celadons.

At the same time, however, it must be admitted that the Old Seto and Seto *temmoku* wares belonged to a strictly limited world—that of the *nouveau riche* governing classes and their associates in the clergy. Nor did their manufacture spread outside of Mino and Seto. In contrast with these wares were the even more rustic, more natural, and more truly universal ceramics that also appeared at this time in the form of high-fired stonewares.

HIGH-FIRED STONEWARES

The name Six Ancient Kilns is familiar to tea ceremony initiates and to all knowledgeable admirers of ceramics in Japan. It is a general name for those six kilns that have been major sites of

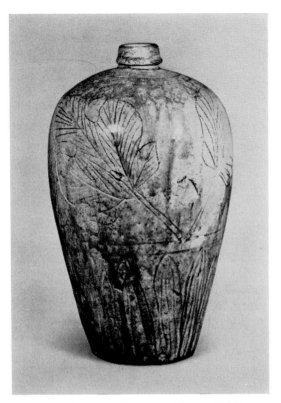

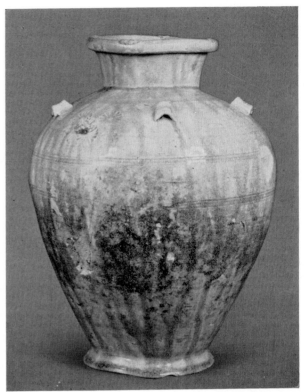

127. *Sakè decanter with pattern of leaves. Old Seto. Late thirteenth to early fourteenth century. Height, 26.3 cm.*

128. *Four-eared jar with stamped floral pattern. Old Seto. Late thirteenth to fourteenth century. Height, 33.8 cm. Excavated at Nikaido, Kamakura, Kanagawa Prefecture.*

ceramic production since the Kamakura period. They are Seto, Tokoname, Echizen (Oda), Shigaraki, Tamba (Tachikui), and Bizen (Imbe).

From late Heian times into the early Kamakura period, most of the kiln sites that had been opened prior to the Heian period ceased to operate, and ceramic production was concentrated within these six areas, although there were, of course, a few lesser sites such as Shidoro in Totomi Province and Kameyama in Bitchu. Also, with the single exception of Seto, the products of all these kilns were high-fired, unglazed stonewares.

The new departures within ceramic culture that occurred at this time were not limited only to the development of true glazed ceramics at Seto. An improvement in quality was made in the time-honored techniques of *sueki*, which had been produced throughout the nation according to long-standing tradition, and the result was another new ceramic style—high-fired nonporous stonewares. After their advent, these wares remained in production for an extremely long time, becoming one of the representative categories of ceramics in Japan.

Up to the mid-Heian period, both *sueki* and *hajiki* wares, including *gaki*, had been manufactured independently of one another everywhere throughout the nation, but after that time the kiln sites gradually tended to be concentrated within certain areas. Also, the two different techniques showed an increasing tendency to blend into one. The eastern areas of Owari and Mino and the western province

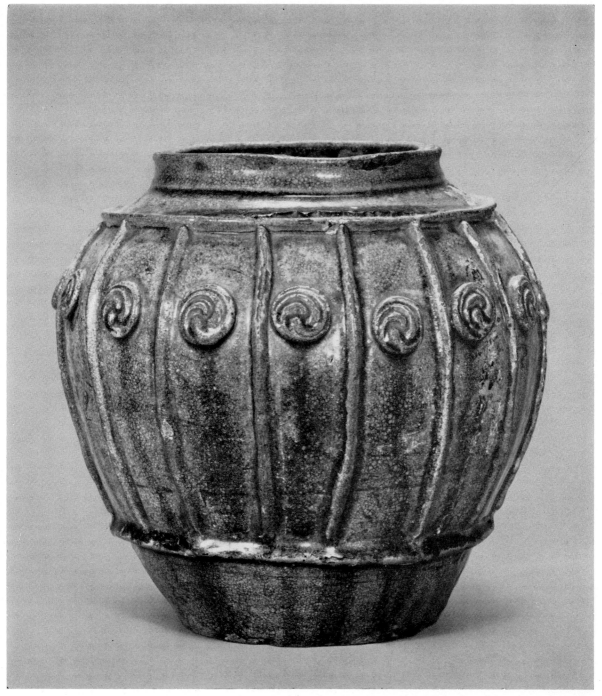

129. *Wide-mouthed jar with applied* tomoe *(comma-shape) pattern. Old Seto. Late thirteenth century. Height, 22.1* cm. *Umezawa Memorial Hall, Tokyo.*

130. Yama-jawan *kiln site. Late twelfth to early thirteenth century. Osawa-shita, Tawara, Atsumi County, Aichi Prefecture.*

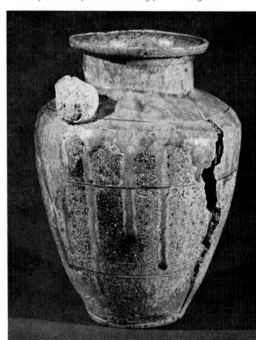

131. *Tokoname kiln site. Thirteenth century. Tokoname, Aichi Prefecture.*

132. *Jar with horizontal stripes. Tokoname. Late twelfth to early fifteenth century. Height, 25.3 cm. Tokoname Ceramic Research Center, Aichi Prefecture.*

Cross Section

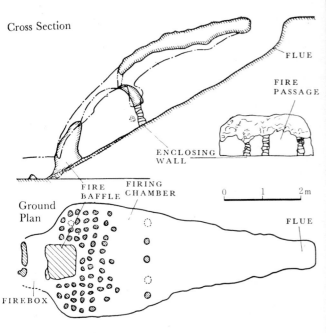

FLUE

FIRE
PASSAGE

ENCLOSING
WALL

FIRE FIRING
BAFFLE CHAMBER

Ground
Plan

0 1 2m

FLUE

FIREBOX

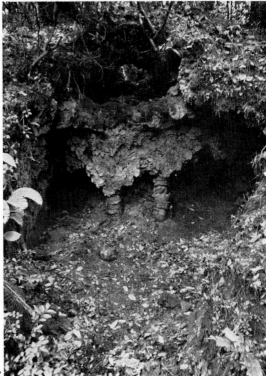

133. Old Seto kiln site. Fourteenth to fifteenth century. Akazu,
Konagaso, Seto City, Aichi Prefecture.

of Bizen arose as the major national kiln sites, supplemented by other important ceramic-producing areas in Mino, Totomi, Echizen, Omi, and Tamba. This development probably has some relationship to the rise of the agricultural areas (typified by the military landholding class), which brought new progress in the provinces and enlivened traffic in commercial goods. With a plentiful supply of fine clay, a long tradition of craftsmanship, and improved trade routes, conditions were ripe for progress in commercial ceramics.

In ceramics made as articles of commerce, the types are determined by quality and consumer demand. Since the people of this period seem to have had a special need for huge water jugs, crocks, and storage jars, as well as drinking vessels, grating mortars, cooking pots, and other kitchen utensils, the potters in all kiln areas began producing immense water jars, vats, and bowls. If such outsized

vessels were to last for any length of time, they had to be very strong indeed. With this in mind, the craftsmen took great pains, using clay of special strength and purity, refining the coiling technique, and lengthening the firing time at high temperature —thanks to which they succeeded in making very durable articles. The forms they created are the very embodiment of the spirit of rural life: simple and unpretentious, yet strong.

The birthplace of this new ceramic trend was in the kilns of the Atsumi Peninsula in Mikawa Province and the Chita Peninsula in Owari Province, the latter of which inherited the craft traditions of eastern Owari Province. The Atsumi and Chita kilns included those like Oarako, which is famous for the giant water jar (Fig. 139) bearing a datable and hence significant inscription relating to Fujiwara Akinaga, Lord of Mikawa (?–1167). Classically restrained jars with floral patterns (Fig.

134. *Jar with lattice-pattern band. Shigaraki. Thirteenth to fourteenth century. Height, 35.2 cm.*

135 (opposite page, left). *Jar. Bizen. Mid-twelfth* ▷ *century. Height, 37 cm. Excavated from Hananose sutra mound, Mount Kurama, Kyoto.*

136 (opposite page, right). *Jar. Tamba. Dated 1344.* ▷ *Height, 51.3 cm. Formerly owned by Kyo-o-gokoku-ji (To-ji), Kyoto.*

122) are also characteristic of the Atsumi kilns.

During the Kamakura period, technical improvements brought about the birth of unusually hard stonewares in the area centering around the Chita Peninsula. These were called Tokoname ware, after the region that contained both the major kilns and the port from which their product was shipped (Figs. 14, 47, 48, 132, 140). The primeval ceramic industry that had flourished in the ancient Sanage kilns was to become the forerunner of glazed Old Seto ware in the north, while its southern extension produced the high-fired unglazed stonewares of Tokoname. It is indeed interesting that these two major styles of medieval Japanese pottery should have sprung originally from the same source.

The articles most typical of Kamakura-period Tokoname wares are the large water-storage jars.

These were made of iron-bearing clay high-fired in oxidizing flames. With their dark colors and dynamic shapes, they seem to have the strength and resilience of steel. The green glazes on their upper portions are handsome, and they are entirely due to natural causes. The beating techniques used after the coiling was done have given fine spring and tautness to the vessel bodies and a double-fold finish to neck openings. Here there is no such artificial decoration as deliberately applied glazes. The aesthetic fate of these vessels is left to the clay itself. The people of the times were attempting to build a new age and a new order, and their spirit dwells in these masterpieces from the hands of nameless artisans.

Such improvements in technique and alterations in form are not limited to Tokoname. From the late Heian period into the Kamakura period,

similar high-fired stonewares arose out of similar conditions at Bizen, where the industry centered around Imbe, as well as at Echizen (Oda in Niu County), Omi (Shigaraki), Iga (Marubashira), and Tamba (Tachikui). Since the clay at each of these sites was high in iron content and since construction techniques, forms, and even kiln designs were identical, it is at times impossible to distinguish the wares by location. All transmit a sense of strength and long tradition. Nonetheless, there are certain characteristics that can be used for identification of these basically similar wares.

Generally speaking, the clays used in the Imbe stonewares were highly viscous, and the lip sections of vessels were rolled back in a curve from the opening: the so-called *tama-buchi*, or round rim (Fig. 16). In articles of the Kamakura period, mouths are unusually small in proportion to the size of the vessel. Also, the raw wares were wrapped in straw rope and stacked before being baked, both of these methods producing accidental variations in color and shape that added ornamental interest. Straw rope was actually utilized in making the characteristic Bizen *hi-dasuki*, or "fire stripe," decoration (Figs. 100, 170) and natural sunburst designs called *bota-mochi*. From late Muromachi on, however, subterranean field clays came into use, and Bizen ware, while preserving these individual characteristics, gradually tended toward urbane refinement.

The unglazed stonewares of Tachikui in Tamba Province, near Kyoto, are in general very similar to those of Bizen, but they are more imposing in form, and the clays are smoother. This could perhaps be attributed to the strong influence of court culture (Figs. 62, 101, 136).

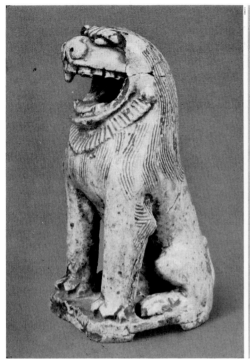

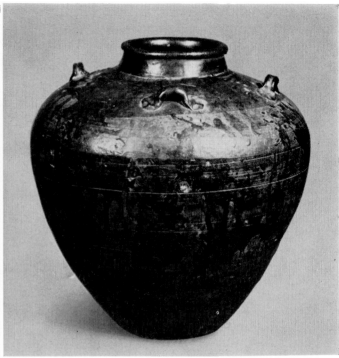

137. Lion-dog. Old Seto. Late thirteenth to fourteenth century. Height, 16.7 cm. Nezu Art Museum, Tokyo.

138. Four-eared tea jar. Old Seto. Dated 1512. Height, 32.1 cm. Tokyo National Museum.

In contrast, although the kilns of Shigaraki in Omi Province were nearly as close to Kyoto as those of Tamba, their products are purely children of nature, rough and unsophisticated. Seed-storage crocks, water vats, and grating mortars are the most common vessel types. By comparison with the other stoneware lineages, Shigaraki clays are somewhat lower in fire resistance, with a high sand and gravel content. The incised *higaki*, or lattice, pattern running in single stripes around the vessels at the shoulder is characteristic of this ware. The rough, frank quality of Shigaraki gives it a feeling of approachability and a strong kinship with ordinary humanity (Figs. 52, 98, 134).

South of Shigaraki, across a single range of hills, lie the Iga Marubashira kilns, the products of which were, understandably, very similar to Shigaraki ware. After the Momoyama period, however, when the manufacture of tea utensils began in earnest, the Iga potters used a viscous, white-body clay that makes it easier to distinguish the two wares (Fig. 103).

The Echizen kilns are thought to have been founded by craftsmen who had moved from Owari. Echizen wares are beautiful, with a natural ash glaze in green tones dripping richly over a warm dark-brown ground (Figs. 51, 99). In general feeling they are quite close to the wares of Tokoname, but through careful comparison of form and ground, distinctions may be made. Similar unglazed stonewares were also made at Shidoro in Totomi Province and at a few other sites.

The above-noted stonewares, which date originally from the Kamakura period, remained in production, principally at the Six Ancient Kilns sites, throughout the Muromachi period. They consisted

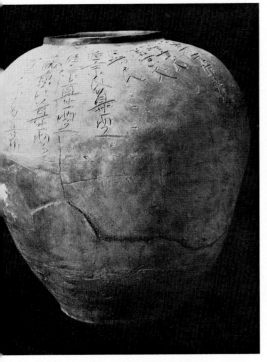

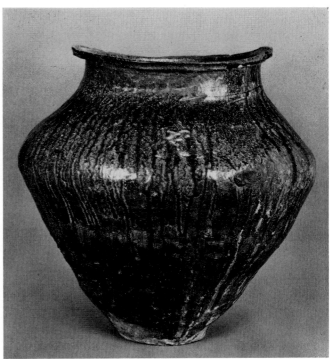

139. Vat inscribed with name of Fujiwara Akinaga. Oarako. Mid-twelfth century. Height, 49 cm.

140. Jar. Tokoname. Thirteenth century. Height, 50 cm. Excavated at Nishi Shiinokiyama, Itayama, Handa, Aichi Prefecture.

mostly of seed-storage tubs, water jars, grating bowls, and other practical everyday objects that fulfilled the immediate needs of the people at large, particularly the farming population. For this reason, they soon came to occupy the leading position in the ceramic culture of Japan. The air of wholeness and solid strength that characterizes these vessels may be said to spring from the same source.

After the opening of the Muromachi period, forms became more finished and colors brighter. On the other hand, the outlines and plasticity became dully "safe" and unimaginative, and one can sense a gradual loss of vitality. This tendency became stronger with each new stage through early and middle Muromachi.

Good evidence of this change is provided in the mouth, lip, and neck sections of vessels. Kamakura-period vessels generally have straight "double lip" edges that open directly and have a decisive air. In Muromachi times, however, the lips curl outward in the so-called "round line," or roll silhouette, and utensils with distinct neck sections become more frequent. Toward the end of the Muromachi period, neck edges droop in a downward curve, and the taut outline of vessel bodies begins to slacken.

CHAPTER SEVEN

The Flowering of Ceramic Art

MINO CERAMICS The hundred years from the latter half of the sixteenth century through the first half of the seventeenth saw sweeping changes in the overall ceramic landscape in Japan. In one corner of the quiet, uncultivated meadows of ceramic simplicity, which had for so long held the hearts of the Japanese people, a brilliant garden of flowers suddenly began to flourish. These consisted of new and strange ceramic forms with colors running riot. Some blossoms of this meadow were large, florid exotics, while others were quiet, elegant, and domesticated. Still others captured the clean brightness of wildflowers in autumn. And all were full of vibrant life, with great power to sway the emotions of the beholder.

This delightful garden went on increasing in vigor and brilliance as the forms and varieties of its blossoming plants went through numerous changes and mutations. This was truly the greatest era of renewal and development in the history of Japanese ceramics.

The most radiant of these developments were to be found in the Mino-Seto sphere, in the east. There, Shino, Yellow Seto (Ki Seto), Oribe, and Black Seto (Seto-guro) all flourished. The central part of Japan saw the development of Raku ware and the lovely Kyoto wares known as Kyo-yaki. And in the west, Old Karatsu (Ko Karatsu), Agano, Satsuma, Hagi, and other handsome wares blossomed.

To continue our gardening metaphor, we may say that these flower beds were fertilized anew by techniques brought from abroad, which enriched the soil of the firmly based medieval pottery tradition. This was accomplished under the sunshine of early modern advances in ceramic production methods. The roots of primeval stocks grew rapidly under these conditions. Strengthened afresh, they sent up flowers of many different hues and fragrances everywhere.

As explained in the preceding chapters, true glazed ceramics (Old Seto) were produced during the epoch from the Kamakura period through early Muromachi, with manufacture centering in the Seto area of Owari Province. At the same time, from other districts, including Tokoname in Mino, Shigaraki in Omi, Marubashira in Iga, Tachikui in Tamba, the neighborhood of Oda in Echizen, and Imbe in Bizen, came a profusion of domestic utensils such as jars, water jugs, mortars, mixing bowls, and eared jugs in high-fired unglazed stoneware, rich with the scent and warmth of the earth itself. The Seto glazed wares were based upon Chinese models and thus fell into the class of luxury goods, so to speak. The products of the other kilns were miscellaneous vessels for everyday use.

Since, however, the desires of court nobles, feudal leaders, and clergymen for luxury goods were mostly filled by ceramics imported from China—literally "chinaware"—and since the ordinary country gentry and farmers did not press domestic

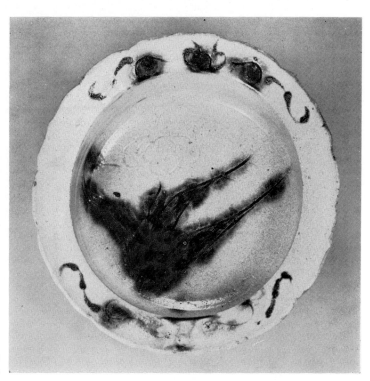

141. *Shallow bowl with iris pattern. Yellow Seto. Late sixteenth century. Diameter, 25.3 cm.*

kilns with overly ambitious demands, medieval Japanese ceramics settled into a long period of stagnation, once the early stage of formative creativity was past. In truth, Seto ceramics had already begun to show signs of flagging, both technically and in production rate, in the years before the latter part of the Muromachi period.

Once the sixteenth century arrived, however, bringing the terminal phase of the Muromachi period, the strength of regional landholders grew, and traffic in commercial goods increased. As a result, provincial castle towns began to show signs of activity, while wealth accumulated and was spread over a greater social area. Especially as the country became progressively more tranquil under the unification policies of Oda Nobunaga and Toyotomi Hideyoshi, there was an ever growing demand for ceramics among the population at large: a demand not only for a greater quantity of

goods but also for an increasingly high quality. The worsening of relations between Japan and Ming China from the end of the sixteenth century on may also have had some bearing on this tendency, for it became more and more difficult to import Chinese goods.

In addition to the changing times, one other factor that gave strong impetus to the further flowering of ceramics was the fashion of tea drinking and the tea ceremony. Tea in general—and the heavy, opaque tea whipped from powdered leaves known as *matcha* in particular—had been popular among the court aristocracy and the clergy of leading temples since the thirteenth century. By the Muromachi period, it had found favor not only with the influential classes of the central districts but also among landholding samurai and other well-to-do citizens in the provinces. We may assume that this popular custom provided the justi-

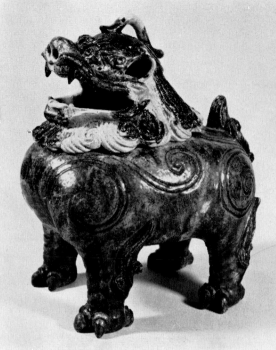

142. *Incense burner with floral pattern. Shino. Late sixteenth century. Height, 8 cm.*

143. *Incense burner in form of a mythical lion, by Sokei. Raku. Dated 1595. Height, 25 cm. Umezawa Memorial Hall, Tokyo.*

fication for Murata Juko in his systematization of the rules of the tea ceremony in the latter part of the fifteenth century. With the advent of Takeno Jo-o in the first half of the sixteenth century, the fashion of tea drinking spread still further, so that ordinary landholders and even the newly risen class of city merchants indulged in it. During the age of Nobunaga and Hideyoshi, tea became a firmly established institution in the lives of the populace at large. The new antitraditionalist tea methods of Sen no Rikyu achieved great popularity among the townspeople of such important commercial and manufacturing centers as Sakai, Kyoto, and Hakata, where the new middle-class culture was burgeoning, having left behind the outmoded social structure of the middle ages. This phenomenon is of great interest to students of ceramics.

As the habit of tea drinking spread, the need for tea utensils increased. A new genre was perforce added to the potter's repertory of objects for everyday use. The builders of the new society required tea utensils with an air of lightness and grace, and this demand could not help but result in the creation of new kinds of ceramics.

This is how such fresh, new ceramic styles as Oribe, Shino, and Yellow Seto came to take their place alongside the older Seto *temmoku* tea bowls in the Tokai district. At the same time, the production center of regional industry shifted from Seto in Owari to the kiln clusters of eastern Mino Province. The new ceramic styles tended to avoid areas where older traditions still held sway. Thus utensils in these styles were made with body clays and glaze mixtures which differed from those of Seto.

In Mino Province, quality *sueki* wares of the official-kiln type (Heian *gaki,* or tile wares) had

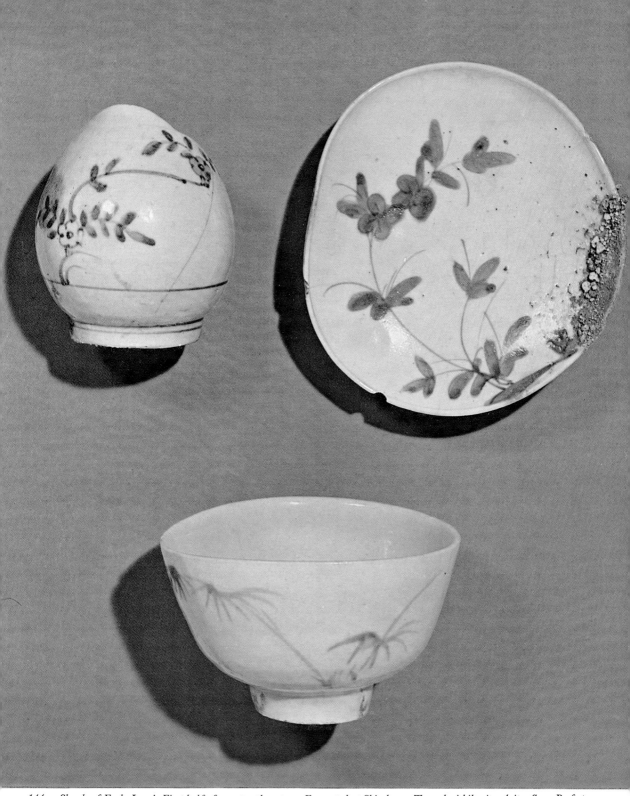

144. *Shards of Early Imari. First half of seventeenth century. Excavated at Shirakawa Tengudani kiln site, Arita, Saga Prefecture.*

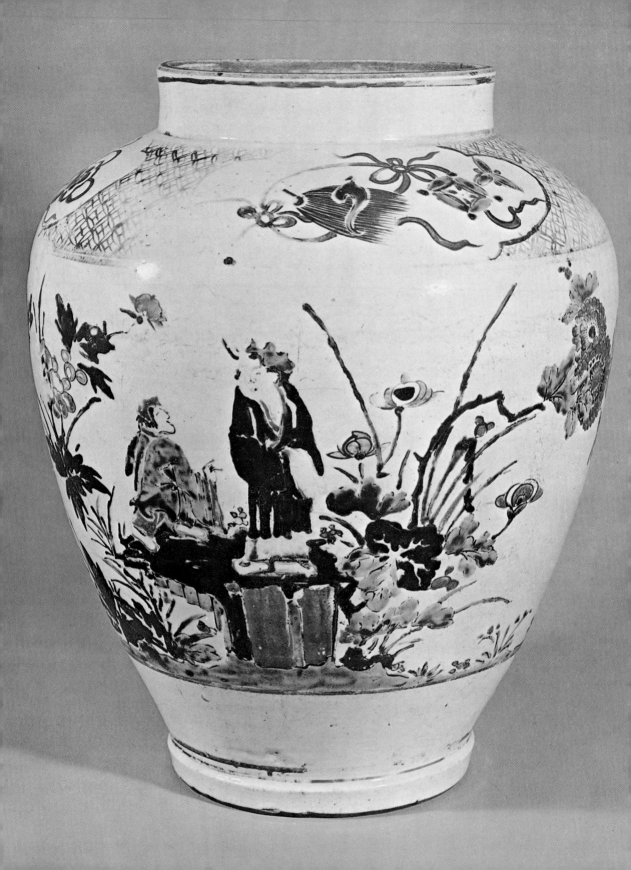

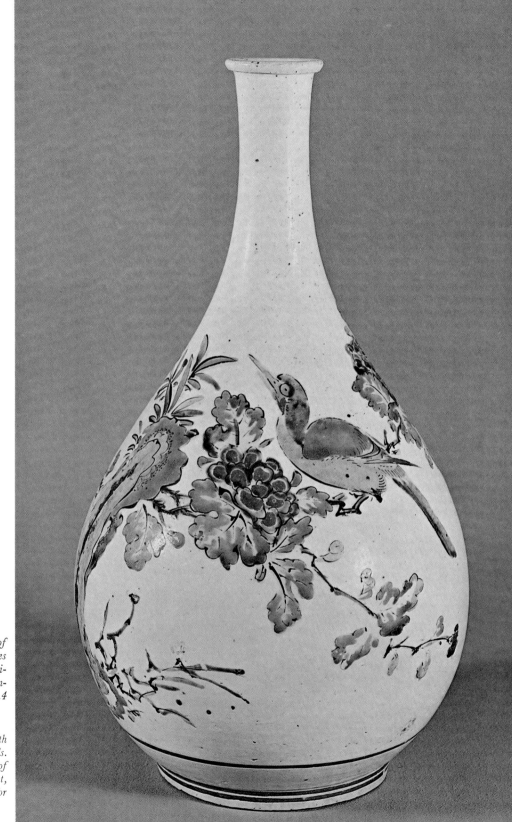

145. Jar with design of human figures among peonies and chrysanthemums. Kakiemon. Second half of seventeenth century. Height, 28.4 cm.

146. Sakè decanter with design of flowers and birds. Kakiemon. Second half of seventeenth century. Height, 30 cm. (See Figure 180 for reverse side.)

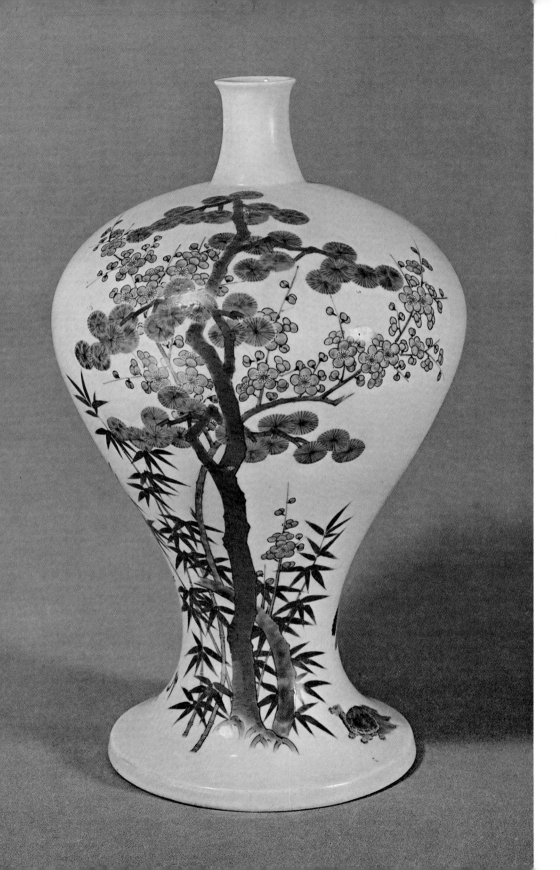

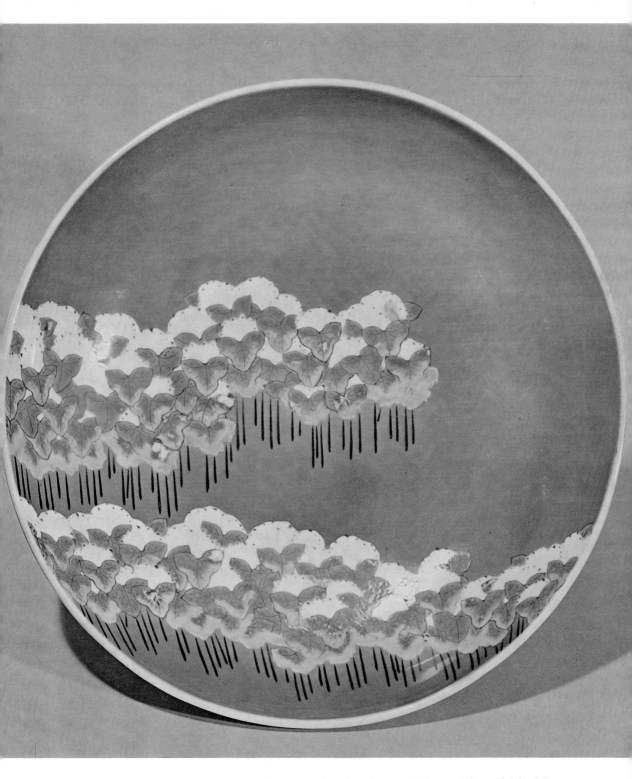

148. *Plate with design of flowering buckwheat. Nabeshima. Early eighteenth century. Diameter, 30 cm.; height, 9.1 cm.*

◁ 147. *Sakè decanter with auspicious design of pine, bamboo, and plum blossoms. Nabeshima. Early eighteenth century. Height, 30.7 cm.*

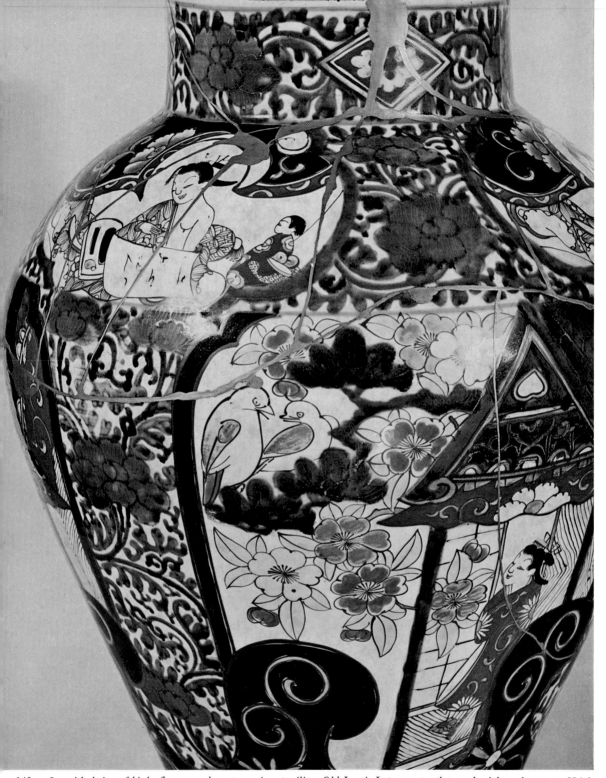

149. *Jar with design of birds, flowers, and courtesans in a pavilion. Old Imari. Late seventeenth to early eighteenth century. Height, 42 cm. Koransha Co., Arita.*

150. *Square bottle with designs of Europeans. Old Imari. Early ▷ eighteenth century. Height, 19.2 cm. Koransha Co., Arita.*

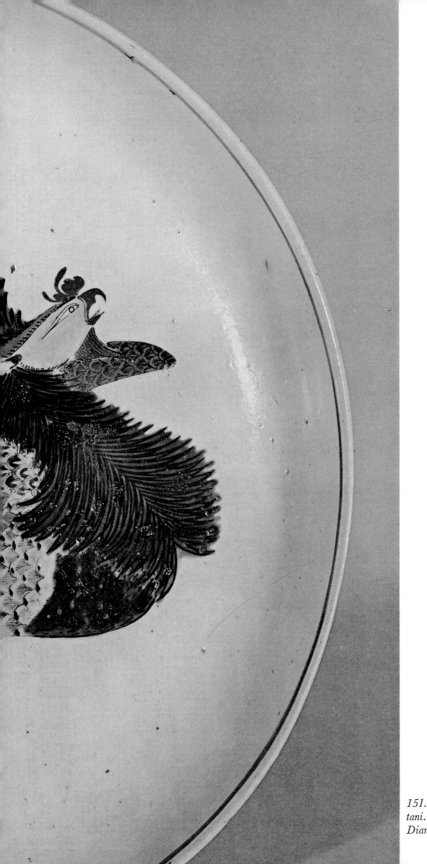

151. *Plate with phoenix design. Old Kutani. Second half of seventeenth century. Diameter, 34.2 cm.*

153. *Dish with design of paths among rice paddies. Old Kutani. Second half of seventeenth century. Length, 23.4 cm.; width, 21.2 c height, 5.4 cm. (See Figure 194 for reverse side.)*

◁ 152. *Set of five small plates with individual designs, by Ogata Kenzan. First half of eighteenth century. Average diameter, 16 cm. Nezu Art Museum, Tokyo.*

154. Bowl with polychrome design of melons on black ground, by Aoki Mokubei. Early nineteenth century. Diameter, 24.3 cm.; height, 10.3 cm. Yamato Bunkakan, Nara.

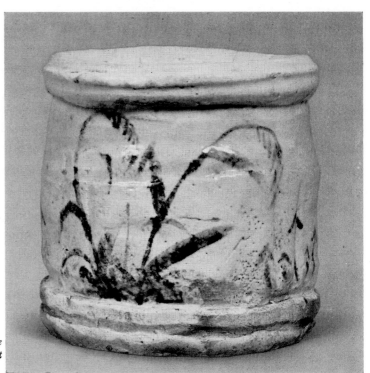

155. *Water jar for tea ceremony. Shino. Late sixteenth century. Height, 18.5 cm. Nezu Art Museum, Tokyo.*

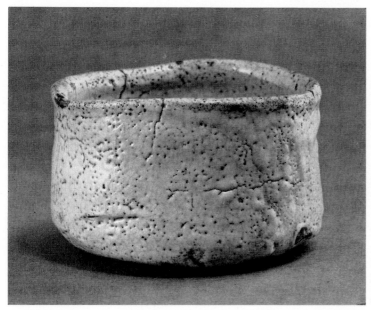

156. *Tea bowl known as Unohana. Shino. Late sixteenth century. Diameter, 13 cm.; height, 8.3 cm.*

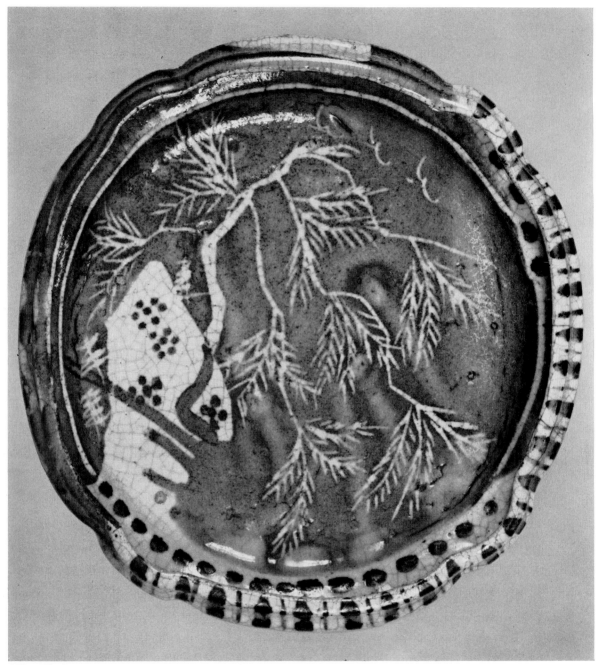

157. *Flat bowl with willow design. Shino. Late sixteenth century. Diameter, 28 cm. Suntory Art Gallery, Tokyo.*

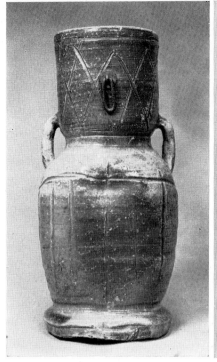
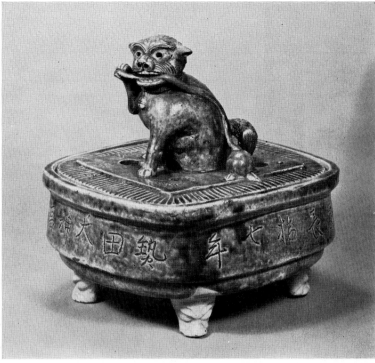

158. *Flower vase known as Jurojin. Iga.*
Late seventeenth century. Height, 28.2 cm.
Nezu Art Museum, Tokyo.

159. *Incense burner. Oribe. Dated 1612. Height, 21.3 cm. Tokyo National*
Museum.

been produced since the Heian period. Again, from Kamakura through Muromachi times, several kilns, such as Kamabora and Kamane at Kukuri and Hiuga at Gotomaki, had turned out utensils similar to Old Seto, but all of these were still very much a part of the Owari sphere of influence, and they did not constitute a distinct sector. During the latter part of the Muromachi period, however, under the protection and encouragement of the powerful Toki clan of Tokitsu, new and fresh blossoms sprouted from the soil of Mino. The earliest of these were the wares known as Yellow Seto and Shino.

The Yellow Seto wares of late Muromachi are yellow-toned ceramics with a light, soft, and most agreeable air. These tea bowls and plates, made from the fine white clay which was the pride of the Mino area, are coated with iron ash glazes just like their Owari Seto counterparts, but the different interactions of clay and fire have resulted in a new and different type of ceramics, with a warmth all its own. Similar color harmonies which give a feeling of warmth may be called a chief characteristic of ceramics in the subsequent Momoyama period. The fine Yellow Seto wares of late Muromachi are believed to have been produced at kiln sites such as Kujiri, Gotomaki, Jorinji, and Akasaba, where they were turned out along with *temmoku*-style bowls.

After this time, in the Momoyama period, Yellow Seto deepened both in the intensity of its yellows and in the degree of its warm quality. In addition to tea bowls and cups, various types of plates, bowls, and flower vases also made their appearance. Among them, it was the decorated wares (*ayame-de*) known as *tampan* that brought special

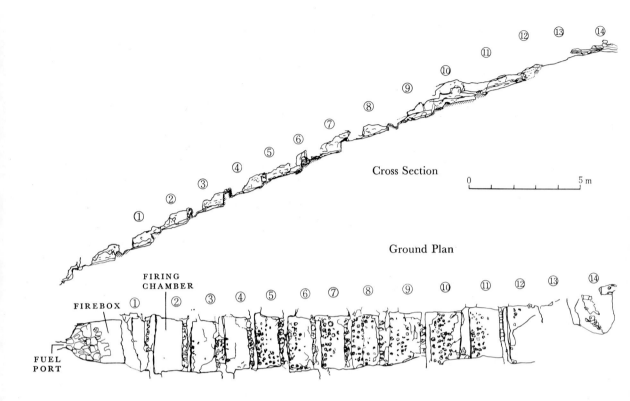

Cross Section

0 5 m

Ground Plan

FIRING
CHAMBER

FIREBOX ① ② ③ ④ ⑤ ⑥ ⑦ ⑧ ⑨ ⑩ ⑪ ⑫ ⑬ ⑭

FUEL
PORT

160. Cross section and ground plan of linked-chamber step kiln. Early seventeenth century. Motoyashiki kiln site, Toki, Gifu Prefecture.

delight to devotees of tea. These were painted with pictorial designs done in a pale-green copper glaze (Fig. 141). Yellow Seto is divided into two main types: 1) glossy, chartreuse-yellow wares (*guinomi-de* or *kikuzara-de*) baked at a relatively high temperature, and 2) the soft, dull-glazed pure yellow *ayame-de* and *aburage-de*, which are fired at lower heat. The latter type has a more modernistic air.

Shino is the most typical and definitive of the Momoyama-period Mino ceramics. Shino wares are covered with a rich white feldspar glaze. They were manufactured in Ogaya, Onada, Gotomaki, and Kujiri in the northwestern part of Toki, as well as at a number of kilns scattered about in the environs of Shimoishi to the south. While each of these kilns had its own particular characteristics,

all of their products were formed from fine white potting clay and covered with thick feldspar glazes. They are generally light in color and have a rich softness.

Among vessel types, bowls, plates, and similar tablewares are especially common, as are tea bowls and deep individual-serving bowls. In addition, there are sakè bottles, incense boxes, flower vases, water droppers, and even inkstones. All have the freshness of light snow but are nevertheless warm and buoyant, rich and strong. Under the white glaze, some of the wares have plant and other natural designs traced out in iron glazes. The faint hint of rose which glows beneath the white-glaze covering is indeed sublime in its loveliness and restraint. The delight in colored pattern that characterizes later Japanese ceramics

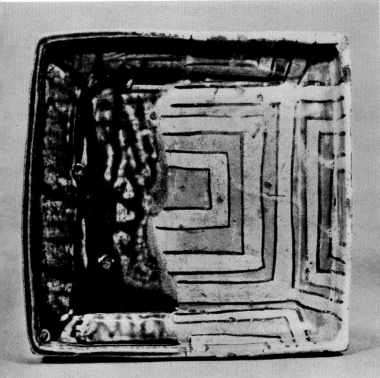

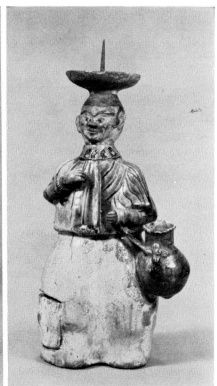

161. Square plate. Oribe. Late sixteenth to early seventeenth century. Length, 21.5 cm.; width, 21.5 cm. Tokyo National Museum.

162. Candlestick in form of a European man. Oribe. Early seventeenth century. Height, 27 cm.

may be said to have originated with Shino.

The unornamented white wares are known as White Shino or Plain Shino (Fig. 156), while those with pictorial designs are called Decorated Shino (Figs. 102, 155). Besides these, there is another important category known as Gray Shino. These were first covered with an iron slip, which was then decorated with graceful scratched designs before being thickly covered with feldspar glazes and baked in reducing flames, so that the iron slip is seen as a warm mouse-gray hue (Figs. 15, 65, 142, 157). Additional varieties are numerous, including Red Shino, Rose Shino, and *neriage-de*, which combines different colors.

Up to this period, high-fired ceramics with white glazes had been missing from the genealogy of ceramics in Japan. In the late Muromachi period,

a ware known as white *temmoku* is said to have been made, but it was so rare as to be almost exceptional. Why, then, should such a highly distinct ware as Shino have been produced during the Momoyama period and been welcomed so enthusiastically by contemporary persons of consequence? To this question there are several possible answers.

First, there is the spirit of the age, which was ready for new patterns and a new color sense. The Momoyama period seems to have been a time that took special delight in complex design and aesthetically rich coloration, as may be seen from the costume fashions of the period. This exuberance was most appropriate to an age that was seeking to open the gateway to a new kind of civilization. In the ceramic field, too, the tendency toward

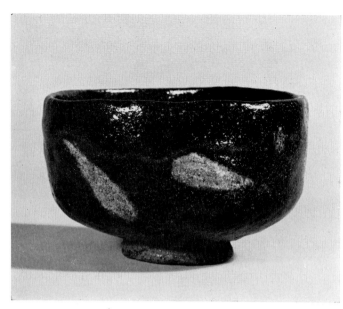

163. Tea bowl known as Chidori (Plover), by Donyu. Early seventeenth century. Diameter, 12.5 cm.; height, 7.8 cm. Fujita Art Museum, Osaka.

164 (opposite page, left). Tea bowl known as ▷ Hayabune, by Chojiro. Late sixteenth century. Diameter, 11.5 cm.; height, 8 cm. Hatakeyama Museum, Tokyo.

165 (opposite page, right). Tea bowl known as ▷ Oguro, by Chojiro. Late sixteenth century. Diameter, 10.7 cm.; height, 8.5 cm.

rich and brilliant colors was doubtless born from the same aesthetic awareness.

There is, however, another theory, which holds that White Shino was not necessarily an independent discovery but rather a derivation from Chinese white-glaze porcelain, the white ceramics of Yi-dynasty Korea, or even, despite its rarity, the white *temmoku* ware produced in Mino during the Muromachi period. Nonetheless, even though this may have much truth in it, it took a peculiarly Japanese kind of originality to change the chill white of Chinese porcelains and white *temmoku* into the warm, emotionally vibrant white glazes which characterize Shino. These glazes were also, in part, an aesthetic feature produced by the simple semi-subterranean chamber kilns of the time.

The term "Shino ware" may be derived from the name of the great tea and incense master Shino Soshin, who flourished during the years around the Daiei era (1521–27) of late Muromachi. Another explanation, however, holds that Shino is simply a corruption of *shiro*, the word for "white" in Japanese. No one knows which version is correct.

The name makes its first appearance late in the Temmon era (1532–55). Throughout the Tensho and Bunroku eras (1573–96), and up until the Keicho (1596–1615) and Genna (1615–24) eras of the early Edo period, many superb ceramics came from Shino kilns. Production, of course, continued after this time, but the utensils gradually sank into mannerism, losing the vitality that permeated the works of earlier years.

During the same eras of Tensho and Bunroku, and at the same place, Mino, another new ware was created: a black ware that stood in complete contrast to the pure-white Shino (Fig. 68). This was Black Seto, produced through a special process that entailed baking the iron-glazed wares in an oxidizing kiln, from which they were removed during the actual firing and suddenly cooled. The shade of black achieved by this technique was far richer and purer than anything seen in the earlier black *temmoku* wares. Thus far, three significant colors had made their ceramic debuts: the yellow of Yellow Seto, the white of Shino (with its attendant grays and reds), and the rich black of Black

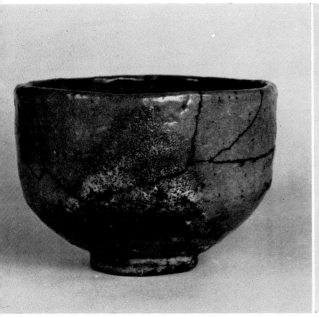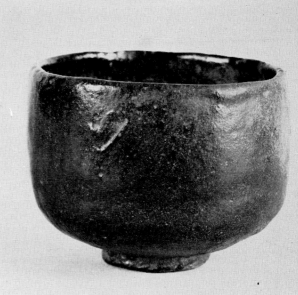

Seto. The next major new arrival was to be the green of Oribe.

Oribe ware derives its name from Furuta Oribe-no-sho Shigenari, a pupil of Sen no Rikyu and a tea master of highly developed artistic sensibilities under whose guidance it was produced. Oribe ceramics are enriched by superb, almost modernistic, concepts of design and by buoyant, glowingly vital coloration relying greatly on blues and greens (Figs. 18, 66, 105, 159, 161).

Oribe ware appeared during the Keicho and Genna eras (1596–1624). Utensils include large bowls, plates, small bowls, deep individual-serving dishes, lidded vessels, sakè bottles, and similar tablewares, as well as tea bowls, small jars for powdered tea, water jars, incense burners, incense boxes, and the like. Additional products included candlesticks, tobacco pipes, inkstones, desk water droppers, and an unusually wide variety of other objects.

Some Oribe specimens are made in standard ceramic shapes—squares, circles, and the like. Others, however, have a strongly *déformé* character in which distortion and imbalance have been deliberately used to create a new kind of artistic equilibrium. These result from the tastes of Furuta Oribe. In their attempt to break out of old traditional conventions to find beauty in new forms, these wares bear witness to a strong thirst for aesthetic discovery.

The blue-green vitriol glazes of Oribe ware have a deep, voluptuous luster, almost like fine glass, but they are also fresh and full of life. Another interesting feature is the endless and supremely imaginative range of hand-drawn iron-glaze design that enhance Oribe wares. These have some points in common with the textiles and lacquerwares of the age, but they are even more original, attesting to the suppleness of brushes freely wielded. Many of the motifs are quite exotic in nature. Among these works there are even some that make us wonder if they might somehow have been derived from Persian ceramics of the early and middle periods.

During the same era, the civilizations of other lands were being introduced by way of the port city of Sakai, just south of Osaka, through which

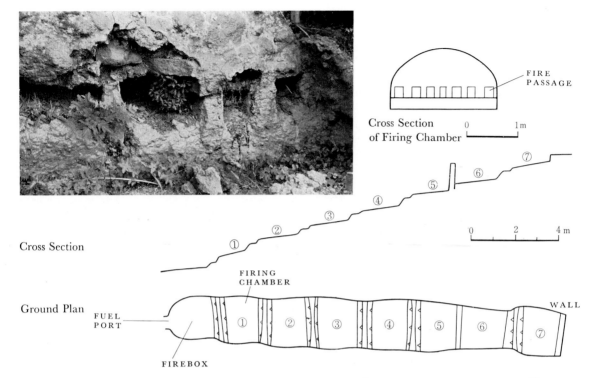

FIRE
PASSAGE

Cross Section
of Firing Chamber

0 1 m

Cross Section

⑦

⑥

⑤

④

③

②

①

0 2 4 m

Ground Plan

FIRING
CHAMBER

FUEL
PORT

FIREBOX

① ② ③ ④ ⑤ ⑥ ⑦

WALL

166. Ruins of linked-chamber step kiln, with cross sections and ground plan. Sixteenth to early seventeenth century. Kitahata, Saga Prefecture.

any number of exotic art objects made their entry into Japan. With his close association with Sakai (the original home of Sen no Rikyu), Furuta Oribe had ample opportunity for direct contact with such foreign imports, which doubtless made it quite natural for him to freely develop artistic conceptions in an exotic style. Evidence of this may be found in the figurine candlesticks in the form of Portuguese men (Fig. 162) and in designs based on European-style tobacco pipes.

In color, concept, and form alike, Oribe wares burst the bonds of tradition in spectacular and revolutionary fashion. While this, plainly enough, may be attributed to the supremely creative spirit of Furuta Oribe, there is yet another factor—namely, the receptive attitude with which the society of the time was ready to welcome and accept new and different modes. Both visually and plas-

tically, Oribe-style taste was the very spirit of contemporary bourgeois society itself, with its distaste for uniformity and its great desire for variety. It proves to us that the social order of early modern Japan was rich in receptivity and in opportunity.

Oribe itself has a wide range of variations. These include Common Oribe, solid green in color; Green Oribe, with painting in underglaze iron beneath the green surface glaze; Narumi Oribe, in which green glazes on a white slip contribute an asymmetrical air; Black Oribe, with black glazes replacing the more usual blue-greens; Figured Oribe; Shino-style Oribe; and other types. There are so many that it would in fact be difficult to name them all.

Behind the perfection of the Oribe style, there was one advanced technical accomplishment that must not be forgotten—the use of the sloping

linked-chamber step kiln (*nobori-gama*; Fig. 166). This was an advanced type of kiln that seems to have entered Japan from Korea by way of Hizen in Kyushu. Much of the technical originality of Oribe may be attributed to the introduction of this kiln type from Hizen. It is probably no accident that the Motoyashiki kiln (Fig. 160), which was a pure example of *nobori-gama* arrangement, produced superior Oribe wares. According to tradition, this kiln technique was first spied out and successfully adapted by Kato Shirozaemon-no-sho Kagenobu (d. 1639), one of the more noted among the "industrial spies" whose stories add color to the pages of Japan's ceramic history.

Views differ as to the origin of Oribe ware. Some regard it as a lineal successor to, and further elaboration of, Shino ware, while others feel that the two are essentially different in nature. I myself feel that while both wares were part of the same order insofar as they are strongly infused with a modern spirit, there was nevertheless a considerable difference in the aesthetic consciousness of the people who created the two wares. Hence, Shino represents an escape from medievalism, while Oribe embodies the plunge forward into modernity. Once the early modern period had passed into history, however, the Mino wares, too, began to exhibit a gradual loss of vitality.

RAKU WARE The contacts between modernism and the art of ceramics were not limited to the Mino-Owari area alone. Contacts were also being made in Kyoto, the time-honored center of Japanese tradition throughout the classical and medieval periods, which was now awhirl with the cultural renaissance of the times. Insofar as Kyoto had itself no ancient ceramic tradition, it created a new array of ceramic types quite different in nature from the innovations that were taking shape in Mino. These were the wares known as Raku, which were a direct and immediate response to the popularity of the tea ceremony.

Raku is an especially light ceramic ware favored for the tea ceremony. Its tea bowls are of particularly fine quality. Raku wares are not wheel-turned; like the Shino tea bowls, they are molded entirely by hand. For this reason, each piece clearly expresses the individuality of the maker's hand. The raw materials are, for the most part, the strongly iron-bearing clays of Kyoto. After the bottom is formed and the sides are built up, the finished vessel is covered with a glaze mixture. The glaze colors are generally red or black, but white is occasionally seen; all are low-fired glazes in a lead solution. The black wares are probably baked at about 1,000°C., while the red wares have a somewhat lower firing point, 800°C. or thereabouts. The kilns are simple single-chamber affairs, small enough to be built in an ordinary garden or courtyard. In form they much resemble miniature versions of the kilns used in recent times for firing roof tiles.

Raku ceramics are light-bodied wares. After the brief flowering of Nara *sansai*, light-bodied ceramics disappeared from the scene, only to be reborn many centuries later as Raku ware. Behind this renaissance there is, as might be expected, an interesting tale.

While no exact year can be assigned as the date when light-bodied ware of the Raku type was first produced, Professor Nobutake Isono's interpretation has tentatively set it at sometime around the beginning of the Tensho era, about 1577–80, in the early Momoyama period. The inventor was a tile-maker known as Chojiro. While engaged in making quality roof tiles for the palaces, castles, and temples that were built in great numbers in Kyoto during the early modern period, he happened to meet the tea master Sen no Rikyu, who was resident in Kyoto at the time and who was just then formulating his own style of the tea ceremony. Under the encouragement and guidance of the great tea innovator, Chojiro began to manufacture tea utensils and especially tea bowls of an entirely new type (Figs. 70, 164, 165).

This may explain why the firing process used in producing Raku ware is so similar to that of a tile kiln. Since Raku ware was simple and unstandardized in technique, anyone could easily find pleasure in it, and since it gave great scope to the individual temperament of the maker, it seems to have been exactly what the new and increasingly influential merchant classes of cities like Kyoto and Sakai

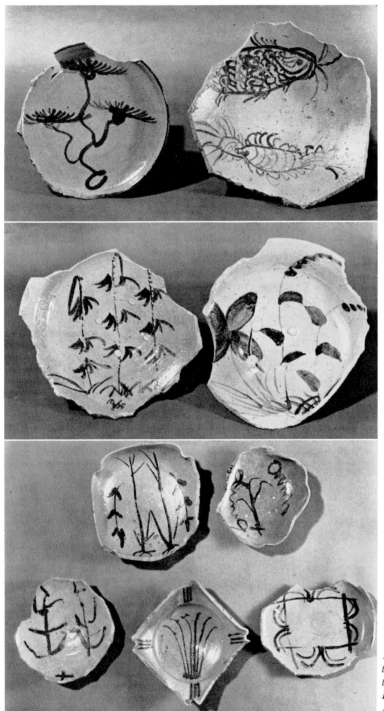

167. *Shards of Old Karatsu. Seventeenth century. Excavated in Saga Prefecture at kiln sites of Kameya no Tani (top), Ichinoseyama Koraijin (middle), and Abodani-shita (bottom).*

were looking for. It goes without saying that Raku ware was also ideally suited to the antitraditionalist spirit of *wabi-cha,* Sen no Rikyu's revolution in tea-ceremony practice. It is a fact that Sen no Rikyu prized Raku very highly and made a point of offering his advice to its potters. In one respect, the Raku bowls and other utensils provide a means of visualizing the great tea master's aesthetic theory.

Chojiro's father was known by the name Ameya Sokei. He is said to have been an émigré tilemaker from Korea, but we do not know if this is true or not. Tradition attributes the name of the ware to the military ruler Hideyoshi, who rewarded Chojiro for making tea wares to his order by granting him a gold signet bearing the Chinese character *raku,* which means "pleasure."

Like Shino and the slightly later Oribe, Chojiro's Raku wares were produced with an eye to use in the tea ceremony. His ceramic pieces tended, however, to be unique, one-of-a-kind creations with something of an "official kiln" character, which may explain why his name and the names of many later Raku potters have been handed down to the present.

This attention paid to individual craftsmen is highly significant, for even though it was limited at first to Kyoto potters, it shows that the ceramic artisans had at last achieved the position of artist-craftsmen. Thus it was the Kyoto area in which a new act in Japan's ceramic history began.

Beginning from the time of its founder Chojiro and his second-generation successor Nonko (also known as Donyu), Raku went on being manufactured over a considerable span of time. Chojiro's works show a general similarity in form, and they have a plebeian congeniality that expressed the feelings of the common people. In contrast, Nonko's creations are characterized by great variety (Fig. 163), which may be a result of the growing self-awareness of the individual artist. In this manner, the nature of Raku utensils differed in accordance with the character of the various Raku craftsmen themselves. But in all of their productions there is rich individuality of plastic concepts.

As time went on, the standard of values in tea utensils grew more complex, especially in the case of tea bowls. Besides color and form, such qualities as surface texture, weight, the feel of the bowl lip in drinking, and the color harmonies with the tea within the bowl became important points of consideration. This development of a multiple standard in judging tea utensils perhaps provides another example of an important characteristic of Japanese ceramics in general. One of the giants among these who deserves special mention is the decorative genius Hon'ami Koetsu (1558–1637), who made so many contributions to the development of the arts, and especially to ceramics (Figs. 107, 168).

OLD KARATSU AND OTHER KYUSHU WARES

At the same time that the first modern ceramics were brightening the scene in the Owari-Mino area and in Kyoto, new types of ceramic products were also appearing in distant Kyushu and the nearby western tip of Honshu: assorted wares that are typified by Old Karatsu (Ko Karatsu) and the other ceramics of the Hizen area.

Like their counterparts in Mino and Kyoto, these Kyushu wares, as we shall call them, were glazed high-fired ceramics, deriving from much the same social conditions characteristic of the early modern period. The actual circumstances of their development are, however, rather different. The wares of Mino and Kyoto were born from within the lineage of the ceramic industry that already existed in Japan. By contrast, the Kyushu ceramics were fostered by the adoption of entirely new techniques brought to Japan from outside—that is, from the Korean peninsula. First of all, let us examine the facts behind this phenomenon.

The first true ceramic ware to be produced on the southwestern island of Kyushu was the so-called Old Karatsu. These jars, water tubs, bowls, and drinking vessels were made from sandy, iron-bearing clay and decorated with a dark-brown iron glaze or with devitrified glazes of ashen white. Since they were built up by the coiling method and pounded into shape manually both inside and out, they are simple and unsophisticated, but they have great strength and an attractive warmth. This type of ceramic ware made its first appear-

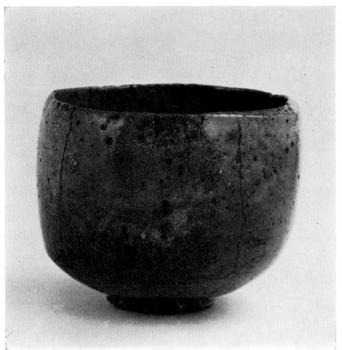

168. Tea bowl known as Bishamondo, by Hon'ami Koetsu. Early seventeenth century. Diameter, 11.7 cm.; height, 9.1 cm.

ance on the Matsuura Peninsula, the part of the eastern Karatsu region closest to Korea, which lies just across the Tsushima Strait. To the best of our knowledge, the oldest kilns (the Hando kilns) seem to have been those in the Kishidake range in southern Karatsu, center of the domain of the Hata clan, "the terror of the Genkai Sea," which had controlled the area throughout the Muromachi period. Here the potters built sloping linked-chamber step kilns in the Korean manner in which they fired ceramic utensils for everyday use (Figs. 166, 167).

As to the actual date of the first Karatsu-style ceramic manufacture, many different theses have been put forward, but the general consensus seems to point to some time during the first half of the sixteenth century—the late Muromachi period. The earliest known documentary evidence is provided by a four-eared jar at the Kazamoto Shrine

on the island of Iki that bears the date of Tensho 20 (1592). Nothing certain can be stated about Karatsu wares before that time.

It is reasonable, and indeed natural, to attribute the birth of Karatsu wares to the influence of the ceramic industry that was flourishing in contemporary Korea. At this time, the latter part of the first phase of the Yi dynasty (1392–1910), the ceramic industry was thriving throughout the Korean peninsula, extending even to the isolated northwestern provinces, but one of the greatest concentrations of active kilns was to be found in the two provinces of Cholla and Kyongju in southern Korea, where many plain household utensils were produced.

These southern Korean ceramic wares were fired in simple sloping step kilns. The utensils bear so close a resemblance to Karatsu vessels that in some cases it is practically impossible to tell the

*169. Tea-ceremony water bowl. Korai Karatsu.
Late sixteenth to early seventeenth century. Height,
15.1 cm.*

two apart. Beyond doubt, the earliest Karatsu ceramics were made in Korean style and according to Korean techniques. It is probably safe to assume that they were the products of Korean craftsmen brought to Japan by the Hata clan.

Thus it came about that glazed high-fired ceramics were first manufactured in one corner of Kyushu as early as late Muromachi and gained considerable currency throughout northern Kyushu. This development may be due to the area's relatively high rate of contact with other countries possessing more highly advanced ceramic cultures. It might also be said that the long-established foreign trade of Hakata and other nearby ports brought about in Kyushu the early opening of a window on modern civilization.

Such is the historical background of modern Kyushu ceramics. The next stage in their development was strongly stimulated by the two invasions of Korea carried out by the military dictator Toyotomi Hideyoshi during the closing years of the sixteenth century. Almost without exception, the many feudal lords of Kyushu and western Honshu who took part in these raiding expeditions made a point of kidnaping or hiring ceramic artists in Korea and bringing them back to Japan, then requiring them to set up kilns and manufacture ceramics within the various feudal domains.

The list of major kilns founded by Korean artists during the Bunroku and Keicho eras (1592–1615) is a very long one. Let us name some of them, beginning in the east: the Hagi kiln (founded by Ri Shakko and Ri Kei) and the Karatsu kiln at Susa, both in the Mori domain of Nagato; the Agano kiln (founded by Chon Hae), first located in the Hosokawa domain of Buzen and later moved to Yatsushiro in Higo; the Takatori kiln (founded by Pal San, known in Japanese as Takatori Hachizan)

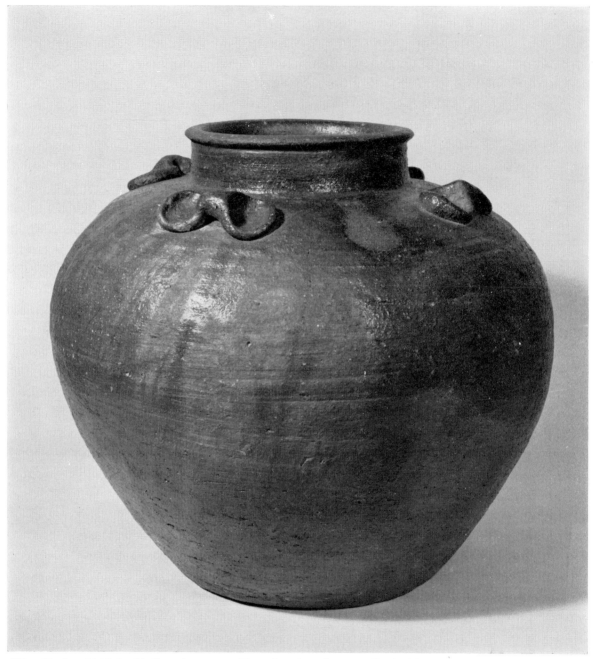

170. *Tea jar with* hi-dasuki *(fire-stripe) pattern. Bizen. Late sixteenth century. Height, 31.4 cm.*

in the Kuroda fief of Chikuzen; the Saka Karatsu kiln (founder unknown) in the principal Nabeshima domain of Hizen; the Taku Karatsu kiln (founded by Ri Sampei) and the Takeo Karatsu kiln (founded by So Den) in the Nabeshima cadet domain, also in Hizen; the Hirado Karatsu kilns (founded by Ko Kan at Mikawachi and by Ri Yukei at Hasami) in the Hirado fief of Hizen. Moving on to Hirado, we find the Shodai kiln (founder unknown) in the Kato fief and, in the Shimazu domain, the Satsuma, Ryumonji (founded by Ka Ho-chu), Tateno (founded by Kim Hae), and Naeshirogawa (or Kushikino; founded by Boku Hei-i) kilns. In addition to their usual stock of utility objects covered with wood-ash or straw-ash glazes in dark brown, amber, or pale gray, all of these kilns also produced utensils for the tea ceremony, such as tea bowls and powdered-tea caddies.

The manufacture of tea utensils and everyday ceramics during the Keicho and Genna eras (1596–1624) was not the sole monopoly of émigré Koreans. After the downfall of the Hata clan there was a general dispersal of potters who had operated kilns in the Kishidake area of Karatsu in late Muromachi times. They spread throughout the Matsuura area, founding their own kilns and continuing to turn out tea wares and wares for household use.

With the invasions of Korea serving as a turning point, the ceramic industry burgeoned spectacularly throughout Kyushu. Behind this development there lay not only the general increase in demand for quality ceramics resulting from the birth of the modern age but also the popularity of the tea ceremony, which swept Japan at the end of the sixteenth century, since the Korean-style Kyushu ceramics, with their simplicity and strong feeling for nature, were found to be quite appropriate for the wabi-cha school of formal tea drinking.

It was Hizen Province in particular that developed a ceramic manufacturing center. At the time of Hideyoshi's first Korean invasion (1592), he established his major base of operations at Nagoya in Hizen, where he often assembled his generals for tea gatherings. In addition, formal tea drinking was very fashionable in the great export center of nearby Hakata. Both of these circumstances caused an increase in the demand for tea wares, and this probably contributed to the development of the industry.

The earliest ceramics to have been fired in the Hizen area are designated by the general name of Ko Karatsu, or Old Karatsu. This generic name is applied to many different types of ceramic ware. The clays used to make Old Karatsu ceramics were sandy and extremely high in iron content. Ordinarily, all vessels were coated with ash, feldspar, or temmoku glazes. Utensils that were covered with only a plain ash slip glaze are known as Undecorated Karatsu (Muji Karatsu), while wares with painted designs in underglaze iron of plants, floral patterns, trees, flying birds, and the like are called E-garatsu (Pictorial, or Decorated Karatsu; Figs. 17, 67, 69, 106, 167). Early works in both styles have the direct simplicity of nature in design and form alike, with an appealing air of peace and repose.

Another Karatsu type is characterized by devitrified white glazes applied to a feldspar-clay ground. This is known as Madara-garatsu—that is, Spotted, or Mottled, Karatsu (Fig. 104). Wares glazed partly in white and partly in a ferrous amber color have the appellation Chosen Karatsu, or Korai Karatsu (Fig. 169). The ceramics known as Temmoku Karatsu have, as might be expected, black glazes reminiscent of temmoku ware.

These are distinctions made on the basis of ornamentation. When the same wares are considered from the point of view of tea-ceremony connoisseurs, there are yet other generic appellations: Oku Korai, Nakao Karatsu, Mishima Karatsu, Seto Karatsu, and the like. Almost all of these names were invented by tea masters, and they demonstrate the extent to which Karatsu wares have become part of the culture of tea.

Karatsu utensils were not, however, limited to tea wares alone. There were also many utility wares such as jars, water vats, bowls, plates, grating mortars, and graters. As a matter of fact, one should not forget that it is these everyday objects that constituted by far the greater part of actual Karatsu kiln output.

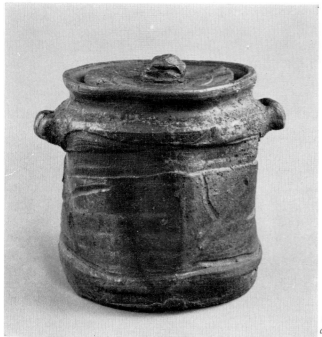

171. Tea-ceremony water jar. Bizen. Early seventeenth century. Height, 19.8 cm.

During earlier phases, kilns outside the Karatsu sphere also uniformly turned out wares decorated with wood-ash, feldspar, and *temmoku* glazes. In no time at all, however, each region began to show increasing individuality in distinct characteristics. Wares of certain areas were decorated by highly original methods that gave them distinctive qualities not found in other districts. One good example is the white-inlay technique used in the Shodai ware of Yatsushiro and certain other wares. This was derived from the so-called *mishima* inlay technique of Korea, a technical triumph of Korean ceramic art.

The early kilns of Kyushu continued to maintain and expand the tradition of Old Karatsu until well into the seventeenth century. By the close of that century, however, the wares had begun to slump into a kind of formalism that deprived them of simplicity and strength, their continued technical improvement notwithstanding.

MOMOYAMA-PERIOD UNGLAZED STONEWARES

From the latter half of the sixteenth century through the early seventeenth, there was great progress in Japan's ceramic culture. A variety of glazed high-fired wares, each having its own individual characteristics, made their appearance, principally in the three ceramic-producing centers of Mino, Kyoto, and Kyushu, resulting in a general trend toward modernity, as described earlier.

Even though these glazed wares did indeed add much color and brilliance to the ceramic landscape, it does not follow that their arrival meant the extinction of the unglazed stonewares, which had held forth as the staple ware throughout the Kamakura and Muromachi periods. Quite the contrary, for the unglazed wares maintained their de facto position as the major ceramic style of Japan throughout the early modern period, just as they had done in previous ages. Tokoname in

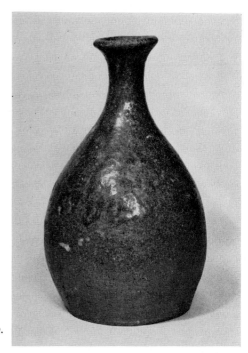

172. Sakè decanter. Tamba. Late sixteenth to early seventeenth century. Height, 27.1 cm.

Owari, Oda in Echizen, Shigaraki in Omi, Marubashira in Iga, Tachikui in Tamba, and Imbe in Bizen—at these and other sites, production continued to flourish (Figs. 100, 103, 158, 170–72).

Around the Momoyama period, some objects from these kilns were chosen for use as tea utensils, and soon afterward intentional production of tea wares was initiated. This tendency to take everyday pots and jars from kilns such as Bizen and elevate them for use as tea equipment was already noticeable in the early sixteenth century. The early (1502–55) use of a Shigaraki *oni-oke* bowl, like that in Figure 63, to serve as a tea-ceremony water container provides one vivid instance of this, and many others could be cited.

After the advent of Sen no Rikyu this emphasis upon domestically produced tea wares grew even greater; for example, there are the so-called *kuni-yaki* wares. These are typified by the tea utensils known as Rikyu-gonomi, or Rikyu-style, which

that master had made to order at established popular kilns like Shigaraki and Bizen. This trend grew stronger as time passed, yielding such styles as Oribe-gonomi and Enshu-gonomi, which were derived from the tastes of Furuta Oribe and the aristocratic landscape designer Kobori Enshu (1579–1647).

Among these, the water jars and flower vases made according to Oribe's taste at the kilns of Bizen showed the potters' creative attempts to find a new vitality in the deliberate ignoring of old conventions even as they strove to retain the natural flavor and vigor inherent in the earth itself. This is a form of abstraction that seeks to discover the future in a conscious denial of the past. Further, the vitality and strength of these ceramics offer concrete expression of the spirit and direction of the age itself. Oribe-style wares held sway throughout the energetic Keicho era, giving place to the more polished and tranquil Enshu-style wares

after the beginning of the more settled Kan'ei era (1624–44). Enshu-gonomi wares were made at Iga, Bizen, Shigaraki, and Tamba. Subsequent to the Kan'ei era, however, these stonewares began to lose their individuality. Even the Shigaraki kilns, which had won renown in the Momoyama period for tea wares and in early Edo for tea jars, gradually declined into mass-production factories that turned out casseroles, teapots, tureens, and similar unglamorous kitchenware.

Porcelain and the Development of Decorated Wares

PORCELAINS WITH UNDERGLAZE PAINTING

As the early modern age progressed, new opportunities for the development of ceramics in Japan arose. In particular, many new techniques were introduced, and at last the manufacture of porcelain began. With the start of domestically produced porcelain, the general picture of ceramic culture became at once even more colorful and complex.

The porcelains of Japan first appeared in the district of Hizen, which had been the center of earlier ceramic manufacture in Kyushu. They were the creations not of Japanese potters but of a group of émigré Korean craftsmen.

In the previous chapter we noted the arrival in Japan of numbers of Korean master potters in the wake of Hideyoshi's invasions of their country in the last years of the sixteenth century. These artisans, skilled in advanced techniques, built kilns and manufactured ceramics in Kyushu during the years following their migration to Japan. The leader of one group of such artisans is said to have been a man named Ri Sampei (in Korean, Yi Sam-p'yong). He established a kiln in the territory of Taku Nagato no Kami, a senior counselor of the Nabeshima clan, and produced wares in the Old Karatsu manner. He hoped, however, to introduce into the Nabeshima domain of Hizen the type of porcelain manufacture that was already being carried on in his native land. Searching diligently for porcelain clays, he discovered them in the neighborhood of Arita. It was in 1616 that his hope was at last fulfilled.

According to tradition, Ri Sampei was also known by the alternate Japanese name of Kanegae Sambei. Until very recently there was not one scrap of positive evidence that could attest to his existence, but the fortunate discovery of his death register not long ago proved beyond doubt the veracity of the Ri Sampei tradition.

Ri Sampei is said to have lived and worked at Tengudani in the Shirakawa section of Arita. Here an ancient kiln site has been discovered that is thought to be the oldest known kiln in the Arita district (Fig. 174). The forms of white and underglaze blue-and-white porcelain bowls (Fig. 139) found within the kiln, the graceful plant designs of the blue-underglaze paintings, and the very structure of the kiln itself—all are practically identical with their counterparts across the strait in Yi-dynasty Korea. This clearly proves that Arita ware of the formative period was founded entirely upon the Korean spirit and Korean technique.

During this period Chinese and Korean porcelains were popular and highly prized, and large quantities of them were entering Japan by way of

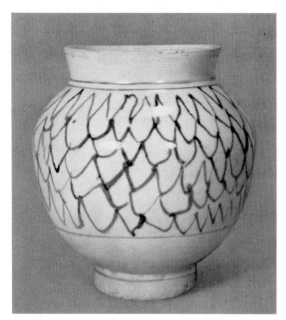

173. Jar with network pattern. Early Imari. First half of seventeenth century. Height, 14.5 cm.

many new porcelain kilns were established (the Heikoba kiln is an example).

Through technical progress, the white ground became purer and more intense. Vessel types increased in number: assorted plates, large bowls, deep individual-serving bowls and other table dishes were made along with the usual tea bowls and sakè bottles. In the pictorial designs ornamenting blue-and-white ware, the streamlined Korean-style motifs of the earliest period gradually gave way to florid and complex patterns in the Chinese manner, with flowers, birds and beasts, landscapes, and topical subjects as well as a variety of conventional auspicious patterns and geometric designs also imported from China (Figs. 20, 71, 72, 173, 175). Designs made by relief stamping were also in use from the earliest times.

The earlier part of the seventeenth century, when the first Japanese blue-and-white wares were produced, corresponded to the end of the Ming dynasty in China, when the so-called T'ien-ch'i (1621–27) and Ch'ung-cheng (1628–44) blue-and-white porcelains were being manufactured. Quantities of these wares were imported into Japan, where their pictorial designs exercised a strong influence over the developing underglaze-blue porcelains of Arita.

Since the products of the Arita kilns were shipped from the nearby port of Imari, they soon became known as Imari ware. Their development owed much to the fine blue-and-white porcelains of contemporary China (Fig. 27).

For some time, the Arita kilns went on turning out wares that were artistically dependent upon China, but as the century approached its midpoint —perhaps around the close of the Kan'ei era in 1644—fresh and graceful designs in the native Japanese manner began to appear. This tendency toward naturalization grew stronger in subsequent decades. By the Genroku era (1688–1704), arabesques, botanical motifs, human figures, and other Japanese decorative elements taken from contemporary copybooks and costume designs were being reproduced upon the curving surfaces of porcelain vessels. This clearly indicates how deeply porcelain utensils had entered the life of the

such commercial ports as Hirado, Nagasaki, Hakata, and Sakai. This trade may have contributed to the domanial desire to copy these wares locally in Hizen and to attempt to fulfill a part of the demand. Clan policy combined with the ambitions of naturalized Korean artists to bring about the birth of Arita porcelains.

Porcelain is hard, durable, and relatively resistant to breakage. Moreover its whiteness gives an air of cleanliness and purity and provides a surface for pictorial ornament in exquisite tones of blue ("blue-and-white" ware). These patterns were freely altered to suit the tastes of successive eras. Further, since porcelains can only be produced in an advanced, efficient form of kiln, the percentage of kiln wastage is greatly reduced.

In such ways, porcelain was superior to the Old Karatsu glazed ceramics being made in western Hizen Province at the time. For this reason, existing kilns of the Arita region showed a gradual tendency to shift from Karatsu-style wares to porcelains (the Hyakken kiln is an example), and

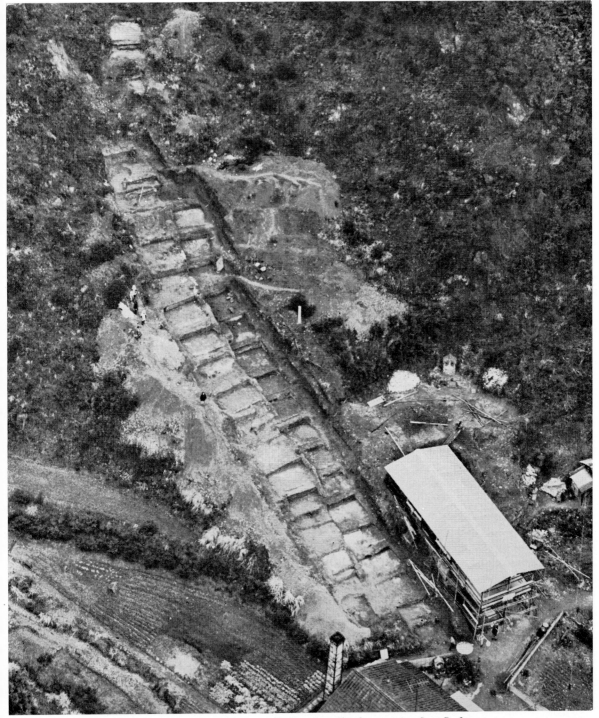

174. *Remains of Early Imari kiln site. Early to mid-seventeenth century. Shirakawa, Arita, Saga Prefecture.*

175. *Plate with plant design. Early Imari. First half of seventeenth century.
Diameter, 14.8 cm. Excavated from kiln site at Arita, Saga Prefecture.*

176. *Sakè decanter with design of chrysanthemums
and mandarin oranges. Nabeshima. Late seventeenth to
early eighteenth century. Height, 30.7 cm.*

urban middle class and what fixtures of daily life
they had become.

NABESHIMA WARE After the manufacture of
white porcelain and blue-
and-white wares had begun at Arita, government
protection was accorded, arising from the need to
improve the economic security of the Nabeshima
domain. In 1628, an official kiln was founded at
Iwayakawachi for the production of white porce-
lains, underglaze-blue wares, and celadons, but at
that time its products were still very simple. It is
said that celadon firing was first taught by a lord-
less samurai from Osaka whose name was Taka-
hara Goroshichi. Later on, during the Kambun
era (1661–73), the domanial kiln was moved to
Nangawarayama and, in 1675, to Okochiyama,
north of Kurogamiyama. It was in this area that

the mature Nabeshima ware was first created.

During the Nangawarayama period of produc-
tion the techniques of celadon and underglaze
blue both showed remarkable progress, but the
most noteworthy phenomenon was the birth of one
Nabeshima innovation in particular—namely,
Polychrome Nabeshima, in which overglaze en-
amels were used to cover the underglaze outlines
drawn in blue. Plates, bowls, side dishes, and other
table utensils were made in this ware (Figs. 176,
177). The inner surfaces of the vessels are finished
in smooth curves, while many objects are high-
footed. Due to the similarity to forms found in
lacquerware, one theory holds that many Poly-
chrome Nabeshima forms were copied from those
of lacquer utensils.

After the move to Okochiyama, further tech-
nical advances were made, and the fifty years from

the Genroku era (1688–1704) through the Kyoho era (1716–36) represented the high point of enameled Nabeshima. This attainment resulted from its having official status and from the very real domanial protection under which it flourished.

Nabeshima is characterized by its pictorial decoration, which is derived from fabric designs, from subjects favored by the Kano and Tosa schools of painting, and from the decorative motifs fashionable in the Edo and Kyoto-Osaka areas. The polished designs of interlaced circles and vines ornamenting the outer surfaces of Nabeshima vessels are also quite masterly.

Colors are relatively few in number, being limited to red, green, and yellow in addition to underglaze blues. Among these, it is the red that stands out as distinctly peculiar to Nabeshima (Fig. 147). Tinged with beige, it is a more restrained and settled shade than the purer vermilion reds of Kakiemon ware (Figs. 145, 146), and it sets the tone for the color harmonies of Nabeshima ware.

The Nabeshima kilns, as we have noted, were run as a domanial enterprise. Their products were made for the use of the Nabeshima clan lords and for presentation as gifts to the Tokugawa shogunate and to the lords who ruled other feudal domains. Subsequent to the Genroku era (in the middle Nabeshima production period), commercial orders from other areas were accepted, but these were limited, coming only from the court aristocracy and feudal nobles. In consequence, Nabeshima wares were the monopoly product of a single Kyushu domain. The wares were intrinsically official in nature, and the Nabeshima clan carried on mass production of such officially sanctioned porcelains. Thus the clan occupied something of an exceptional position in the ceramic history of Japan.

As may be seen from this brief sketch, the beauty of Nabeshima porcelains was essentially the product of a hothouse environment. In plates, bowls, and elaborately molded vases and bottles alike, forms are exact, precise, and highly refined; nowhere is there any trace of so much as a single slip or flaw. The same is true of decoration. Each individual line is drawn with the precise degree of perfection accorded to the others, and there is not one jot of roughness or carelessness. The application of overglaze enamels to Polychrome Nabeshima wares shows particularly fine finish. With their precise division of the special Nabeshima colors, each carefully laid down, these porcelains are masterpieces of tasteful elaboration. In the celadons, with their faint hints of green, the colors are clear, showing the best possible precision control. This height of perfection combined with beauty and elegance could only be achieved in works from a wisely managed official kiln (Figs. 19, 75, 147, 148, 176, 177).

There are a few possible flaws that might be mentioned. Due to their very perfection, Nabeshima wares do not give an impression of abundant vitality, and they are poor in any real sense of vigor or verve. In ornament, too, they are classically elegant, but they do run to excess; at times the overdone complexities of official court aesthetics become a positive hindrance. These are qualities shared by all products of official kilns during the mid-Edo period. Further, they tend to be so ornamental that they are lacking in originality, and one gets the impression that beauty itself is subordinate to the all-important standard or norm.

Later on, we shall take up the development of a strongly plebeian ware that was also produced within the confines of Arita: Old Imari porcelain. The fact that two such different wares could exist and develop side by side in the same area is both interesting and significant.

In summary, we may say that Nabeshima was created in response to the aesthetic psychology of nobles and aristocrats who were restricted by tradition and by their own privilege. The same situation may be found in other officially sponsored arts and crafts of the time and is especially noticeable in the manufacture of pictorial lacquerware.

KAKIEMON WARE

When Japanese admirers of porcelain hear the name Kakiemon, they envision the rich glow of tranquil ivory-white porcelain decorated with gracious designs of the warmly classical, purely Japanese style of painting known as Yamato-e. These designs are handled with elegance and grace in a well-ordered

spatial arrangement, and they charm the viewer with their agreeable feeling of warmth and long familiarity. Both in form and in color, Kakiemon wares are porcelains in good Japanese taste. The appealing orange-reds peculiar to Kakiemon are especially beautiful, approximating the vermilion gleam of ripe persimmons (Figs. 22, 33, 73, 145, 146, 178–80). These porcelains have the brilliance and richness of Chinese overglaze-enamel wares from the Chia-ching (1522–66) and Wan-li (1573–1620) eras, but they embody, if anything, an even greater degree of appealing delicacy and refinement.

The creation of overglaze-enamel wares by Sakaida Kakiemon, one of Japan's greatest geniuses of ceramic decoration, was an achievement that was eventually to bring worldwide fame to Japanese ceramics. Kakiemon's success occurred toward the middle of the seventeenth century—to be more exact, at the close of the Kan'ei era (1624–44)—while Imari blue-and-white wares were continuing to develop.

Overglaze enamels, or polychrome enamels, are known in Japanese as *aka-e* or *iro-e* and in Chinese as *wu-ts'ai*. These porcelain vessels are very handsome, with exquisite designs in blue, red, green, yellow, and at times gold or other colors enhancing their rich white surfaces. In China, superb enameled utensils were produced at the Ching-te-chen porcelain kilns in Kiangsi from the Yuan dynasty (1280–1368) on, gaining in popularity after the beginning of the Ming period (1368–1644). The Chia-ching (1522–66) and Wan-li (1573–1620) eras of Ming are particularly well known for the manufacture of exceptionally fine wares.

From the Muromachi period on, decorated

177. Three views of plate with auspicious design of pine, bamboo, and plum blossoms and underside design of peonies. Nabeshima. Late seventeenth to early eighteenth century. Diameter, 20.3 cm.

Chinese wares were also imported into Japan, where they were treasured by aristocrats, land-holding gentry, and rich merchants. The Swatow ware (known in Japan as *gosu aka-e*) made at Fukien and Kwangtung during late Ming and the porcelains made during the T'ien-ch'i era (1621–27) toward the close of that dynasty found special favor among Japanese tea connoisseurs.

After their arrival at Nagasaki, these Chinese imports were marketed across the entire country. The first Japanese to turn a genuinely thoughtful eye upon these expensive and popular wares was Tojima Tokuzaemon of Imari, a dealer in ceramics. After he had learned the technique of overglaze enameling from Chou Chen-kuan, a Chinese potter at Nagasaki, he decided to establish overglaze-porcelain manufacture in Japan. With this in view, he handed on the necessary information to

the potter Sakaida Kakiemon at Nangawara in Arita, probably at some time during the early years of the Kan'ei era.

The technique of producing overglaze-enamel porcelains is demanding in the extreme—all the more so because of the difficulties of attempting to insure that the color-bearing glazes adhere to the porcelain surface and of striving for artistic quality in the actual designs. Kakiemon worked hard at his task, and around 1644 he succeeded, bringing about the beginning of overglaze porcelain production in Japan. In spite of the well-known superiority of the ceramic culture of Korea, that country's potters did not produce overglaze-enamel porcelains (this was perhaps due to national temperament). In Thailand, too, which was strongly under the influence of China's ceramics from the fourteenth century on, the creation of

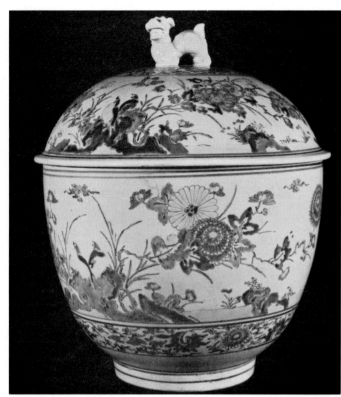

178. Lidded bowl with flower-and-bird design. Kakiemon. Second half of seventeenth century. Height, 36.7 cm. Umezawa Memorial Hall, Tokyo.

179 (opposite page, left). Octagonal bowl with ▷ design of quails and millet. Kakiemon. Second half of seventeenth century. Diameter, 23.9 cm.

180 (opposite page, right). Reverse side of sake ▷ decanter shown in Figure 146. Kakiemon. Second half of seventeenth century. Height, 30 cm.

decorated porcelains was not achieved. Considered in the light of these facts, Japan's outstanding success in this technique appears even more significant.

Concerning the nature of the Kakiemon style in its earliest years, from around 1640 to 1680, there are many points yet to be clarified. In addition, one theory even holds that the Kyoto enamels were actually produced earlier, but the truth of this is not yet known. Nevertheless, it is probably safe to assume that Japanese porcelains with overglaze painting stemmed originally from Arita. It is also clear that the earliest Arita overglaze designs were mainly copies of Chinese wares, based on Chinese painting of late Ming and early Ch'ing. One cannot claim that the milk white of the ground or the enamel reds and other colors are anything but derivative, although it is possible to perceive an

expansive air in style, resulting from the temper of the times.

In later eras, porcelains in the Kakiemon style were exported all over the world by the Dutch East India Company. They continued to improve gradually, and by the late seventeenth and early eighteenth centuries, a characteristic style of decoration had evolved. This was an elegant, purely Japanese mode, and the characteristic warm red, known today as Kakiemon red, and other lovely, pure colors were successfully developed. By such devices as the iron-red line circling the edges and lips of vessels, the paintings themselves were highlighted even more effectively. Another noteworthy feature was the use of a special warm cream white (in Japanese, nigoshi-de) for the porcelain ground. Overglaze-enamel porcelains in genuine Japanese style had reached maturity at last.

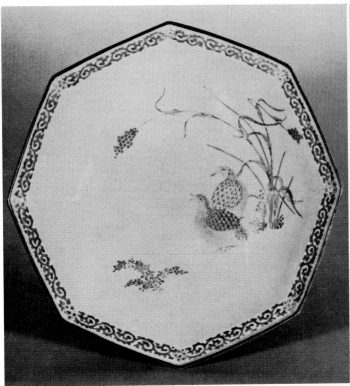

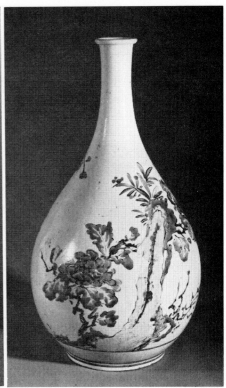

OLD IMARI When, thanks to the efforts of Sakaida Kakiemon and his followers, enameled porcelain was successfully produced at Arita, its techniques began gradually to spread throughout the district. The later seventeenth century also saw the development of overglaze porcelains in a style unrelated to the Kakiemon style. This was the so-called Old Imari ware.

The term "Old Imari" is, as a rule, used to identify porcelains produced in Arita during relatively early times; it does not, however, include Nabeshima and Kakiemon. Even so, the genre of Old Imari covers a multitude of meanings, for it was produced over a long period with many different stages and variations.

During the first era, known today as Early Imari, the influence of Korean Yi-dynasty porcelains was very strong. After this stage passed, the porcelains received considerable influence from China, meanwhile becoming naturalized and developing real originality of design. This is the general outline of Imari history. To be more specific, the period of Old Imari is generally said to extend from the 1640's to the middle of the eighteenth century. The peak of this span corresponds to the colorful Genroku era. Besides the strikingly original Kakiemon and Nabeshima wares, which had long since been created in independent styles of their own, other unrelated wares also made rapid progress, and the gorgeous, inventive polychrome-enamel wares of Arita ("brocade wares") arrived to take their place beside the slightly older Arita blue-and-white.

Therefore, the term "Old Imari" does not mean "old" in the temporal sense alone; specifically, it refers to products of the era in which Arita porce-

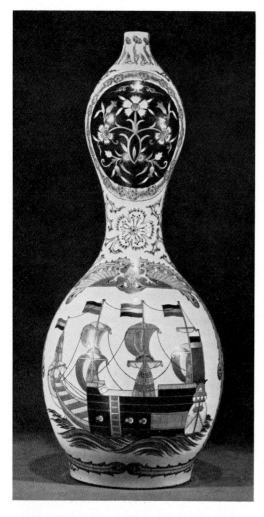

lains underwent their most flamboyant development. Among these porcelains, it is the polychrome-enamel wares that attract the most attention.

During the age of Old Imari, the utensils fired in the Arita kilns represented practically all imaginable categories of ceramics: everything from jars, pots, sakè bottles, plates, bowls, and other table goods to incense burners, figurines, and ornamental objects (Figs. 21, 77, 79, 80, 149, 150, 181–84). These include not a few direct copies of Chinese ceramic articles. A good example is provided by the large lidded jars with short necks and sloping shoulders (in Japanese, *chinko tsubo*) imitating jars from South China that had first come to Japan as containers for pharmaceutical goods or other luxury substances (Figs. 77, 149).

The main characteristic of pictorial Old Imari porcelains (*nishiki-de* and *some-nishiki*) is the gorgeousness of the ornamental colors and designs. The pictorial decoration generally covers every inch of the vessels, while there are many variations of color, all of which creates an air of marked complexity.

Design elements used in the enamels were also rich in variety. There were pictorial subjects and purely decorative patterns as well as combinations of the two. Figurative subjects included pictures of birds and flowers, landscapes, and animals executed in the Chinese or the Korean manner, as well as themes derived from Japanese schools of painting or from the illustrated printed books that were growing in popularity at the time. Subsequent to the Genroku era, representations of Europeans (principally Hollanders) and European ships also appeared (Figs. 21, 181, 184).

Great variety is also to be found among abstract and decorative patterns, many of which were obviously based on fabric designs or taken from design manuals. As for the frequently encountered combinations of abstract and figurative motifs,

◁ *181. Reverse side and bottom of sakè decanter shown in Figure 21. Old Imari. Late seventeenth to early eighteenth century. Height, 56 cm. Cleveland Museum of Art.*

these too may be divided into the two categories of Japanese and Chinese style.

We must not forget to look for one of the sources of the manifold nature of Old Imari ornament in the close relationship between Imari porcelains and the nations of Europe and Asia. During this era, western Europe was moving through the latter stages of the baroque toward the rococo, and craft articles of richness, splendor, and classic elegance were greatly prized. Evidence of this may be found in the specifications of orders for Kakiemon and Imari—specifications that doubtless contributed to a wide range of design and elaboration found in these wares. Orders from other lands resulted in the production of utensils to suit the tastes of those lands. This in turn had a considerable influence upon porcelain objects made for domestic use.

The overseas export trade in Arita porcelains, particularly in Kakiemon and Imari ware, began around the middle of the seventeenth century, when the Japanese porcelain industry had just been established. In the countries of Asia and western Europe, superb Chinese porcelains were in great demand. During the second half of the seventeenth century, however, ceramic export was practically suspended, owing to internal disturbances that occurred as the Ch'ing dynasty supplanted the Ming, as well as to the uncertainty of maritime safety. In order to fill this hiatus in Chinese exports, the enterprising Dutch East India Company hit upon the idea of promoting Japanese porcelains instead.

As a result of these conditions, the first overseas export of Hizen porcelains took place at approximately the same time as their first commercial production, about 1646 or 1647. The volume of export wares grew steadily greater year by year. Thanks to this brisk demand, Hizen porcelains continued to develop and improve in quality, and the rate of production was increased.

The Hizen porcelains that found their way to Europe (especially Kakiemon and other overglaze-enamel wares) were highly regarded and treasured by purchasers in the Netherlands, Germany, France, and England. All over western Europe, their forms and designs were imitated in locally

182. *Plate with design of peonies and fence. Old Imari. Second half of seventeenth century. Diameter, 21.3 cm. Koransha Co., Arita.*

produced porcelains, and such copies and derivations were widely produced even in England. At an unexpectedly early date, western Europe was swept by a vogue for Japanese ceramics. In spite of differences in scope, this has some similarity with the craze for Chinese ceramics that spread over the Middle East during medieval times.

KYO-YAKI : NINSEI AND OTHERS Raku ware developed in the Kyoto area at the beginning of the Momoyama period, as we have noted in the previous chapter. Quite apart from this unique ware, however, are the decorated ceramics, embodiments of the new age, that flourished in Kyoto, the cultural and geographical heart of Japan.

Since Kyoto had long been the political center of the nation, it was sensitive to the currents of the times and readily accepted cultural influences from

183. Bowl with design of dragon and phoenix. Old Imari. Late seventeenth to early eighteenth century. Diameter, 25 cm.

the outside. These influences gave form to the metropolitan civilization of the capital. When the military leaders Nobunaga and Hideyoshi held power, the structure of Japanese society underwent great changes. The culture of southern and western Europe began to seep into Japan through such ports as Sakai. Predictably, Kyoto responded in a direct and immediate way that extended even to the arts and crafts. New goals and forms were sought, and the past was discarded as outworn. This trend can be seen as one of the major causes for the evolution of *wabi-cha,* Sen no Rikyu's simple but profound style of tea ceremony, promulgated in direct defiance of the older, more elaborate tea aesthetics of the aristocracy.

The form of ceramic utensils made for the tea ceremony reveals the temper of the age. In addition to smooth tea bowls of an even roundness, distorted, eccentric wares were also produced. Revolutionary wares such as Raku, Shino, and Oribe

became popular in the central districts, while quaintly deformed water jars and vases (Iga ware, for example) that might almost be termed abstract were greatly appreciated. All of these were straws in the prevailing winds of the age.

In the use of color, the situation was identical. The simpler ceramics of earlier ages, with their plain monochromatic dark browns and yellow-greens, were artistically superseded as more striking colors came into use: brilliant white (Shino), gray (Gray Shino), blue-green (Oribe), vivid blacks and reds (Raku and Rose Shino). Designs were added in underglaze iron, and vibrant form was combined with striking color to achieve new effects. These exemplify some of the great changes that were sweeping through the heart of Japanese civilization. Further, in the mid-Momoyama period, Colored Raku appeared, with the additional tones of green and purple or golden brown, giving new pleasure to users of ceramics (Fig. 143).

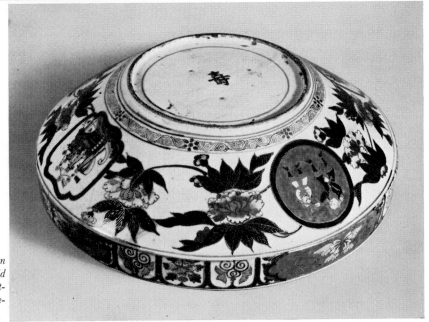

184. *Two views of bowl with design of Europeans and European ships. Old Imari. Late seventeenth to early eighteenth century. Diameter, 30 cm. Umezawa Memorial Hall, Tokyo.*

185. Four-eared tea jar with design of wisteria, by Nonomura Ninsei. Late seventeenth century. Height, 28.8 cm. Hakone Art Museum, Gora, Kanagawa Prefecture.

186 (opposite page, left). Teapot with design of ▷ phoenix in appliqué, by Aoki Mokubei. Nineteenth century. Height, 11 cm.

187 (opposite page, right). Jar with design of fish, ▷ by Okuda Eisen. Late eighteenth to early nineteenth century. Height, 16.5 cm.

In the Kyoto area, this abandonment of old limitations and the introduction of vivid colors into the world of ceramics were not the monopoly of Raku potters alone. Kyoto produced many new wares about which little is known today: Awata-guchi, Oshikoji, Old Kiyomizu, Yasaka, and others. Nonetheless, in the beginning at least, the chromatics of these wares seem to have been limited to overall slip glazes and did not include application of individual pigments. Needless to say, they were still ordinary ceramic wares and not true porcelains.

The demand for color and pattern grew as time went on. Soon after Sakaida Kakiemon succeeded in devising overglaze enamels in Arita, Nonomura Ninsei also began to turn out decorated ceramics in Kyoto—and this with no appreciable time lag. The development of this new Kyoto ware was probably stimulated by the advent of the Kyushu enameled

porcelains. In contrast to the overglaze wares of Arita, which were based in great measure upon continental models and produced with an eye to foreign export, the Kyoto wares stressed the classical Japanese style and retained much of the flavor of traditional court art.

Ninsei is the art name of a ceramic artist, and by extension it also indicates the ceramics he produced. His true name was Nonomura Seiemon. He was born and raised in Tamba, where he first learned the potter's craft. Later on, he moved to Kyoto, where he founded a kiln near the Ninna-ji, a large temple at Saga, on the western outskirts of the capital, in or about 1647. He produced ceramics known as Omuro ware, and he may have received an official appointment (according to a theory proposed by Sakutaro Tanaka).

Under the patronage of the prince-abbot of the Ninna-ji, he taught ceramic art and began the pro-

duction of decorated wares. This may explain why he used the name Ninsei (the *nin* character being identical to that in the name of the temple) after 1657. His kiln turned out all sorts of tableware, tea utensils, and ornamental objects. Judging, however, from surviving works, he appears to have laid greatest emphasis upon storage jars, tea bowls, jars for powdered tea, incense burners, and water jars (Figs. 84, 85). Among his creations, the most highly regarded are his famous enameled four-eared jars for storing leaf tea. Each has its own strikingly executed pictorial motif: pines and camellias, moon and plum blossoms, the cherry trees of Mount Yoshino, wisteria (Fig. 185), landscape with pavilion, waterfall with ascending carp, poppies (Fig. 24), rustic temples, and others. In form, all these vessels closely resemble storage containers from South China. They have, however, been formed upon the wheel with consummate skill, having fine

walls and classical form. The designs, colors, and technique of overglaze decoration are without peer, representing the zenith of accomplishment in decorated ceramics.

Among the pictorial elements employed by Ninsei are representations in the manner of the Kano school, which preserved a feeling of Chinese-style painting. Included also are designs taken from the graceful native Yamato-e tradition and devices based on popular pattern manuals of the day. All of these, however, are permeated by two qualities they share in common: a bold brilliance of conception and layout, expressing the taste current in the early Edo period, and a graciously sentimental atmosphere that characterizes the Kyoto-Osaka area even today. The wide range of colors—gold, silver, red, blue, yellow, green, purple, and black—succeeds in expressing complexities of tonal harmony never before attained in ceramics. The art of

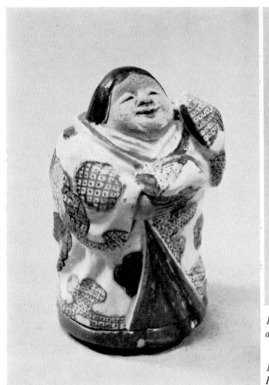

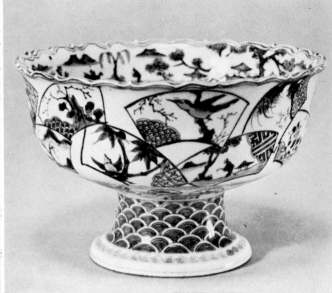

188. *Incense container in form of Oto Goze (a traditional comic character), by Ninnami Dohachi. Early nineteenth century. Height, 7.6 cm.*

189. *High-footed bowl with design of emblems of good fortune, by Eiraku Hozen. Mid-nineteenth century. Height, 11.5 cm.*

Ninsei has many points in common with the decorative lacquerware painting of the day, but it is in fact even more vibrant.

The rich precision in form, lavish and strong pictorial designs, and brilliantly harmonized assemblage of colors that originated with Ninsei set important standards for the ceramic arts of Kyoto, the heart and arbiter of Japanese culture.

With the advent of Ninsei, Kyoto became one of the main Japanese centers for ceramics with surface decoration. After Ninsei's death his work was continued by a number of other gifted individuals such as his immediate successor Ninsei II and Ogata Kenzan (1663–1743; Fig. 152) in the mid-Edo period. These artists were followed in later Edo times by Okuda Eisen (1753–1811; Fig. 187), Ninnami Dohachi (1783–1855; Figs. 82, 83, 188), and Eiraku Hozen (?–1854; Fig. 189), all of whom created superb and highly original decorated ceramic wares.

One other significant characteristic of Kyoto ceramics, whether Raku wares or the works of artist-potters such as Ninsei, is the fact that the individual utensils are signed with seal impressions identifying the makers. This indicates the recognition and increasingly high respect that were accorded to the craftsmen, not to mention the new interpretation of ceramic vessels as works of art. Both of these tendencies indicate the opening of the modern era in ceramic art.

OLD KUTANI Once the technique of producing overglaze enamels had been perfected within the Arita region of Hizen Province, it soon came to be practiced in other areas as well, such as Himetani in Bingo Province (Fig. 81), **Saga**

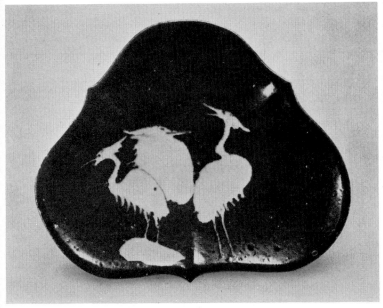

190. *Plate with design of white herons. Suisaka. Second half of seventeenth century. Median width, 15.3 cm. Tokyo National Museum.*

191. *Gourd-shaped sakè decanter with geometric and flower patterns. Old Kutani. Late seventeenth century. Height, 20.1 cm. Tokyo National Museum.*

in Kyoto (Nonomura Ninsei; Figs. 84, 85), and Kutani in the province of Kaga, which faces the Japan Sea. All these kilns flourished in the years between 1644 and 1658. Among their wares, it is the Old Kutani ceramics of Kaga that are best known, not only because of their striking originality but also for the many difficult historical problems they pose.

Throughout the Edo period, Kaga was the domain of the powerful Maeda family of feudal lords, one of the more important "outside" clans whose feudal ties to the ruling Tokugawa shoguns were relatively loose. The vast realm of the lords of Kaga was the center of agricultural production on the relatively isolated Japan Sea side of the nation, and it was also important in the Japan Sea shipping trade. For these reasons the subjects of the Maeda daimyo were relatively prosperous, and the populace at large enjoyed a degree of culture that en-

couraged the growth of the arts and crafts. In these fields, influences from other areas were readily adopted and absorbed. Ceramic art, of course, was no exception.

From the early Edo period on, demand for luxury ceramics was strong in Kaga, and it was a major market for considerable quantities of the Chinese wares imported through Hirado and Nagasaki. Even the European wares that came to Japan in Dutch merchant vessels found princely purchasers among the Maedas. Evidence of this is to be found in surviving records of the Dutch East India Company.

Among the Chinese wares that entered Kaga, late Ming and early Ch'ing overglaze-enamel porcelains seem to have been especially common. The people of the area must have sought these wares with more than ordinary fervor. Considering the conditions in Kaga Province in general, and

192. *Plate with design of quails and millet. Old Kutani. Second half of seventeenth century. Diameter, 30.5 cm.*

193. *Plate with geometric pattern. Old Kutani. Second half of seventeenth century. Diameter, 37.5 cm.*

the desires of the times in particular, the invention of the locally produced overglaze-enamelware known as Old Kutani does not seem strange in the least.

Old Kutani is the name for the decorated porcelains that were presumably produced under the auspices of the Daishoji fief, a cadet division of the Maeda domain. The kiln was located in the small mountain village of Kutani, approximately twelve miles upstream from present-day Yamanaka Hot Springs on the Daishoji River in Ishikawa Prefecture, although much archaeological research still has to be done before the veracity of this can be affirmed.

According to generally accepted traditions, when word of the Arita success with decorated porcelain reached Maeda Toshiharu, daimyo of the Daishoji fief, he determined to ferret out the Arita techniques. He chose a man named Goto Saijiro, who was connected with the Kutani gold-mining

operations, and sent him to Kyushu as an industrial spy. After Goto's return to Daishoji, he founded the Kutani kiln and succeeded in the manufacture of overglaze porcelains. Even the dates of this event are uncertain; some attribute the establishment of the kiln to the Manji era (1658–61), others to the Kambun era (1661–73), but the date of about 1655 proposed by Chisaki Nakagawa seems to be as reasonable a conjecture as any.

By the end of the Genroku era, in the early eighteenth century, Kutani production had apparently come to an end. This was perhaps due to financial problems in the Daishoji fief or, alternatively, to the difficulty of obtaining pigments for use in enamels and colored glazes. The porcelains produced during this brief span of four or five decades are known today as Old Kutani.

Old Kutani utensils run strongly to dishes and tableware. Plates both large and small, bowls, and sakè bottles are especially common. In base clays,

194. *Reverse side of dish shown in Figure 153. Old Kutani. Second half of seventeenth century. Length, 23.4 cm.; width, [...]2 cm.; height, 5.4 cm.*

195. *Plate with design of giant white radish and eggplant. Yoshidaya. Second half of seventeenth century.*

shaping techniques, and firing methods alike, variety rather than uniformity is the rule. High vessel feet—similar to those of contemporaneous Chinese wares, which tend to be indented toward the inside—may perhaps be cited as a common characteristic, although exceptions to the rule do exist.

Among these wares, the plates in particular stand out for their rich and handsome pictorial ornament, which seems a veritable incarnation of the brilliance, vigor, and dash that characterized early Edo style. Some specimens resemble late Ming and early Ch'ing wares. Others echo the styles of Kakiemon and Imari. Still others are in the manner of the Tosa, Kano, or Yamato-e schools of painting, while exotic European or Southeast Asian motifs and derivations from fabric patterns also exist. Certain utensils have combinations of representative and geometric designs. All are characterized by a grand scale and lively, in-

tently toned lines. The heavily applied ornamental glazes in red, indigo, green, purple, and yellow are close in feeling to primary colors, with their striking brilliance. The combinations of these designs and colors have done much to establish Old Kutani as the strongest and most vital of Japanese decorated porcelains, filled with an almost modern sense of, and lust for, life. In particular, the so-called Green Kutani, executed in green, indigo, yellow, and purple, with red banned from the color scheme, is distinguished by its imaginative qualities.

Old Kutani wares express the very sensibilities of the enterprising, independent people who were amassing new strength amid the stark geographic and political landscape of the Japan Sea coast. At the same time, they represent the essence of life itself (Figs. 23, 86, 87, 151, 153, 191, 192–94).

Even though they fall into the same category of overglaze-enamel porcelains, Old Kutani wares are vastly different from the graceful chinoiserie of

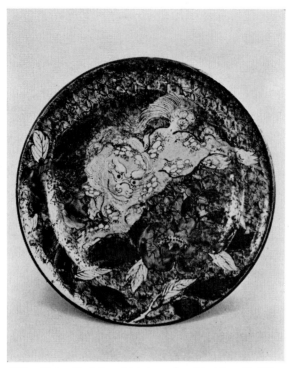

196. Plate with design of peonies and mythical lion. Yoshidaya.
Nineteenth century.

Kakiemon, the chilly feudal perfection of Nabe-shima, the commercial amateurism of Old Imari, or the aristocratic verve of Ninsei's Kyoto wares. Rather, they seem to transmit something of the vivacious energy of a strong people.

Although it is possible to describe the tangible and intangible qualities of Kutani porcelain wares themselves, attempting to make any concrete statement as to their origin remains something of a problem. The excavation of an Old Kutani kiln during 1970 and 1971 revealed that the kiln had produced white ware, blue-and-white ware, celadon, and iron-glazed ware, but the painting on the blue-and-white ware was quite different from that identified with Old Kutani up to this time. In fact it was painting in the Kyoto style. It is not yet clear whether overglaze enameling was done at this kiln. Such matters as these probably require still further research.

After the era Old Kutani, enamel-porcelain production was revived in the province of Kaga under the guidance of the Kyoto potter Aoki Mokubei. It achieved some renown under the name of the Kasugayama kiln, but it was short-lived, and manufacture soon ceased. Toward the close of the Edo period, around 1824, the rich mercantile house of Yoshidaya in Daishoji re-established porcelain production, manufacturing the so-called Yoshidaya ware (Figs. 195, 196). This is based on the style of Old Kutani, but both in quality and in construction it is inferior to the older ware. Nonetheless, it is interesting as a reflection of the spirit of the commercial classes and the unstable social conditions of the late Edo period.

CHAPTER NINE

The Development of a Nationwide Ceramic Industry

CERAMICS IN THE EARLY AND MID-DLE EDO PERIOD The founding of the Tokugawa government in the seventeenth century at the new administrative capital of Edo provided Japanese ceramics with fresh opportunities for growth. As the new feudal system took shape, there developed an impetus for the growth of local industries within the various feudal domains, while war as such became a thing of the past. Partly as a result of this, the townspeople, who lived by industry and trade, gained greater economic power, and the demand for consumer goods increased. Naturally, this meant an increase in the demand for ceramics as well, but in this increase there was another factor that must not be overlooked: the fashion of tea drinking and the tea ceremony.

At the beginning of the Edo period, there were, as we have seen before, three different categories of ceramics, all holding their own: the time-honored unglazed stonewares; glazed high-fired ceramics, which had become especially popular after the close of the medieval age; and high-quality porcelains, relative newcomers to the scene.

The variety of these categories and the increase in types of vessels and wares combined to add new brilliance to the ceramic scene. Nevertheless, there was little change in the number and location of ceramic manufacturing ventures or in the production rate itself. The principal sites of kilns producing unglazed stoneware were the same as they had been: Imbe in Bizen, Tachikui in Tamba, Shigaraki in Omi, Marubashira in Iga, and Tokoname in Owari. The output of these kilns consisted largely of everyday household articles for popular use, with an occasional leavening of tea utensils.

With glazed ceramic wares, the situation was the same. These were mass-produced in a limited number of regional centers: at Seto in Owari Province and in the eastern sector of Mino Province in eastern Japan; in and around Kyoto in the central district; and in Kyushu (especially the northern part) and Nagato in the west. Here, the products were generally household articles and tea wares for the gentry, the townspeople, and well-to-do farmers.

The area of porcelain production was still as limited as it had been at the start, being no more than a narrow strip of land centering around Arita in Hizen Province. The products, mostly tablewares, were shipped to all parts of the country; presumably they went to consumers who were somewhat more prosperous than the purchasers of the other ceramic types.

By the middle of the seventeenth century, the demand for porcelains and other ceramics had at

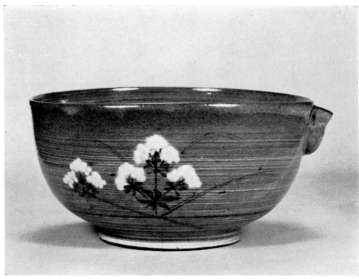

198. *Lipped bowl with floral design. Utsutsugawa. Eighteenth century. Diameter, 16.8 cm.*

197. *Finial ornament for balustrade post. Attributed to Rihei. Second half of seventeenth century. Height, 17.5 cm. Tokyo University of Arts.*

last grown large enough to allow an increase in kiln sites, as well as in the types of vessels produced. This tendency is particularly noticeable in the field of nonporcelaneous glazed ceramics. In Shikoku, for example, there had been no ceramic production whatsoever prior to this time. In 1649, however, the manufacture of Takamatsu ware (Fig. 197) was begun by Morishima Sakubei Shigetoshi (also known as Kida Rihei) at Takamatsu in Shikoku, followed shortly afterward by Kuno Shokaku's founding of the Odo kiln in 1653. At Matsue, near Izumo in the San'in district, which faces the Japan Sea, the Rakuzan kiln was opened during the Keian era (1648–52). Finally, at Yagami in Hizen Province the last decade of the century saw the production of Utsutsugawa ware (Fig. 198), the decoration of which differed from that of the older Karatsu-style wares.

Nor was this all. Far to the north, in the Soma Nakamura area of Iwaki Province, in the Tohoku

district, Nonomura Ninsei's pupil Tashiro Gorozaemon had begun the manufacture of Soma ware as early as 1648, while in the previous year the Mino potter Mizuno Genzaemon had opened the Aizu kiln at Hongo in the Aizu district of Iwashiro Province. From this period also dates the prosperity of the Etchu Seto kiln in Oda-mura, Etchu Province, which had been previously founded by the Mino Seto potter Hikoemon during the Bunroku era (1592–96).

This spread of ceramic manufacture into new territories is indeed noteworthy. At the same time, however, another important phenomenon occurred: additional kilns began to appear at new sites in and around the old established ceramic-producing districts of Seto-Mino, Kyoto, and Kyushu. In the eastern sector alone, there were Akatsu, Shinano, Hora, Go, and Shintani in Seto, as well as Kujiri, Dachi, Tsumagi, Tajimi, Kasahara, Ichinokura, and Oroshi in the Mino district,

1.	Akudo	20.	Suzu	40.	Ko Banko	59.	Dohachi	79.	Ger
2.	Kokuji (Kuji)	21.	Kosugi	41.	Koto	60.	Asahi .	80.	Tal
3.	Kirikobe	22.	Etchu Seto	42.	Anto Akogi	61.	Akahada	81.	Rak
4.	Sado (Aikawa)	23.	Takayama	43.	Shigaraki	62.	Yamato	82.	Fuji
5.	Hirashimizu	24.	Obayashi	44.	Iga	63.	Kosobe	83.	Him
6.	Aizu (Hongo)	25.	Shitoro	45.	Zeze	64.	Kikko	84.	Kan
7.	Soma	26.	Ohi		Kyoto Kilns (46–59)	65.	Kawauchi	85.	Odc
8.	Koisago	27.	Kasugayama	46.	Raku	66.	Izushi	86.	Nos
9.	Mashiko	28.	Suisaka	47.	Awataguchi	67.	Tamba (Tachikui)	87.	Sus
10.	Kasama	29.	Yoshidaya	48.	Ninsei	68.	Mita	88.	Hag
	Edo Kilns (11–16)	30.	Ko Kutani	49.	Kenzan	69.	Akashi	89.	Hag
11.	Kenzan (Iriya)	31.	Echizen	50.	Ko Kiyomizu	70.	Kairakuen		
12.	Edo Banko	32.	Ubagafutokoro	51.	Mizoro	71.	Inkyuzan		
13.	Korakuen	33.	Ofuke	52.	Otowa	72.	Tozan		
14.	Sumidagawa	34.	Nakatsugawa	53.	Oshikoji	73.	Awaji		
15.	Edo Kikko	35.	Mino kilns	54.	Yasaka	74.	Ushinoto		
16.	Toyama	36.	Seto	55.	Eiraku	75.	Shizutani		
17.	Suzaka Kikko	37.	Sanage	56.	Makuzu	76.	Mushiake		
18.	Matsushiro	38.	Atsumi	57.	Eisen	77.	San		
19.	Ueda	39.	Tokoname	58.	Mokubei	78.	Bizen (Imbe)		

...ai	90.	Agano	100.	Hasami
...matsu	91.	Takatori kilns	101.	Hirado
...zan	92.	Yanagawa	102.	Utsugawa
...a	93.	Shodai	103.	Kameyama
...etani	94.	Yatsushiro	104.	Nagayo
...eyama	95.	Karatsu kilns	105.	Hogasaki
		ARITA KILNS (96–99)		SATSUMA KILNS (106–109)
...yama	96.	Early Imari	106.	Ryumonji
...Karatsu	97.	Kakiemon	107.	Chosa
(Matsumoto)	98.	Imari	108.	Naeshirogawa (Kushikino)
(Fukagawa)	99.	Nabeshima	109.	Tateno

KYOTO KILNS

⊙46 ○55
⊙47 ●56
○48 ●57
○49 ●58
○50 ●59
○51
○52
○53
○54

EDO KILNS

○11
○12
●13
●14
●15
●16

Key: Dates of Founding

□ Pre-Kamakura (before 1185)
■ Pre-Kamakura (before 1185) and in continuous production since date of founding
△ Kamakura (1185–1336) and Muromachi (1336–1568)
⊙ Momoyama (1568–1603)
○ Early Edo (1603–1735)
● Late Edo (1735–1868)

NOTE: The symbol ⊕ designates a ceramic center whose various kilns are listed elsewhere on the map. Sites of Sueki kilns are not shown.

not to mention the kiln which produced Ofuke ware (Fig. 200) on the grounds of Nagoya Castle, a stronghold of the Tokugawas. A similar situation existed around Kyoto—the Zeze and Asahi kilns, for example—and in Kyushu.

Ultimately, as we have already seen, this energetic wave of kiln building was a result of the general improvement in the people's standard of living and of the vogue for tea. But the immediate stimulus came from efforts to build up regional industries within the individual feudal domains and from the fashion among aristocratic tea fanciers, including both feudal lords in the provinces and the court nobles of Kyoto, of producing tea utensils, ornaments, and dishes on a private basis. Most of the new kilns opened during the seventeenth century may be placed in one or the other of these categories—domanial industry or private industry—and some in both. Kilns fitting both categories generally turned out a variety of items for everyday use in addition to the regulation tea utensils.

Invariably the techniques and methods used at all these kilns were transplanted from one of the three major ceramic areas. The Odo ware and Takamatsu ware of Shikoku, the Utsutsugawa ware of Kyushu, and the Soma ware of the Tohoku district were all direct extensions of the Kyoto ceramic industry. Aizu ware, also in Tohoku, was of Mino origin, while the Rakuzan kilns of the San'in district inherited the style of the western Hagi ware. All these kilns merely followed the style of their respective parent factories early in their histories, but they began to develop individuality later on, as a response to the local demands of the communities they served. Good examples of this are Soma ware and Aizu ware, the former with its characteristic designs of horses and the latter with its iron glazes and textured glazes in rich combinations (Fig. 199).

By comparison, the boundaries of the porcelain industry did not show any remarkable enlargement. The scarcity of suitable porcelain clays and the difficult techniques involved are of course important factors, but the main reason for the failure to expand lies in the secretiveness of the Nabeshima domain, which was determined to protect its monopoly at all costs. For this reason, while porcelain kilns did increase in number within Hizen Province, hardly any were established in other areas. From the seventeenth century on, the Dutch East India Company became the middleman for many orders from overseas, while internal markets for porcelain increased apace. Also, the discovery in 1712 of fine porcelain clay in the Amakusa area of Hizen did much toward increasing porcelain output within the province. The fact is, however, that regions without such favorable conditions doubtless found that the costs of porcelain manufacture were prohibitive.

Exceptions to the general limited expansion of porcelain manufacture are found in a few cases: the Kutani ware of Kaga Province (Figs. 23, 151, 153), which was produced in the years around the Meireki era (1655–58), and the Himetani ware (Fig. 81) manufactured in Hirose, Bingo Province, from 1648 through 1655. While both of these are overglaze-enamel wares, the former is particularly distinguished for grandeur and brilliant individual beauty in color and design alike. The latter, far more modest in scale, nonetheless has great refinement and charm. Even so, neither of the kilns had a long life span. Kutani seems to have ceased operation before the latter part of the Genroku era, while the demise of Himetani may be dated 1670 or thereabouts. In all likelihood, the profit basis was not sufficient to encourage any very vigorous development.

During the middle years of the Edo period, kilns went on increasing in number, although there were no spectacular advances. In the entire course of the eighteenth century, there are only a few random instances worthy of even passing mention. One is the polychrome Banko ware, which incorporated exotic pictures and was produced between 1736 and 1741. The Banko kiln was established near Kuwana in the province of Ise by Numanami Rozan, the same man who later set up a kiln at Koume in Edo, where he manufactured ceramics for the Tokugawa government on a private basis. In 1731, Ogata Kenzan also established a kiln in Edo, at Iriya. While interesting, none of these kilns are of any major significance. Toward the end of the century,

however, the opening of certain new kilns may be seen as a precursor to the increased development which was to follow: Gennai ware produced at Shido-mura in Sanuki (1751–64), Akahada ware produced in Koriyama of Yamato Province (1781–89), and Shizutani ware in Bizen (1661–73).

In summary, the majority of eighteenth-century kilns, both new and old, leaned heavily on tradition as they continued their operations. Meanwhile, out of this the individuality of regional styles was gradually developing and making itself apparent. Nonetheless, it often happened that, while regional flavor grew progressively stronger, beauty and harmony born from the humanistic creative instincts of the craftsman grew proportionately weaker. In this it is possible to detect a feudalistic tendency toward overemphasis on form and formalism. The stagnation that beset the Tokugawa political system during the eighteenth century was thus reflected in the ceramic arts. By contrast, however, wares such as Banko and Gennai, which attempted to break free from the imprisoning formalism of the past, appear to us as fresh, even revolutionary, heralds of a new age soon to dawn.

REGIONAL CERAMICS IN THE LATE EDO PERIOD

Once the eighteenth century gave way to the nineteenth, a wave of sudden expansion and development broke in upon the world of ceramics in Japan. In the years around 1800, the number of kilns increased amazingly, extending over nearly the entire nation. New and old kilns flourished alike. In particular, porcelain production, which had been limited so long to one sector of Kyushu, began to spread, soon reaching as far as eastern Japan. Kiln construction improved, making possible a greater concentration of mass production. The gigantic slope kilns of Seto provide a good example.

So many new kilns opened that it would be difficult to name them all here. Even if the list is limited only to the major new wares, it is still a very long one. In the Tohoku district, there were Kuji ware at Osanai village in Rikuchu Province (1822),

Hirashimizu ware in Yamagata of Ugo Province (1789–1801), and the Akudo ware of Shimoyuguchi in Mutsu Province (1806). The Kanto district boasted Sumidagawa ware, Kikko ware, and Korakuen ware (all 1804–17), and Toyama ware (1840) in Edo alone, while Hitachi Province produced Kasama ware (1830–43). In Shimotsuke Province, Mashiko potters began making the ware of the same name in 1853, and the Koisago Nasu wares date from 1854. In the Hokuriku district, the production of Aikawa ware (also called Sado ware) began in the Sado Island town of Aikawa around 1800. Other new Hokuriku kilns produced the following wares: Kosugi ware at Kosugi in Etchu Province (1804–29), Yoshidaya Kutani at Daishoji in Kaga (1823–24), and Kasugayama ware in Kanazawa (1806). In the Chubu district new products included the Matsushiro ware of Matsushiro in Shinano (1804–18) and Kikko ware of Suzaka (1845–53), while new styles and new prosperity came to such old established Chubu ceramics as Tokoname ware of Owari, Shidoro ware of Totomi, and Obayashi ware of Ina in Shinano Province.

Several new kilns were established in the Kinki district, producing Koto ware at Hikone in Omi Province (1829), Sanda ware at Sanda in Settsu Province (1785), Kairakuen ware at Wakayama in Kii (1804–30), and others. In the San'yo district (around the Inland Sea) there were the kilns producing Awaji ware at Inada on Awaji Island (1818–30), the Tozan kiln in Harima Province (about 1829), and the Mushiake kiln in Bizen Province (1804–18). The San'in district gained the Inkyuzan ware of Kunoji (1789–1801) and the Ushinoto ware of Ushinoto (1830–44), both in Inaba Province, as well as a revival of Fushina ware in Izumo Province (1789–1801). In Shikoku the San'yo factory of Sambommatsu in Sanuki Province was in operation around the 1830's, and new kilns opened in the Kyushu provinces of Hizen, Higo, and Satsuma.

A number of brilliant ceramic artists were active in Kyoto at this time: Okuda Eisen (1753–1811; Fig. 187), Aoki Mokubei (1767–1832; Figs. 154, 186), Ninnami Dohachi (1783–1855; Figs. 82, 83, 188), Eiraku Hozen (?–1854; Fig. 189). Eiraku

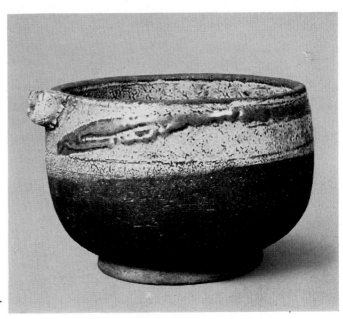

199. Lipped bowl. Aizu. Eighteenth century. Height, 12.9 cm. Tokyo National Museum.

Wazen (1823–96), Ogata Shuhei (1788–1839), Makuzu Chozo (dates unknown), Kiyomizu Rokubei (1738–99), and many others. In the Seto area too there were masters of genius such as Kato Shuntai (1802–77) and Hirasawa Kuro (1772–1790's).

The proliferation of kilns throughout the nation around 1800 is a most interesting phenomenon. Like the development of more general aspects of the Bunka and Bunsei eras (1804–30), it may be attributed in part to a rapid increase in the power and influence of regional landholders and the commercial bourgeoisie.

While continuing the techniques of the older kilns from which they derived, these new kilns turned out ceramics with a sharply regional flavor. As in the parent kilns, emphasis was laid upon craftsmanship, as a result of which many works of high technical brilliance were produced. Japanese ceramic wares—with the exception of the everyday utensils meant for ordinary domestic use—appeared in myriad guises and aspects of increasing color and elaboration. But even though it may have

represented a technical tour de force, this brilliance is often no more than a kind of beauty in stereotype. The increase in the number of works completely devoid of any meaningful human essence may have been an inevitable outgrowth of the decaying Tokugawa social system. By contrast, a more truly vital beauty was likely to be maintained in the humble domestic utensils.

Similar development patterns and reflections of the temper of the times may be found in the porcelain industry. Porcelain manufacture continued to flourish in Hizen and Satsuma, just as in the past. With the approach of the nineteenth century, however, it suddenly burst its bounds and quickly spread throughout the nation.

The first porcelain factory outside Kyushu was the Tobe kiln, founded near Matsuyama in Shikoku in 1777. With Tobe as a beachhead, the industry soon spread to the Pacific coast side of Shikoku, where the Nosayama kiln of Kochi was in operation during the early nineteenth century. In the Kinki district, manufacture of porcelains and celadons began in 1804 at Sanda of Settsu Prov-

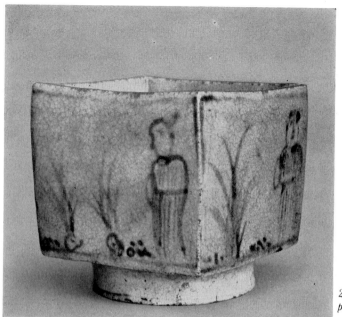

200. Square bowl with design of human figures and plants. Ofuke. Eighteenth century. Length, 10.3 cm.; width, 10.3 cm.

ince, while porcelain production in some Kyoto kilns dates from about the same time.

An even more important milestone was reached in 1807, when the first porcelain factory was opened in the Seto area. The founder, Kato Tamikichi, who had studied porcelain manufacture at Arita, now turned his hand to producing underglaze blue-and-white wares derived from the Arita style. Seto, with its long tradition in ordinary ceramics, gradually gained importance as a major center of the porcelain industry as well. Soon, porcelain production began in neighboring Mino, and before long it had spread throughout the eastern provinces.

Porcelain manufacture in the Tohoku district began in 1800 at the Hongo kilns in Aizu, while a kiln for blue-and-white wares was also established at Kirikobe in Sendai. Needless to say, there was also expansion within the original stronghold of the porcelain industry, Kyushu itself, as blue-and-white manufacture spread to such kilns as Kameyama (1804) and Hogasaki (1823) in the Nagasaki area.

Thus it came about that utensils made of porcelain found their way into households everywhere in Japan. As a natural outcome of the needs and the progress of society at large, porcelains gradually assumed the lead in the world of Japanese ceramics.

The porcelain vessels typical of this era are gorgeous in ornament as well as elaborate in shape and construction. But this lavishness was no more than a meaningless display of forms, and as a whole these wares are lacking in universal human appeal. In artificial beauty and contrived brio, they are no different from the ordinary ceramics of the time. Here, too, the beauty of genuinely honest workmanship was preserved only in the unpretentious objects which were made to serve everyday purposes.

With the aesthetic confusion of the declining Tokugawa social order still unresolved, the ceramics of Japan made the transition from the Edo period into the Meiji era (1866–1912) and the widening horizons of the late nineteenth-century world.

Although many new kilns had been established

throughout Japan in the latter years of the Toku-gawa period, the leading centers of the ceramic industry remained, and still remain, the same: Seto and Mino in the east, Kyoto in the central district, and the Hizen and Satsuma areas of Kyushu in the west.

Japan is today one of the leading countries in the world in terms of ceramic arts. Western potters have come to Japan by the hundreds to study with modern Japanese potters of the *mingei*, or folk-art group. The list of leading *mingei* potters includes Shoji Hamada, the late Kenkichi Tomimoto and the late Kanjiro Kawai. The simple shapes and abstract designs of much of today's pottery in Japan join the Western with the traditional styles to produce beautiful and original works that are in keeping with the long heritage of pottery and porcelain production in the nation.

Much ceramic creation being done today continues to use the methods and styles of ancient Japanese models. Among master potters who have worked in this tradition during the twentieth century are Toyozo Arakawa, Imaemon Imaizumi XIII, the late Hazan Itaya, the late Toyo Kane-shige, the late Hajime Kato, Tokuro Kato, Kyuwa Miwa, Muan Nakazato, and Kakiemon XII. Their works, although they often resemble those of earlier periods. decidely reflect the tastes of the modern age.

The ancient kilns and those set up during the Edo period are for the most part still functioning, producing wares for tea-ceremony and everyday use for the Japanese people, and some of the better products of these kilns, expecially those in the Kyushu area, are sold abroad, attracting good prices in the best shops in the West. At the same time, an industry for the production of Western-style chinaware was begun in Japan during the modern period, and the plates, cups, and bowls turned out by the better-known factories are considered to be of a quality comparable to those produced anywhere in the world for Western tables.

ACKNOWLEDGMENTS

As I bring this book to an end, I wish to offer thanks to all the specialists and scholars without whose aid it could never have been written. The following works were particularly invaluable: *Sekai Toji Zenshu* (Ceramics of the World), sixteen volumes, published by Kawade Shobo, Tokyo; *Nihon no Kokogaku* (The Archaeology of Japan), six volumes, published by the same company; and *Toki Zenshu* (Ceramics), thirty-two volumes, published by Heibonsha, Tokyo. I have relied heavily upon all of these, and I am deeply indebted to the many specialists who assisted in their compilation. In addition, I wish to mention the reference value of *Tosetsu* (Studies in Ceramics), the specialist journal of ceramic arts, which I frequently consulted.

I regret that the editorial policy of this series prevents me from making individual mention of all my source materials. Nevertheless, I should like to take this opportunity to apologize for the omissions and to acknowledge my debt to those whose work contributed to the preparation of the book.

TITLES IN THE SERIES

Although the individual books in the series are designed as self-contained units, so that readers may choose subjects according to their personal interests, the series itself constitutes a full survey of Japanese art and will be of increasing reference value as it progresses. The following titles are listed in the same order, roughly chronological, as those of the original Japanese editions. Those marked with an asterisk (*) have already been published or will appear shortly. It is planned to publish the remaining titles at about the rate of eight a year, so that the English-language series will be complete in 1975.

1. Major Themes in Japanese Art, by Itsuji Yoshikawa

*2. The Beginnings of Japanese Art, by Namio Egami

3. Shinto Art: Ise and Izumo Shrines, by Yasutada Watanabe

4. Asuka Buddhist Art: Horyu-ji, by Seiichi Mizuno

5. Nara Buddhist Art: Todai-ji, by Tsuyoshi Kobayashi

6. The Silk Road and the Shoso-in, by Ryoichi Hayashi

*7. Temples of Nara and Their Art, by Minoru Ooka

*8. Art in Japanese Esoteric Buddhism, by Takaaki Sawa

9. Heian Temples: Byodo-in and Chuson-ji, by Toshio Fukuyama

*10. Painting in the Yamato Style, by Saburo Ienaga

11. Sculpture of the Kamakura Period, by Hisashi Mori

*12. Japanese Ink Painting: Shubun to Sesshu, by Ichimatsu Tanaka

*13. Feudal Architecture of Japan, by Kiyoshi Hirai

14. Momoyama Decorative Painting, by Tsuguyoshi Doi

15. Japanese Art and the Tea Ceremony, by T. Hayashiya, M. Nakamura, and S. Hayashiya

16. Japanese Costume and Textile Arts, by Seiroku Noma

*17. Momoyama Genre Painting, by Yuzo Yamane

*18. Edo Painting: Sotatsu and Korin, by Hiroshi Mizuo

*19. The Namban Art of Japan, by Yoshitomo Okamoto

20. Edo Architecture: Katsura and Nikko, by Naomi Okawa

*21. Traditional Domestic Architecture of Japan, by Teiji Itoh

*22. Traditional Woodblock Prints of Japan, by Seiichiro Takahashi

23. Japanese Painting in the Literati Style, by Yoshiho Yonezawa and Chu Yoshizawa

24. Modern Currents in Japanese Art, by Michiaki Kawakita

25. Japanese Art in World Perspective, by Toru Terada

*26. Folk Arts and Crafts of Japan, by Kageo Muraoka and Kichiemon Okamura

*27. The Art of Japanese Calligraphy, by Yujiro Nakata

*28. Garden Art of Japan, by Masao Hayakawa

*29. The Art of Japanese Ceramics, by Tsugio Mikami

30. Japanese Art: A Cultural Appreciation

The "weathermark" identifies this book as having been planned, designed, and produced at the Tokyo offices of John Weatherhill, Inc., 7-6-13 Roppongi, Minato-ku, Tokyo 106. Book design and typography by Meredith Weatherby and Ronald V. Bell. Layout of photographs by Ronald V. Bell. Composition by General Printing Co., Yokohama. Color plates engraved and printed by Nissha Printing Co., Kyoto. Monochrome letterpress platemaking and printing and text printing by Toyo Printing Co., Tokyo. Bound at the Makoto Binderies, Tokyo. Text is set in 10-pt. Monotype Baskerville with hand-set Optima for display.